Kandinsky's Teaching at the Bauhaus

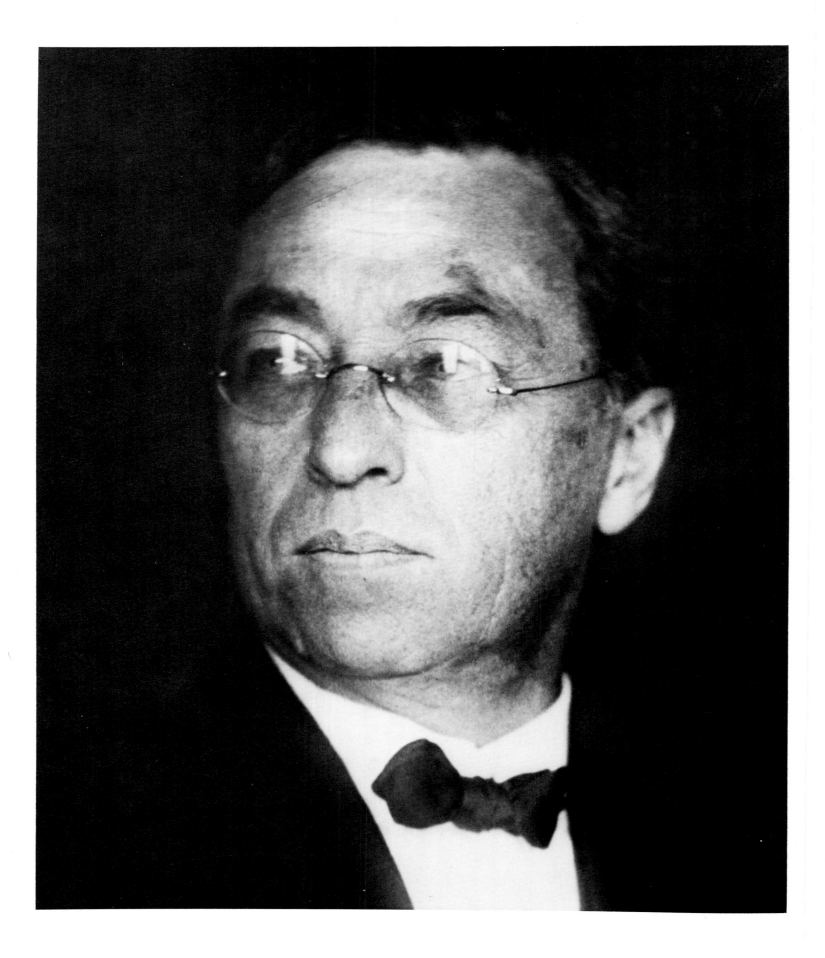

Clark V. Poling

Kandinsky's Teaching at the Bauhaus

Color Theory and Analytical Drawing

RIZZOLI
NEW YORK

To Eve Corey Poling

Published in the United States of America in 1986 by
RIZZOLI INTERNATIONAL PUBLICATIONS, INC.,
597 Fifth Avenue, New York, NY 10017
Copyright © 1982 Kunstverlag Weingarten GmbH
English language copyright © 1986 Rizzoli International Publications, Inc.

Originally published in 1982 by Kunstverlag Weingarten GmbH, Weingarten/Württ, W. Germany under the title *Kandinsky–Unterricht am Bauhaus,* under the auspices of the Bauhaus Archive, Berlin. The catalogue was prepared in cooperation with Christian Wolsdorff.

Library of Congress Cataloging-in-Publication Data

Poling, Clark V.:

Kandinsky's teaching at the Bauhaus.
Bibliography: p.
1. Color in art. 2. Drawing—Technique.
3. Art—Philosophy. 4. Composition (Art)
5. Bauhaus. 6. Kandinsky, Wassily,
1866-1944—Influence. I. Title.
ND1489.P63 1986 701 86-15451
ISBN 0-8478-0780-0

Composition by Roberts/Churcher, Brooklyn, NY
Printed and bound in Japan by Dai Nippon Printing

Frontispiece: Wassily Kandinsky, 1925.
Photograph by Hugo Erfurth, Dresden

Contents

Foreword

With this publication, the Bauhaus Archive presents its collection of the works of students who attended the courses taught by Wassily Kandinsky at the Bauhaus. The collection comprises over two hundred individual sheets preserved from the courses entitled "Color Seminar," "The Abstract Form Elements," and "Analytical Drawing," as well as a few lecture notebooks with transcriptions by students. It represents an immense body of material originating in the years between 1922 and 1933 and collected by the Bauhaus Archive over a period of two decades, beginning in 1960, through donations from all over the world and purchases. The works of Hans Thiemann and Eugen Batz have formed and continue to form the core of the collection, which presently consists of contributions by twenty-four participants in Kandinsky's seminars. Our effort has been to compile systematically a collection that would act as a true and multifaceted mirror of Kandinsky's teaching activities at the Bauhaus. The collection represents today by far the most encompassing and inclusive body of works from Kandinsky's Bauhaus courses and unites the majority of materials that have survived the years of the Nazi regime, exile, and two world wars; we will continue our endeavor to complete the collection.

Not included in this *catalogue raisonné* are those holdings in the Bauhaus Archive of student sheets derived from Kandinsky's private painting class held in Munich and Murnau before the First World War. This phase is represented in the Bauhaus Archive by 222 individual sheets (mostly tempera sketches on paper), the creator of which, Maria Strakosch, was instructed by Kandinsky over a period of years. The paintings are intense in color, Fauvist and impulsive, with many impasto highlights. The ornamental tendencies of the compositions have a counteractive, taming effect on their untrammeled color. Wassily Kandinsky's own painting seems to be almost unreflectively registered in the work of his student—none of the strict methodology that underlies his Bauhaus didactic theory can as yet be discerned. But we must pause to ask ourselves if our selection is entirely representative. The Bauhaus Archive contains not a single individual representation of Kandinsky's teaching activity in Russia between the end of the First World War and his move to Germany in late 1921.

The author of this text, Clark V. Poling, is associate professor of art history at Emory University in Atlanta, Georgia, and former Director of the Emory University Museum of Art and Archaeology. He has conducted various investigations of the color theories of the Bauhaus artists, beginning with his doctoral dissertation at Columbia University in New York City. His deliberations provided the basic concept for an impor-

tant exhibition, "Bauhaus Color," organized by the High Museum of Art in Atlanta and shown at two other American museums in 1976. Poling analyzes and describes his material—the results of the classes held by Kandinsky at the Bauhaus—as an art historian. Primarily he makes formal comparisons, as well as comparisons drawn from the history of form, and is most concerned with artistic and art-historical aspects of the work; yet he is fully aware of the relationship of Kandinsky and his circle to Gestalt and perceptual psychology, as has been invaluably studied by Marianne L. Teuber. Poling's analyses are carefully grounded in historical criticism rather than empty speculation, following the premise that conclusions must be subject to demonstrable proof. In matters of editing, and especially in the preparation of the catalogue, Christian Wolsdorff stood dependably by Prof. Poling's side. We are, therefore, justified in asserting that this publication of students' works preserved in the Bauhaus Archive will fundamentally complete Kandinsky's own pedagogical publications from the Weimar and Dessau years, the Bauhaus Book *Point and Line to Plane,* and his *Cours du Bauhaus,* posthumously published by Philippe Sers. Here we see the evidence of Kandinsky's pedagogical influence: the students' works, reproduced, described, and carefully interpreted.

Even before he came to Weimar and assumed teaching responsibilities, Kandinsky was always one of the central figures of the Bauhaus, and he remained so until the end. His image—the students' assessment of him—was a matter of controversy. To the majority he seemed (in contrast to Paul Klee) dry, dogmatic, and professorial. Kandinsky had great authority and was respected, but he was never the object of spontaneous or heartfelt liking. He was sought out as an advisor, and his opinions held weight. He was totally clear in his own mind about his position with both students and colleagues. His post was that of vice-director of the Bauhaus. Kandinsky was included in all decisions in which the direction of the Bauhaus was concerned or had a say. The superiority of Kandinsky's position (at least during the Gropius era, but most probably afterward as well) becomes clear when we consider the fact that from the first his rigorously decreed theory of the aesthetic link of certain colors to certain forms received barely any argument and was subject to serious contradiction only much later on. The results of the 1923 color questionnaire presented at the Bauhaus were obviously influenced, if not actually determined, by Kandinsky's views. Everyone knew that blue belonged to the circle, red to the square, and that yellow found its formal correspondence in the triangle. This is doubtless one possible set of synaesthetic transferences, but obviously it was and is not the only one. (Oskar Schlemmer, who didn't participate in the survey, reported in a diary entry of 3 January 1926 that he had doubts about these fixed determinations, and he raised arguments in favor of other correspondences.)

Kandinsky's urge for schematization may seem eccentric to today's researchers, but it needn't. Like a few of his contemporaries, Kandinsky was concerned with the recognition of synaesthetic norms and with their communicability. He wanted to expand the realm of artistic experience both subjectively and socially. Among other innovations, he pondered the possibility of a notation of colors that would be analogous to musical notation in its practical application. Opposing the unbounded quality of Expressionism, Kandinsky and his friends were engaged in seeking rules that could be applied in the service of communication. Despite the many esoteric traits in Kandinsky's writings they were not intended to exclude the general public. Instead, his writings fit in with the social designs of the Bauhaus and became an ineradicable part of its conception. In this way especially, Kandinsky was *bauhauslich,* "Bauhaus-like."

The first people on our list of those to be thanked are the creators of the student

material: Alfred Arndt, Eugen Batz, Otti
Berger, Hermann Fischer, Wilhelm Im-
kamp, Ida Kerkovius, Petra Kessinger-
Petitpierre, Hans Kessler, Karl Klode,
Lothar Lang, Fritz Levedag, Heinrich
Neuy, Katja Rose, Herbert Schürmann,
Irmgard Sörensen-Popitz, Hans Thie-
mann, Frank Trudel, Fritz Tschaschnig,
Bella Ullmann-Broner, Charlotte Voepel-
Neujahr, Gerhard Weber, and Vincent
Weber. We especially thank not only the
originators but also the donors of the
works catalogued here. The Bauhaus Ar-
chive also thanks Prof. Clark V. Poling,
the first to examine our material from the
Kandinsky classes from a historical-criti-
cal vantage point, as well as our col-
league, Christian Wolsdorff, who above
all served in the process of cataloguing.
Not least of all, we thank Hero Schiefer,
the understanding director of Weingarten
art book publishers. We remember with
sorrow Nina Kandinsky, who died on 2
September 1980. We are bound to her in
gratitude for her many tokens of friend-
ship; she would have been pleased by
this publication.

Berlin, spring 1982

Hans M. Wingler

Kandinsky teaching the Preliminary Course,
Dessau, 1931

Introduction

In Wassily Kandinsky's long and very productive career as an artist and theorist, teaching occupied an important position. He taught at the Bauhaus for nearly eleven years, his tenure lasting through all the important phases of the school's development, except for the first three years after its founding in 1919. Arriving in Weimar in June 1922, he participated in the consolidation of the theoretical and practical program, leading to the large Bauhaus Exhibition in early fall of 1923. He remained with the school through its years in Dessau, from summer of 1925 to summer of 1932, and during the final months in Berlin up to its dissolution in July 1933 under pressure from the National Socialist regime. Thus he was on the faculty under all three of the directors—Walter Gropius, Hannes Meyer, and Mies van der Rohe—and witnessed the development of a greater emphasis on technical knowledge and utilitarian design. His pedagogical activities consisted of a Theory of Form class—part of the Preliminary Course given to all beginning students—and advanced theory courses taught from 1928 on, plus the direction of the Wall-Painting Workshop in Weimar and a Free Painting class, beginning in 1927. In these he lectured and advised on a very broad range of theoretical and practical matters, from theories of color and form to the use of technical media, and from the history of art and architecture to notions of functionalism.

His contributions were crucial to the development of the Bauhaus educational program, which combined empirical investigations of visual phenomena, a wide variety of artistic and scientific theories, and practical applications to the problems of art and design. The primary documentation for his teaching is provided by various materials, most of which haven't received scholarly attention up to now: Kandinsky's own extensive course notes, totaling 231 pages in the French edition of his *Ecrits complets,* edited by Philippe Sers; and the more than 200 works done by his students, now at the Bauhaus Archive. The latter comprise color exercises and compositions, analytical drawings, and formal studies. In addition there are Kandinsky's articles on his teaching and the course outlines published during the Bauhaus period. This evidence shows that naturally he incorporated into his courses the materials in his numerous theoretical writings from the same years and from the preceding Munich and Russian periods. Much specific information in his teaching notes, ranging from scientific references to comments on changes in locomotive design, amplifies what is known from his published writings. This is especially true for his color theory, as he had considerably elaborated his ideas since the late 1911 publication of *On the Spiritual in Art,* his major work that dealt

with the subject of color. The more than ninety color studies at the Bauhaus Archive, furthermore, are particularly important as demonstrations of the basic principles and phenomena that he taught. They also exemplify a characteristic of Bauhaus pedagogy, to which Kandinsky contributed: the development of series of assignments on individual visual problems, such that students could work empirically with theoretical material and its practical ramifications. The chartlike quality of most of the exercises, using geometric forms in simple arrangements, is also typical, intended, as it was, to achieve clarity and objectivity in these "scientific" investigations.

In the present study, the first section describes Kandinsky's multiple teaching activities at the Bauhaus and the general approach and content of his courses. His presence at the school raises the question of the place of theoretical courses, and especially the teaching and practice of painting, in the curriculum, given that the Bauhaus was dedicated primarily to applied design rather than to fine arts. Kandinsky addressed these issues in his writings during the period, as well as the subject of the relationship between theoretical systems and intuition in the practice of art and design. His philosophy of teaching, therefore, is related to his conception of artistic creation. Kandinsky's critical attitude toward functionalism was a response to developments in that direction at the school, to which he counterposed the ideal of the unification of the arts, which Gropius had originally proclaimed in founding the Bauhaus. Kandinsky's mural projects, the first and most ambitious of which involved the collaboration of students, and his theater designs were realizations both of his desire for "synthetic" art and of the large-scale applications of his artistic principles.

Color theory received a substantial amount of attention in Kandinsky's lecture notes, and nearly half of the surviving student exercises relate to this subject. These studies exhibit far greater variety and range than the analytical drawings, which make up most of the remainder of the student works, along with a small number of formal studies. Of the pedagogical materials, therefore, those concerning color make the greatest contribution to understanding Kandinsky's artistic theory. In evolving his ideas, he drew on many sources, most importantly the theories and systems of Goethe, the painter Philipp Otto Runge, and perceptual scientists such as Ewald Hering and Wilhelm Ostwald. Furthermore, he was influenced by other artists of the late nineteenth and early twentieth centuries, and at the Bauhaus he shared some concepts with Johannes Itten and Paul Klee. His lectures and class assignments show the breadth of his approach to color. The principles and phenomena he treated included: his color system demonstrating the ordered relationships of the basic hues; the interactions of colors and their role in pictorial compositions; and the relationship between color and the formal or graphic elements. Seen in relation to Kandinsky's theoretical writings, such as *On the Spiritual in Art,* the student exercises and the teaching notes provide a very full view of his concepts of color and indicate how they were applied in his own art.

The analytical drawings, done as part of Kandinsky's preliminary course, reveal important aspects of his theories of the formal elements and their structural relationships. They are also fascinating examples of the variety of approaches that individual students might take to the same visual problem. Based on still lifes set up for the whole class to work on, these assignments were intended to train the students in a systematic way of seeing forms. The underlying theoretical principles were those set forth in Kandinsky's major Bauhaus publication, *Point and Line to Plane* (1926), and his lectures on form correspond quite closely to the contents of this book. In their approach the exercises were related to Itten's analyses of old master compositions, and the basic concepts of form involved were

influenced by perceptual psychology. Here, then, was another example of the adaptation of scientific material in the formulation of Kandinsky's thinking, a predilection he shared with his Bauhaus colleagues. The whole enterprise of analytical drawing was part of the search for objective principles or visual laws that would make up the *Kunstwissenschaft,* or science of art, a major goal of the school.

The significance of these pedagogical theories lies in the importance of Kandinsky in the history of modern art and of the Bauhaus as the major twentieth-century school of design. Kandinsky contributed substantially to the program of the school, and the principles that he and his colleagues developed have had a strong international influence on art schools and design practice in this century, especially in Europe and the United States. Kandinsky's teaching sheds light on his artistic career and theories as a whole. He played a major role in the development of abstract art, and through his paintings and writings he had a broad impact on his contemporaries from before the First World War through the 1920s, 1930s, and even later. This subject, therefore, furthers our understanding of significant aspects of twentieth-century culture, the evolution of abstract art and modern design, and the attempt to formulate a science of art.

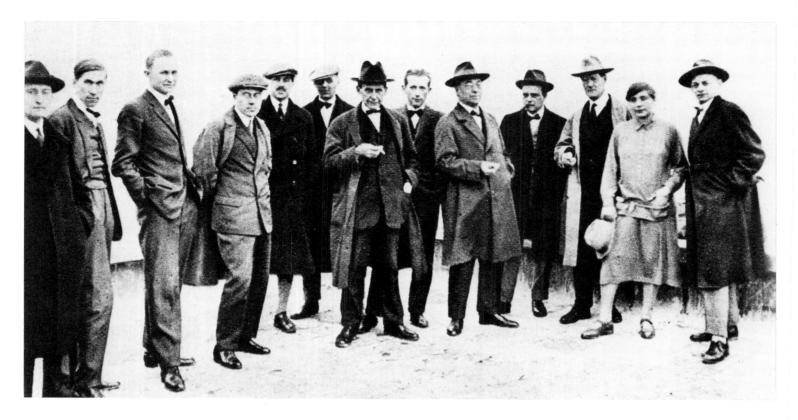

1 The faculty of the Dessau Bauhaus, 1926
photographed on the roof of the Bauhaus
Workshop building. *From left to right:* Josef
Albers, Hinnerk Scheper, Georg Muche,
Laszlo Maholy-Nagy, Herbert Bayer, Joost
Schmidt, Walter Gropius, Marcel Breuer,
Wassily Kandinsky, Paul Klee, Lyonel
Feininger, Gunta Stölzl, Oskar Schlemmer

Kandinsky at the Bauhaus

Why was the abstract painter Kandinsky invited to join the Bauhaus faculty, to teach at a school dedicated to "the great structure," to unifying the practical and "pure" arts—and why in fact was he interested in joining that enterprise? The preponderance of his own artistic output had, of course, been paintings, and would continue to be so for the rest of his career—easel paintings that might be considered to exemplify the isolated "salon art" that Gropius had decried in the founding Bauhaus manifesto of April 1919.[1] Kandinsky himself had long been interested in the integration of the arts and had even undertaken projects in the applied arts. Indeed, the Arts and Crafts movement had had a significant influence on his early thinking, as Peg Weiss has shown, and he created numerous designs for craft objects during the time he lived in Murnau in Bavaria (1904–1914), including furniture, pottery, jewelry, embroidery, and dresses.[2] These represented an impulse toward creating a total design ambiance, related naturally to the ideal of the *Gesamtkunstwerk,* or total work of art, which Kandinsky had inherited from the tradition of Romanticism. He expressed this conception in his call for a great synthesis, in "Monumental Art," in his Russian writings of around 1920.[3] Already, in his years in Munich before the First World War, he had conceived his own work of synthetic art, his

theatrical piece *Yellow Sound,* and had developed his ideas on this subject in a major essay, "On Stage Composition," published with the script for the play in *Der Blaue Reiter* (1912).[4]

Apart from sharing with Gropius and the early Weimar Bauhaus the vision of an ideal union of the arts, including handicrafts, Kandinsky had demonstrated a serious commitment to the teaching of art. Early in his career he organized and taught at the Phalanx school in Munich, from the winter of 1901–02 to 1903.[5] Subsequently, during his years in postrevolutionary Russia, he was deeply involved in the newly formed institutions of art education. In January 1919 he was appointed instructor at the Free State Art Studios (Svomas) in Moscow.[6] In May 1920 he helped form the Institute of Artistic Culture (Inkhuk) and formulated a program for it that in many respects anticipated his later teaching at the Bauhaus. The studies at the Institute should, he proposed, be based on an investigation of the elements of color and form and their psychological effects, incorporating the findings of a variety of sciences in addition to experiments conducted at the school itself; and this research should culminate in the study of "Monumental Art," coordinating the visual arts, music, dance, and various forms of theater.[7] Kandinsky's continued interest in the artistic synthesis offered by performance

arts is further indicated by his role as a director of the Theater and Film Division of the Art Department of the People's Commissariat for Enlightenment (Narkompros).[8] Following his resignation from Inkhuk at the end of 1920, due to the rejection of his proposed program by the leftist Constructivist faction on the grounds that it was too psychologically oriented, Kandinsky participated in the organization of the Russian Academy of Artistic Sciences (RAKhN). In fact, his plan for the Physicopsychological Department of the Academy, proposed and accepted during the summer of 1921, was an abbreviated version of his Inkhuk program. It too, however, was not directly implemented, because of his departure to Berlin at the end of 1921, though the plan was later incorporated, in modified form, into the Academy's program.[9] Ultimately, Kandinsky's development of his theoretical and pedagogical ideas in Russia contributed significantly to his Bauhaus teaching.

It seems, in fact, that Kandinsky knew of the Bauhaus shortly after its founding in April 1919. As a member of the committee in charge of the International Bureau of the Department of Fine Arts, he came into contact with German artists' organizations, including the Work Council for Art and the November Group.[10] In a report on these groups, published in 1919 and apparently written by Kandinsky, he described the synthetic approach of "the new academy at Weimar" under the direction of Walter Gropius. Thus it may even be that Kandinsky's 1920 program for Inkhuk was influenced in part by his knowledge of the Bauhaus and its concern with the unification of the arts. Such shared goals would certainly have made him well-disposed toward the invitation that he received in autumn of 1921 to join the Weimar Bauhaus.[11]

With the growing opposition to his work and ideas in Russia, on artistic and political grounds, Kandinsky obtained permission for a three-month stay in Germany. He was, in fact, never to return to his native country after this exodus. Arriving in Berlin at the end of December 1921, he joined the Bauhaus faculty the following June.[12] This return to Germany after a seven-year absence occasioned an immediate and active reinvolvement in the German art world. In the year following his return, exhibitions of his work were held in Berlin at the Galerie Goldschmidt-Wallerstein, and in Munich at the Galerie Thannhauser; and he was represented at the important International Art Exhibition in Düsseldorf, for whose catalogue he provided the preface. In addition, murals of his design were exhibited at the Jury-Free Exhibition at the Glass Palace in Berlin, and he was included in the First Russian Art Exhibition, held in the autumn at the Galerie von Diemen in Berlin, a project organized by Narkompros in conjunction with the Foreign Organization for Relief of Famine in Russia.[13] In a different area of activity, the year 1922 marked the appearance of his portfolio of twelve prints, *Small Worlds*, printed at the Bauhaus and published by the Propyläen Verlag in Berlin.

Of course, Kandinsky had already been well known in the German avant-garde in the years immediately preceding the War, through his numerous exhibitions and writings, his codirection of *Der Blaue Reiter* and connection with Der Sturm. The three editions of his book *On the Spiritual in Art* that the Piper Verlag, in Munich, published between December 1911 and fall 1912 were early evidence of the widespread interest in his theories. In 1920, even before his return from Russia, he was brought again to the attention of Germans through the publications of Konstantin Umanskij which treated his relationship to recent artistic activities in Russia, and by the monograph by Hugo Zehder that surveyed his art.[14] In his foreword to the latter, Paul Ferdinand Schmidt, director of the Stadtmuseum in Dresden, stressed the effect of Kandinsky on German artists, which he saw as a growing influence, especially on artists in the Sturm circle.[15] Particularly relevant for Gropius was the deep interest that his close friends and cofounders of the Work

ANHALTISCHER
KUNSTVEREIN
JOHANNISSTR. 13

GEMÄLDE AQUARELLE

KANDINSKY

JUBILÄUMS-AUSSTELLUNG

60.

GEBURTSTAG

Geöffnet:	Wochentags: 2 - 5 nachm.
	Mittwoch u. Sonntag 11 - 1
Eintritt:	Mitglieder: Frei
	Nichtmitglieder: 50 Pfg.

2 Herbert Bayer. Poster for the
Kandinsky exhibition in Dessau, 1926

Council for Art, Bruno Taut and Adolph
Behne, felt in Kandinsky's work and theo-
ries, as shown by Marcel Franciscono in
his study of the evolution of Gropius's
ideas for the early Bauhaus.[16] Indeed,
Behne too considered Kandinsky a sig-
nificant influence on modern German art,
an opinion he expressed in his preface to
the exhibition of German art held in Mos-
cow in 1924.[17]
In addition to Kandinsky's commitment to
teaching, to the development of a sci-
ence of art, and to the synthesis of the
arts, therefore, his prominence as an ar-
tist both in Germany and internationally
was surely an important reason Gropius
wanted him at the Bauhaus. His prestige
as a pioneer in the development of ab-
stract art and his reputation as author of
an already impressive list of theoretical
publications would certainly add luster to
the fledgling institute.

Kandinsky's Courses

The primary duty for which Kandinsky
was brought to the Bauhaus was to teach
one of the Theory of Form courses, along
with Paul Klee; together with Johannes
Itten's Preliminary Course, these classes
constituted the obligatory first half year of
instruction for all the students. As Fran-
ciscono has shown, the need for this kind
of preliminary program had been deter-
mined by Gropius and Itten by the au-
tumn of 1920, in order to contribute to the
development of objective principles of art
and design, and provide theoretical in-
struction that would counteract the defi-
ciencies in the students' backgrounds.[18]
Though Kandinsky also took an active
role in the direction of the Wall-Painting
Workshop for the remainder of the Wei-
mar period of the Bauhaus and later initi-
ated a free painting course in Dessau, his
major work at the school always lay in the
Theory of Form classes.
As part of the first semester preliminary
course, Kandinsky was responsible for
"elementary form instruction," the nature
of which is suggested in the newly re-

vised *Statutes of the State Bauhaus in Weimar* of July 1922, the month following his arrival at the school. Here a major component in the Theory of Form part of the curriculum is "Design: 1. Theory of Space, 2. Color Theory, 3. Composition."[19] Kandinsky's first Bauhaus essays, included in the book published for the large Bauhaus Exhibition in late summer of 1923, indicate somewhat more fully the range of material and method of approach in his teaching. In both "The Basic Elements of Form" and his "Color Course and Seminar" he outlined a systematic treatment of visual phenomena from the simplest to the more complicated, necessitating, he asserted, analytic and synthetic processes respectively.[20] In the realm of forms, he began with the three fundamental shapes—triangle, square, and circle—and their three-dimensional counterparts—pyramid, cube, and sphere. On the evidence of his earlier proposed plan of studies for the Institute of Artistic Culture in Moscow (1920), it is clear that he must have begun even more basically, following the sequence of point, line, and plane that he would later use in his Bauhaus book of 1926.[21] In treating form, color, and the combination of these two, he proceeded from individual elements to their interrelationships, conceiving of the latter as "the purposive juxtaposition" of the elements "within a unified structure—the construction. . . ." The final stage is the subordination of the elements and the "construction" to the "artistic content of the work," resulting in true "composition."[22]

In addition to this hierarchical scheme, other aspects of Kandinsky's teaching are manifest in his essays of 1923. He espoused the Bauhaus goal of unifying art, science, and industry, and among the sciences he specifically cited mathematics, physics, chemistry, physiology, and psychology as relevant to this synthesis. As indicated in his Russian proposal, it was the physiological and, even more, the psychological effects of forms and colors that most interested him, though he also acknowledged in his teaching the

importance of the mathematical aspects of forms, the physical nature of light, and the chemical makeup of pigments. However, for the most part, he adopted scientific material quite selectively, and usually without citing it specifically, rather than thoroughly or systematically organizing his course material around it. Technical problems, materials, and methods evidently were given consideration in his teaching but were clearly subordinate in the ultimate value assigned them. This attitude is especially apparent in Kandinsky's statement of early 1924, "The Work of the Wall-Painting Workshop of the State Bauhaus," where he distinguished the

"two separate investigations. . . , which embrace the nature of color in the sense which is most essential for the workshop:

1. The chemical-physical characteristics of color—its material substance.

2. The psychological characteristics of color—its creative forces."[23]

In the Dessau period, Kandinsky expanded the scope of his theoretical teaching, while the school as a whole increased its practical and technical orientation. From these years have survived more detailed evidence as to the content of his courses, in published outlines and, more important, in his own copious teaching notes, which begin with the first summer semester in Dessau, in June 1925, the very month he arrived in this new location of the Bauhaus.[24] At the same time, from July to the beginning of November, he wrote his book, *Point and Line to Plane,* based on notes he had originally made over a decade earlier during late summer and fall of 1914, when at the outbreak of the War he had gone to Goldach on the Bodensee. In 1923 in Weimar he had begun reworking this material, which formed an important part of his Bauhaus teaching.[25]

While Kandinsky no longer directed the Wall-Painting Workshop in Dessau—that responsibility passing to the former stu-

dent Hinnerk Scheper—he gradually augmented his theoretical courses and instituted a painting class. Analytical Drawing was formally added to Abstract Form Elements, and together they constituted his first-semester course. While there is evidence that he began instruction in analytical drawing in 1922, his first class notes for this course date from 1926, and it is officially listed in a Semesterplan that probably dates as early as 1927.[26] This new curriculum listing reflects the major changes in the school's program that were instituted when Gropius created the architecture department, bringing Hannes Meyer to the school in April 1927, to teach in and soon to head the new department. At the same time as this practical aspect of the program was instituted, instruction in the fine arts was formally begun, in the Free Sculpture and Painting Seminar, of which Kandinsky's painting course formed a part. While his notes for these classes begin in mid-May of that year, the course had been under consideration since at least the late summer of the previous year. In September 1926 he wrote in a letter to Will Grohmann that, whereas he and Klee had been giving "practical advice" in painting only to those students who approached them on their own initiative, starting in the fall he hoped that "regular though not required instruction in painting" would be offered. He asked that the information be kept in confidence, since the arrangements had not yet been definitely worked out—indicating the delicate nature of officially admitting pure painting into the Bauhaus curriculum.[27] In fact, the course evidently didn't actually begin until late the following spring.

Kandinsky's satisfaction with the opportunity to teach painting is suggested by his reference to the "new timetable" of studies in his article, "And, Some Remarks on Synthetic Art," of 1927. Having first stated that the Bauhaus and the Vkhutemas (Higher Art-Technical Studios) in Moscow had given technics first place, he said that the Bauhaus was progressing toward equalizing the two factors, art and technology. As a result,

"The student should, apart from his specialist studies, receive as broad a synthetic education as possible. Ideally he should be endowed not only as a specialist but as a new person."[28]

However, the introduction of a fine arts course, on the one hand, and the inauguration of the architecture department, on the other, began the actual breakdown of the unity of fine and applied arts that had been the rallying cry of the Bauhaus. The initial moment occurred while Gropius was still director, though it is usually attributed to Meyer's directorate, which began nearly a year later, in April 1928.[29] Once his influence was established, this division did indeed become pronounced, with painting classes by Klee and sculpture taught by Joost Schmidt, in addition to Kandinsky's course—these coexisting with the more general antiaesthetic tendencies and emphasis on practical design and social purpose that characterized the Meyer era.[30]

Like the Analytical Drawing portion of his first-semester course, the painting course did not involve formal lectures. Instead, it consisted of "exercises on subjects chosen by the students or assigned, group analysis of free work, mutual criticism, discussion of the basic laws. . . ."[31] This emphasis primarily on independent work befitted the advanced status of the painting students, who took the course during their fourth semesters or later [32] As Kandinsky's notes show, the class often worked from arrangements of three-dimensional forms, such as semiabstract still lifes, or from two-dimensional compositions of color and forms, but the students also brought in landscapes and other compositions of their own.[33] Kandinsky's comments ranged from the use of color harmonies, juxtapositions, or scales to the formal structure of the students' work, and he also discussed comparisons with old masters and modern paintings and gave advice on technical matters. The results of his class were

19

exhibited in the rooms of the Anhalt Art Association in 1928, and were discussed by Ludwig Grote in the Bauhaus journal. He noted that the range of works displayed showed that Kandinsky's teaching wasn't dogmatic, that there seemed to be no prescribed "formulae for artistic creativity." At the same time, "A sense for order and the principles [of design] distinguishes all the exhibited works."[34] This characteristic reflects the fact that Kandinsky based part of his teaching of painting on the geometric principles of his approach to analytical drawing, and advised the students to strive for a large compositional form or structure in their works.[35] This is clearly shown in the geometrical still life by Hermann Röseler used as an illustration to Grote's article.

At the beginning of Meyer's directorate, a new theoretical course for advanced students was instituted, Kandinsky's fourth-semester classes on "Artistic Design."[36] One of the purposes of this course evidently was to address the differences between the fine arts and practical design, considering the relationships between art, architecture, and technology. Activities and products of the Bauhaus workshops were discussed, as were more strictly artistic matters: the analysis of old masters, diverse cultural manifestations such as traditional Chinese and Russian art and architecture, and the relationships of abstract and representational art. The recurrent theme was the question of functionalism, Kandinsky disagreeing with the use of strictly utilitarian criteria and instead applying his aesthetic ideas to practical objects, as will be discussed later.

Later, during the period of Mies van der Rohe's direction of the Bauhaus, this fourth-semester class was superceded by a second-semester course that included many of the same kinds of subjects, but was also, naturally, conceived as a direct continuation of the first semester. Whereas the latter treated the basic elements of form, the second semester dealt with problems of composition, es-

pecially the various sorts of rhythms and the formal tensions creating them.[37] In addition, Kandinsky incorporated numerous references to scientific materials in this last course that he developed at the Bauhaus, referring to the study of plants, animals, crystallography, and astronomy. Both the fourth- and second-semester courses, therefore, show Kandinsky's response in his teaching to the increasing concern over practical and technical matters at the Bauhaus under Meyer and Mies. Nevertheless, instead of directing his theoretical formulations toward true applicability in the areas of practical design, Kandinsky assimilated the examples of science, technology, and functional production to his essentially artistic, aesthetic point of view.

Throughout his years at the Bauhaus, Kandinsky's pedagogical methods remained essentially the same. Theoretical and empirical approaches were combined by supplementing his lectures with assigned exercises on specific formal problems, which were subsequently analyzed by teacher and students alike.[38] When appropriate, he included material or advice on practical, technical questions such as pigments, binding agents, and support materials. The collaborative character of his courses was also achieved by having the students give talks on their own investigations or considerations of various phenomena and topics. In his teaching notes, in fact, Kandinsky frequently recorded the discussions and comments by the individual students, as well as his own responses. His personality as a teacher seems to have had two sides. On one hand, he was reserved and even aloof, correctly, somewhat formally dressed, and gave the impression of being unapproachable.[39] He presented his theoretical concepts with clarity, logic, and absolute certainty, believing them to be laws, and he expected his students to summon forth the ability to follow him intellectually.[40] He disliked being contradicted in class, though he was very willing to discuss alternative points of view in the pauses or in other,

less formal, contexts. His intellect and breadth of mind were respected—as one student expressed it, "He knew so much, like an Oriental sage. His universal knowledge in art history, psychology, cultural history, anthropology, etc. . . . impressed us students."[41] While he repeated the same basic presentation of theories and assigned the same exercises time after time in giving his courses, as is shown by the multiple dates on his lecture notes, he constantly varied the supporting material, the explanatory examples and parallels, drawing on his wide knowledge and interests.[42]

On the other hand, apart from this aspect of the artist as lawgiver, Kandinsky had a great interest in his students and in helping them to develop their own artistic personalities and sureness of judgment. He encouraged them and offered constructive criticism of their work, in spite of its being quite different stylistically from his own. They felt he was trying to open their eyes to new ways of seeing, rather than to inculcate a particular artistic mode. For some, at least, he exhibited a paternal kindness and a friendly interest in personal concerns, and even at times gave material aid to those in need.[43] In sum, Kandinsky had a strong commitment to teaching, a sense of mission in this regard, as Peg Weiss has characterized it in describing his early involvement with the Phalanx school at the beginning of the century.[44] Though successful and well known as a painter in his own right, he maintained his allegiance to the Bauhaus until the final closing of the school, while others like Klee and Moholy-Nagy left to pursue careers focused more on their own art. This is further evidence of his continuing devotion to his teaching.

3 Hermann Röseler. *Still Life,* 1928

The Student Works

The color exercises, analytical drawings, free studies, and paintings done by Bauhaus students for Kandinsky's courses constitute the largest body of student works to have survived from the school; almost all of this material is now preserved at the Bauhaus Archive.[45] Several characteristics of this body of class-related works are impressive: the range of theoretical concepts explicitly and vividly illustrated by the exercises, especially those concerning principles of color; the extent of the variations on the basic assignments, particularly in the analytical drawings; the possibility for individual invention and research; and the inventiveness of the techniques and formats used in presenting the visual investigations. Furthermore, a large number of the studies seem to have been intended as definitive presentations of the principles and phenomena, carefully executed in a finished manner, with typed labels explaining the concepts or effects they deal with; in other words, these have the look of public presentations, and some probably were exhibited outside the Bauhaus soon after they were executed.

These characteristics are in marked contrast to those of the surprisingly small number of student exercises that seem to have survived from Klee's teaching.[46] The latter are relatively small, not for the most part meant as finished works in the way that much of the Kandinsky instructional material was. They are more informally executed and appear to have been done just for the edification of the student who executed the work and for the class itself. The presence of holes for ring binders in most of the studies further suggests this in-class function: they look like supplements to the student's course notes. While Klee's theoretical teaching of color and formal principles was certainly conceptually complex, the surviving student exercises do not begin to represent that richness. From Kandinsky's classes, on the other hand, there are elaborate sets of exercises that reflect the various principles he taught.

As for the other components of the Preliminary Course, the studies of materials and the structural and spatial constructions executed for Moholy-Nagy's classes are not specifically comparable to Kandinsky's assignments in subject and construction.[47] They had a partial justification as leading to an understanding of the practical properties of materials, ultimately applicable to the functional goals of the Bauhaus. This characteristic can be contrasted with the primarily aesthetic nature of the Kandinsky exercises, in spite of the fact that his teaching of visual principles could have limited application in the development of principles for graphic design.

Comparison with the work of Albers's students in the Preliminary Course also points to differences of a general sort. His assignments included constructions of paper and other ordinary materials, collages manipulating typography and photo-illustrations, and optical illusions created by repetition of basic graphic elements. These exercises were the result of a more direct and empirical experimentation by the students than were Kandinsky's assignments. For Albers it was general principles of approach that guided the work—especially the invention and development of a visual idea or simple structural device with an economy of means. Kandinsky, on the other hand, provided the students with a whole series of specific theoretical concepts that were to be visually realized through the exercises.

Some of Itten's Preliminary Course assignments are more directly comparable to Kandinsky's. On the whole, they encompass a broader range of exercises.[48] Kandinsky, after all, taught only a part of the Preliminary Course, whereas Itten had been in charge of the whole course. Some categories of the Itten exercises would not in any case have interested Kandinsky, such as the material studies, nature drawings, and the other drawings and collages using representational elements. However, the light-dark studies, the form

and rhythm studies, and the few surviving Bauhaus-period color studies bear comparison with Kandinsky's assignments. As discussed below, some of the color studies may in fact have influenced Kandinsky: for example, the contrast exercises using the square-in-square format by Vincent Weber, and also some of the works by Ludwig Hirschfeld-Mack done as part of his own color seminar, an adjunct to Itten's Preliminary Course. In addition to the theoretical content of these studies, their simplicity and clarity as demonstrations of color phenomena, achieved partly through their hard-edged geometry, give them the character of the objective didactic presentations that Kandinsky embraced for his teaching materials.

The majority of the Itten exercises, however, are much more loosely executed and expressive. This is exemplified by the predominant use of charcoal as the medium and is seen especially in the light-dark and rhythm studies. The suggestive and impulsive qualities of these student works befits Itten's expressionism, in contrast to the cooler, more clearly defined nature of Kandinsky's Bauhaus-period constructivism, to use the term as a broad stylistic designation. The studies of linear rhythms done in Itten's course show very well the difference in attitudes toward the students' investigation of graphic means. In the Itten studies there is, overall, a boldly improvisatory quality, while in the analytical drawings done under Kandinsky the dramatic linear elements are the result of a process of careful geometric analysis. This inherently systematic quality characterizes the whole series of exercises assigned by Kandinsky.

As indicated here, therefore, Kandinsky devised a series of carefully focused assignments on specific color phenomena and principles. Among the major types were the color ladders and scales, stepped and concentric, which show the value relationships of the primary colors and of black and white, as well as their spatial effects. The color circle was used to illustrate the sequence of primaries and secondaries and to show the opposite or complementary pairs. Square-in-square formats provided for the systematic pairing of colors in order to show the varying spatial effects and changes of hue, value, or intensity caused by degrees of contrast. In addition, there was a series of demonstrations of the correspondences between colors and forms: colors and angles, curves, and basic geometric shapes. More complex phenomena were studied with a design based on a grid, arranging the primary and secondary colors plus black and white so as to achieve balance or focal accents, principles with applications in pictorial composition. Also for compositional use were the studies showing the reversal of the theoretically natural or logical spatial positions of colors through their interaction with forms and through their placement— exercises that created elusive pictorial effects.

The other major group of student exercises from Kandinsky's classes were the analytical drawings, showing the progressive and systematic analysis of still lifes set up in class, a process of discerning the geometric nature of the relationships between the objects. The final results were abstract images of axial order and dynamic movement. Free studies were done as extensions of both parts of Kandinsky's Preliminary Course, in order to experiment further with the chromatic and graphic elements and to develop pictorial compositions based on their interrelationships and effects. Variations on the analytical drawings were based on specific drawings, transformed to such a degree through linear elaboration or the addition of geometric planes of color that they appear to be independent abstract works. Finally, there are the paintings done in Kandinsky's free painting class. These manifest varying degrees of adherence to his teaching, attesting to his tolerance of different styles and approaches to painting by the students.

Personal inventiveness played a role in the more strictly theoretical parts of Kan-

4

5

4 Hans Thiemann. *Construction with Triangles*, 1930 (C. 123)

5 Hans Thiemann. *Horizontal-Vertical Construction*, 1930 (C. 126)

6 and 7 Friedly Kessinger-Petitpierre. Sheets 1 and 11 from the portfolio *The Square*, 1930 (C. 60 and 70)

dinsky's teaching as well. Some of the color studies by Hans Thiemann show this characteristic, as in his sequences of triangles that demonstrate progressions both in color and in the scale from black to white (Fig. 4, C. 123). This is a unique adaptation of a device from Kandinsky's art to elaborate an aspect of his ideas on the correspondence of colors and forms. Another unique study is this student's *Horizontal-Vertical Construction,* in which he devised his own formal design to illustrate Kandinsky's correlation of lightness, chromatic warmth, and verticality, as opposed to that of darkness, coolness, and horizontality (Fig. 5, C. 126). Friedly Kessinger-Petitpierre showed similar inventiveness in the variations and "free variations" done in the analytical drawing course. A particularly unusual instance is her portfolio *The Square,* with its twelve ink-and-wash drawings (Fig. 6, 7; C. 60, 70). In the square format provided by these sheets, Kandinsky's formal vocabulary of triangles and circles, clusters of angles and diagonal lines, as well as irregular wavy lines, are combined in different constellations to form lively pictorial compositions.

Individual research occasionally had a place in the student exercises, at least in the case of some of Bella Ullmann-Broner's color studies. She utilized Ostwald's twenty-four-color circle in one of her studies (Fig. 56, C. 143), and in others she adapted scientific material from a

special volume of Felix Krueger's journal, *Neue Psychologische Studien,* devoted to the subject "Light and Color." She probably learned about this publication from the lectures on Gestalt psychology given in the winter term of 1930/31 by Count Karlfried von Dürckheim, an associate of Krueger at the University of Leipzig, lectures that Kandinsky evidently also attended.[49] From one article she adopted the calculations of lightness value for a series of colors in a sequence between white and black, providing a scientific, numerical commentary on the value scale that was so important in Kandinsky's teaching of color (Fig. 8, C. 151 and C. 155).[50] From another article, she derived an unusual ten-color circle (Fig. 9, C. 147). Based on research into perceptual sensitivity to colors, the scientists determined that the eye can distinguish more degrees of difference among the cool colors and that thus the traditional color circle must be corrected by expanding that area and diminishing the part given to the warm hues.[51] Ullmann-Broner's chart represents a simplification of their solution, with arrows drawn across the center to connect the complementary colors.

In considering the qualities of presentation and technique that characterize the studies done for Kandinsky, a group of works from the winter semester of 1929/30 is particularly interesting and impressive. The exercises were executed by six

6

7

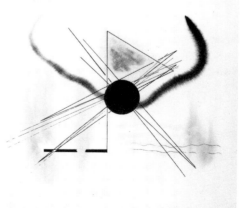

students who evidently took the Preliminary Course at the same time: Eugen Batz, Kessinger-Petitpierre, Karl Klode, Heinrich Neuy, Thiemann, and Ullmann-Broner. Surprisingly, these works constitute approximately half of all those that seem to have survived. Their special characteristics are their rather elaborate construction and finished execution, as well as their particularly explicit labelling information. These factors suggest that they were prepared with the idea of being publicly exhibited, and at least some were probably included in the traveling exhibition "Ten Years Bauhaus, 1920 to 1930," which opened in late January 1930 in Dessau and then went to Essen and other cities. These works carried out the important task of showing the public the pedagogical accomplishments of the Bauhaus. In addition to this, however, there was at this time a conflict going on between Kandinsky and Hannes Meyer and his supporters, and Kandinsky may have wished to have his didactic theories presented in the best and most thorough way possible. The finished and effective qualities of the studies could well explain why more of them have been preserved by the students than from any other period of Kandinsky's teaching.

Of the color studies in this group, many were specially mounted or executed directly on black or gray paper, so that the colors would be shown to rich effect. Furthermore, many are large in size, up to approximately 49 x 35 centimeters. The largest and most elaborately constructed are those by Thiemann, using gouache and colored papers, diagrams, typed labels and texts.[52] In addition to being handsome and visually effective, therefore, the studies contain a good deal of conceptual information making their theoretical points fully and clearly. Typing the labels and including diagrams suggests, of course, the effort to communicate the ideas to an audience outside the class. One of Thiemann's sheets, the *Color Scales and Color Circles* (Fig. 43, C. 124), reviews a sequence of the course material by grouping several theoretical illustra-

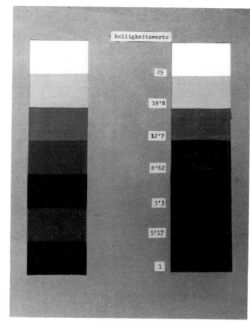

8

tions, a practice that Kessinger-Petitpierre followed in a number of her studies (Fig. 10, 11; C. 39, 41). These finished demonstrations are like developed versions of class notes.

The analytical drawings from the winter semester of 1929/30 are also more elaborate than earlier examples. It was at this time that the stages of the analytical process, from simplification of the still-life objects to geometrical translation of their essential visual relationships, were combined in single studies through the use of one or two transparent sheets superimposed on the first-stage drawing. The inherent visual axes and nodal points discerned by the student in the initial drawing could be shown on the next layer; and the quintessential visual movement or simplified schema of these abstract relationships, the *main tension,* could be registered on the top overlay. Through the use of different colored inks, the various stages and sometimes the parts of one stage were distinguished. Occasionally semitransparent colors were utilized so that the underlying lines could be clearly seen. The best examples of this overall approach are the exercises by Ullmann-Broner, who affixed concise typed labels on the various layers to iden-

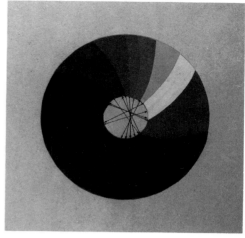

9

8 Bella Ullmann-Broner. *Gradations of Lightness,* 1931 (C. 151)

9 Bella Ullmann-Broner. *Demonstration of the Distribution of Color in the Circle with Complementary Colors,* 1931 (C. 147)

10 Friedly Kessinger-Petitpierre. *Main Tension—Secondary Tension,* 1929/30 (C. 39).

11 Friedly Kessinger-Petitpierre. *Variation,* 1929/30 (C. 41)

10

11

12

13

12 Hans Thiemann. *Dramatic Tension, Obstinately Curved,* 1930 (C. 128)

13 Hans Thiemann. *Lyrical-Calm Tension,* 1930 (C. 129)

the center of the field, as in some of Kandinsky's own works, while the illusionistic use of repeated simple linear elements probably shows the influence of graphic exercises in Albers's course (Fig.14, C. 45).[53] Although it's not possible to identify the particular works in the "Ten Years Bauhaus" exhibition, contemporary newspaper accounts attest to the general effect of the pedagogical demonstrations. The anonymous review in the *Volksblatt Dessau* briefly described the goal of the analytical drawings—to see the essential tensions in the objects—and mentioned the development of "free abstract works" by the students. Then it concluded:

"The exhibition shows very nice examples of these marvelously systematic works. Here those Bauhaus elementary shapes and their handling demonstrate the complete seriousness with which they work at the school."[54]

While the student exercises coming from the 1929/30 semester are especially impressive, they do not represent a radical change in concept or method from earlier studies. They are simply more complete and explicit as theoretical demonstrations and are as a whole more ambitiously executed. Kandinsky's own teaching notes, as discussed below, and the group of studies by Lothar Lang show that the basic set of assignments concerning color theory had been established at least by the beginning of the Dessau period. The large series of analytical drawings by Charlotte Voepel-Neujahr and a number by Lang, as well as Kandinsky's notes, indicate that the conception of that process was well formulated by fall of 1926 at the latest. As for later exercises, the studies by Hans Kessler, Herbert Schürmann, and Fritz Tschaschnig, as well as the *Color Studies* portfolio Ullmann-Broner did following the completion of her analytical drawings, bear ample testimony to the continuation of the principles embodied in the works from the 1929/30 winter semester.

As already suggested, student works from

tify the kinds of tensions and the aspect of the analytical process being represented. This practice was also followed by Kessinger-Petitpierre. In two of Thiemann's studies, possibly conceived of as a pair, the labels are noteworthy for identifying the expressive effect of the works: *Lyrical-Calm Tension* describes a balanced still-life arrangement, the schematic diagram for which is an elaborate looping curve; while *Dramatic Tension, Obstinately Curved* labels an abstract network of opposing angular and curving lines, its dominant accent a single long S-curve, tautly stretched out on a diagonal (Fig. 12, 13; C. 128, 129).

As already mentioned, and discussed more fully in the section here on analytical drawing, Kessinger-Petitpierre's extensive group of analytical drawings, variations, and related free studies shows the range of pedagogical and artistic possibilities of the approach taught by Kandinsky. These designs are particularly varied in technique and effect, using a variety of colors, with not only drawn lines but also some areas of loosely painted washes. In addition to her series *The Square,* the portfolio *Abstract Form Elements* contains a number of interesting independent compositions. In one of the drawings entitled *Penetration,* the intersecting geometric forms hover and coalesce near

Kandinsky's classes frequently possess noteworthy aesthetic qualities and visual effectiveness. Batz's series of exercises illustrating the basic principles of color theory taught by Kandinsky, for example, have a very direct and vivid character—brightly colored, clearly arranged, and precisely rendered. Typically, they are like the charts found in the works of theorists and scientists ranging from Goethe and Chevreul to Bezold, Rood, and Hering. But in scale, forcefulness, and aesthetic effect they are recognizably products of a design class, as well as having the quality of successful demonstrations in an exhibition. Often the formal inventiveness of individual students would transform a basic theoretical concept into a subtle and memorable design, such as Lang's *Color Scale* (Fig. 50, C. 101) or Kessinger-Petitpierre's *Colored Angles and Elementary Colored Relationship* (Fig. 70, C. 24). An animated or energetic character was achieved in some of the studies of the correspondence of colors and lines, with their large-scale dramatic curves and angles, and this effect is also seen in some of the analytical drawings and variations, as in the work of Voepel-Neujahr and Ullmann-Broner.

Sometimes one of the more narrowly defined class assignments, such as the exercise using a subdivided square to show chromatic balancing and emphasis, would result in a work that succeeds as an independent abstract composition. Such is the case with the relatively large example by Lang, entitled *The Center Accented by Blue-Red Opposition* (Fig. 57, C. 100). In addition to following Kandinsky's concept of the way complementary colors relate to each other across the picture surface or when directly juxtaposed, the study uses the noncomplementary blue-red opposition for its simultaneous contrast effects. The grid-based design derives, of course, from the Dutch De Stijl artists, as well as from some of Itten's early color assignments. Within this fairly straightforward format, albeit subtly altered in places, Lang has presented a variety of visual groupings, determined by the placement and orientation of the particular rectangles of color and by their degrees of chromatic and tonal contrast. This combination of simplicity and complexity, both formal and coloristic, gives the work its interest and impact.

Some of the exercises investigating the spatial interactions of colors and forms and the contradictory manipulation of their normative relationships have a more richly pictorial quality than the majority of assignments (Batz Fig. 90, 91; C. 12, 13; and Tschaschnig Fig. 89, C. 137). With their directness of formal design, they introduce spatial complexities through color, the secondary hues appearing as mixtures of the overlapping primaries. As in Batz's image of the basic geometric shapes treated both as linear figures and as solid planes of color, the forms hover vividly against a black background (Fig. 90, C. 12). Ultimately influenced by the visual starkness and conceptual character of Russian Suprematism and the tradition of international Constructivism, studies such as these combine clarity and pictorial ambiguity.

The variations and free studies are most likely to assume the status of independent works of art. For instance, Voepel-Neujahr's *Color Composition after an Analytical Drawing* (Fig. 97, C. 198) shows how abstract and pictorialized the variations of the geometric networks could become, through nuances of color and value. Klode's study, *Transparent and Opaque Planes with Weight Above* (Fig. 78, C. 87), is a beautiful large gouache with overlapping rectangles and trapezoids in somber colors, on a black background. The changes of hue as the forms overlap and the slanting sides and tipped alignments of the planes create ambiguities of spatial positioning, characteristic devices in Bauhaus art and of Constructivism in general. The idea of placing the "weight above" derived from Kandinsky's theories, according to which the top of the picture plane possessed "a feeling of lightness"; when placed in that region, "All heavier forms . . . gain in weight.

14 Friedly Kessinger-Petitpierre. *Penetration,* 1929/30 (C. 45)

15

16

15 Karl Klode. *Untitled Composition,* 1931 (C. 88)

16 Karl Klode. *Analytical Drawing with Schema,* 1930, (C. 86)

Their heavy sound is thus reinforced." Accordingly, a relative balance of pictorial tensions could be achieved by this kind of arrangement, the heavy forms at the top countering the inherent heaviness of the lower part of the picture plane.[55] Some of Kandinsky's theories of pictorial composition, thus, are investigated in this study.

Klode's gouache probably was done in Kandinsky's painting class, as was an interesting oil painting by him (Fig. 15, C. 88).[56] The larger size of this work is typical of some of the more ambitious paintings done in the class. Mention has already been made of the geometricized still-life composition by Röseler (Fig. 3) that was used to illustrate the 1928 article by Grote on the young Bauhaus painters.[57] Klode's painting, too, is indebted to Kandinsky's use of still life in his teaching, though its imagery is more abstract. In front of a shallow, ambiguously defined spatial container floats an odd geometric figure consisting of angular black lines terminated by a small circle and an irregular geometric shape. The linear constellation looks very much like the schema from one of the analytical drawings (compare Klode Fig. 16, C. 86), and the background is similar to the shallow stage typical of still life space. The effect created by the abstract figure and its setting is of both uncertainty and wit.

Werner Drewes's painting *Aggression* (Fig. 17, C. 19) is more complex and dynamic in color, technique, and imagery. As its title indicates, it presents a conflict: the long, spiny diagonals coming from the left confront the stable, predominantly horizontal rectangular forms in the lower center and on the right. Overall, the painting is a set of contrasting visual qualities, with loosely brushed areas opposed to clearly defined geometric forms. The colors embody the theme through the contrast of violet and yellow, black and white, and some areas of orange-red and bits of blue. In the upper left, the morphology and placement of forms shows similarities to Kandinsky's style, with the suspended quality of the forms and their small, sometimes irregular geometric shapes—circle, rectangles, crisscrossing stripes, and flat horn-shape. This area seems almost impulsively expressionist compared to the ordered architectonic character of the other parts of the painting, which include a reference to the contemporary flashed-glass works of Albers in the set of alternating horizontal bands of yellow and black.

This inclusion of a motif from Albers, like the difference between the two student paintings, indicates Kandinsky's permissive attitude toward the pursuit of the students' own artistic interests, in order ultimately to encourage them to develop their own personal styles. Indeed, the works from the painting class ranged from abstract compositions to representational pictures, and some were naturally enough influenced by the art of other Bauhaus masters, notably Paul Klee.[58] The basic endeavor of the class, of course, was to work with the principles of color, form, and composition that Kandinsky taught in his more elementary classes, as the examples discussed also indicate.

Considered as a whole, the studies produced in his courses reveal a broad conceptual scope, as has been seen, and range from narrowly determined subjects to more complex ones and to independent work. Clarity of form and concept and careful execution and presentation are the prevailing characteristics of these works. They show the way Kandinsky's teaching aimed to develop understanding of visual phenomena, knowledge of theoretical principles, and the ability to analyze and intuitively group essential relationships and formal structures. Moreover, they attest to the importance of the student's direct involvement with course material—a typical aim of Bauhaus pedagogy—as opposed to their relying unduly on the teacher's lectures to gain mastery of the basic elements and principles of art and design.

General Themes

Throughout his courses at the Bauhaus, as well as in his writings, Kandinsky devoted a good deal of attention to general theoretical questions in addition to the specific treatment of forms, colors, and their interrelationships. His first-semester course on Abstract Form Elements is paradigmatic in this regard. The four preliminary lectures were intended to place the elementary material that followed in perspective with regard to the ultimate purpose of art and the recent history of artistic trends. They treated general topics concerning the need for a synthetic approach to the arts, based ultimately on an understanding of the inner values of the formal elements.[59] Following this introduction was the main sequence of lectures, on color—discussed in detail later in this study—and on the graphic elements, point, line, and plane, and their relationships to color.

At the outset, Kandinsky discussed the modern phenomenon of specialization in the intellectual and spiritual disciplines—the isolation of religion, ethics, art, science, and philosophy. Even these individual fields were compartmentalized—as, for example, in the divisions between the arts and, within painting itself, between the various genres. Such specialization he saw as arising especially out of the nineteenth century, though it continued to plague the twentieth. To this condition he counterposed the ideal of synthesis, by which he meant the unity of all fields of mental activity, but particularly of all of the arts and of the opposing poles within recent art: form versus content, and theory versus intuition.

A number of Kandinsky's writings during his Bauhaus period and the immediately preceding years dealt with the question of synthesis. His Moscow proposal of 1920 had advanced the idea of a study of the interrelationships of the arts with the goal of creating a "Monumental Art" unifying them all. In "Abstract Synthesis on the Stage" of 1923, as its title indicates, he proposed the new theater as combining the essential features of the other arts, considered as abstract elements: architecture (space), painting (color), sculpture (spatial extension), music (sound), dance (movement), and lastly, poetry.[60] While of course this general idea is heir to the Romantic concept of the *Gesamtkunstwerk,* Kandinsky's specific formula-

17 Werner Drewes. *Aggression,* 1932 (C.19)

29

tion is a modern version of Wagner's notion of opera.[61]

Writing about his Bauhaus classes in the same year, 1923, Kandinsky stressed the need for combining the analytic investigation of artistic elements with a synthetic approach, encompassing physical properties, perceptual effects, and inner feelings.[62] In an essay written in April 1923, "Yesterday, Today, Tomorrow," Kandinsky outlined the antithetical trends that he discerned in contemporary culture—analytical, materialist, and theoretical versus synthetic, spiritual, and intuitive—and concluded that they were actually converging toward the same ends: "synthetic, 'monumental' art," in the practical realm, and in the theoretical, a science of art.[63] These were certainly the goals of his own pedagogical activities. He concluded on the hopeful note: "Thus, the worn-out words of yesterday, 'either-or,' will be replaced by the one word of tomorrow, 'and.' "

These themes were dealt with more fully in the first lectures of Kandinsky's Preliminary Course, formulations that one finds faithfully reflected in the later essay, "And, Some Remarks on Synthetic Art," published in 1927. As a background to current work toward a unification of the arts he cited three kinds of pre-nineteenth-century synthetic art that survive in the modern period: architecture, theater, and the church. In buildings, painting and sculpture may be coordinated with architecture; and ballet and opera exemplify theatrical syntheses.[64] Expressing the Romantic conception of the Middle Ages, transposed to his own national tradition, he asserted in his essay, ". . . that in the old Russian church all the arts served, with equal prominence and to the same extent, a single goal—architecture, painting, sculpture, music, poetry, and dance (movement of the clergy)."

Kandinsky believed that recent artistic developments showed an evolution toward increased interiority and synthesis, as well as significant contributions to the formulation of a science of art. In his teaching, he outlined the history of mod-

ern art, beginning with the mid-nineteenth century, to demonstrate this development.[65] He briefly treated the major artistic movements—Impressionism, Neo-Impressionism, Cubism, Expressionism, and abstract art—with regard to their relationship to nature and abstraction, theory and expression, and their discoveries in the realms of color and form. Abstract art, of course, he considered the culmination of this history, because it used the pure pictorial elements for inner purposes rather than being tied to the externals of nature. Such points he also expressed in his 1925 essay "Abstract Art."

Other general subjects that were important in Kandinsky's Preliminary Course as well as in his other classes were the question of intuition versus calculation and of the relationship of content and form. Painting in particular, he asserted, showed the unmeasurability of formal factors and their intractability to pure reason, and therefore the necessity for intuition.[66] Optical and psychological effects—due to the interactions of colors and forms—guaranteed the need for a synthesis of reason and feeling in conceiving art. Otherwise, purely rational processes would produce academic art as in the past, or more recently, Constructivism, which he condemned for dealing merely with the external aspects of the formal elements of art rather than with their inner tensions and resonances.[67] These thoughts found their fullest expression in his later essay, "Reflections on Abstract Art" (1931), in which he identified intuition as "the source common to all the arts" and warned against exclusive reliance on reason. He again cited the "pure Constructivists": these artists ". . . have made various attempts to construct on a purely materialistic basis. They have tried to eliminate 'out-of-date' feeling (intuition). . . ." As an antidote to this kind of thinking, Kandinsky referred to the naive painter Henri Rousseau, who had reported "that his paintings were particularly successful when he would hear within himself in an especially distinct manner 'the voice of his deceased wife.' " Kandinsky concluded,

"Likewise, I advise my pupils to learn how to think, but to paint pictures only when they hear the voice of 'their dead wife.' "[68]

Closely linked to the concepts of intuition and reason, for Kandinsky, were those of content and form.[69] He discussed these terms in his teaching in much the same way as in his theoretical writings of the mid-twenties, such as *Point and Line to Plane* and "Abstract Art." It is not the external, material forms, but their inner forces or tensions that bear the content of a work of art. Thus, "the content of a work finds expression in composition, i.e., in the inwardly organized sum of the tensions necessary in this [particular] case."[70] While reason or calculation are used to manipulate the visual elements and their formal relationships, intuition is required for the understanding of their inner meaning and their synthesis in the final expressive work. Kandinsky's concept of composition involves this integration, which transforms external properties in the ultimate artistic result: "Composition is the internally purposive subordination 1. of individual elements; 2. of the structure (construction) to a concrete pictorial goal."[71]

The Nature and Role of Theory

The rational side of Kandinsky's approach, as teacher and writer as well as in his own art, was of course very much involved with theoretical questions. Through the course of his career, he formulated an extensive body of theory regarding the artistic elements and their compositional use and expressive function. In this enterprise his ultimate goal was to develop a science of art, an ideal that, like the *Gesamtkunstwerk,* had its roots in the Romantic generation. As noted earlier, he himself linked the two—synthetic art and the science of art—in writings of the early twenties, seeing them as the consequences of the new developments in art.[72] In the quest for a systematic theory of art, Goethe and Philipp Otto Runge were important models for Kandinsky and other early twentieth-century artists in Germany. In his foreword to Hugo Zehder's book on Kandinsky (1920), Paul Ferdinand Schmidt specifically cited Runge as a forerunner, for having created "a scientific foundation for a theory of colors."[73] Even more than Runge, Goethe provided a precedent for the kind of science that Kandinsky valued, due to the poet's empirical, phenomenological approach, his systematic ordering of material, his broad range of scientific interests, and his embrace of the psychological and symbolic aspects of experience and expression. Kandinsky quoted extensively from Goethe in his Bauhaus teaching, citing his poetic characteristics and references to natural phenomena.[74] He himself followed this dual approach even in his use of a famous citation from the foreword to Goethe's *Theory of Colors,* "The colors are actions of light, its active and passive modifications": he used the quotation as a preface to listing the wavelengths of light and the color sensations that they cause, scientific information he had adopted from Matthew Luckiesh's book *Light and Work.*[75] A more fundamental influence exerted by Goethe, apart from the specific aspects of his color theory, discussed later, was the practice in his scientific work of arranging material in series from the simplest phenomena to the most complex, progressively deriving the latter from the former. This method was explained by Rudolf Magnus in his 1906 book *Goethe as Investigator of Nature,* which Kandinsky may have read during his Munich period or upon taking up residence in Goethe's city, Weimar.[76] Indeed, the presence of this cultural giant in Weimar was strong and was certainly felt by Kandinsky as well as other Bauhaus teachers, notably Itten, Klee, and Moholy-Nagy. The Goethe Museum's exhibits of his scientific materials must have focused their attention on this aspect of his activities. Even before the War, however, Kandinsky would have been aware of Goethe as a theoretician, one who was not limited by the specialization and positivism that Kandinsky decried. The theosophist Rudolf Steiner had edited the volumes of Goethe's scientific writings in the *German National Literature* series and subsequently wrote in praise of his unifying view of art, religion, and science. As Sixten Ringbom has proposed, this theosophical interpretation of Goethe must have had a formative influence on Kandinsky's concept of a science of art.[77]

There is a wealth of scientific and quasi-scientific references in Kandinsky's teaching notes, as already mentioned, and as further indicated in the discussion of his color theory below. Furthermore, his list of sciences to be used as a basis for the study of color shows the range of his interests. However, he actually drew on such materials quite selectively, in order to confirm or extend the theories he himself had evolved or had derived from the sources most sympathetic to him, such as Goethe. Apart from the question of utilizing the findings of scientific disciplines, there is in Kandinsky's teaching and theoretical work a systematic quality, particularly in the organization of his material, best exemplified by his book *Point and Line to Plane.* As Franciscono has

suggested concerning Klee's approach, it has "something of the methodicalness of science and its analytical rigor—the science of a scholar rather than of a physicist."[78] The same can be said of Kandinsky.

Earlier, in the Russian postrevolutionary context, with the founding of institutes that were to advance knowledge in the fields of art and design, Kandinsky had proposed experimental research concerning the artistic elements and compositional principles.[79] In particular he advocated the practice of questioning people about the physical and psychological effects of various kinds of forms. Subsequently at the Bauhaus he and the members of the Wall-Painting Workshop conducted such a survey, circulating a questionnaire to the students and staff asking them to match the primary colors with the basic shapes.[80] Through this procedure the findings were felt to have objective, scientific validity.

As for the educational application of the science of art, Kandinsky commented on this question in his 1926 essay, "The Value of Theoretical Instruction in Painting." By thoroughly studying the artistic elements, "the student acquires—apart from the capacity for logical thought—the necessary inner feeling for artistic resources." The pedagogical approach to achieving this goal was to combine theoretical instruction with practical exercises. The knowledge acquired thus by the student

"must be implanted in his interior so thoroughly that it penetrates to his fingertips of its own accord: the artist's 'dream,' be it modest or most powerful, is of no value in itself—as long as the fingertips are incapable of following the 'dictates' of this dream with the utmost precision."[81]

This essay may represent Kandinsky's strongest statement in favor of "objective, i.e., . . . scientific thought," even though he was advocating making it part of an "inner" process. By 1928, perhaps to counterbalance the emphasis on objec-

tivity and material, physical qualities during the Meyer period, he was stressing the importance of intuition. In his article "Art Pedagogy," he asserted, "Art can neither be taught nor learned." In all creative work, theoretical doctrines had a necessary role but could hardly replace intuition.[82] In the course of his own work, as he reported elsewhere, theoretical material underwent a process of absorption: "Those theoretical matters on which one reflects, and in the course of time understands and makes one's own, naturally produce an effect (in unconscious form) in one's subsequent works."[83] This conception of internalizing objective knowledge so that it could be used almost instinctively as part of the creative process is expressed perhaps most forcefully by the anecdote he recounted concerning his teacher Anton Ažbè, with whom he studied in Munich in the late 1890s. At a time when Kandinsky was studying anatomy, Ažbè advised him:

"You must know anatomy, but in front of your easel, you must forget it."[84]

While such statements indicate how theoretical knowledge would be transmuted in the act of creating a work of art, there remains the important question of how this focus on artistic elements and the artistic process was to serve the educational goals of the Bauhaus. Kandinsky believed strongly that the pictorial principles he taught had a validity beyond the confines of painting itself, that they were applicable to the other areas of design and thus could contribute substantially to the synthetic work of the school. As a specific instance of the relevance of painting, he cited color, which he asserted has a place in all the workshops, so that the way it is studied in painting can be applied generally. The position of painting in the past decades also offers justification for continued attention to its principles and their implications: "Painting is the art that has advanced at the forefront of all other art movements and has fertilized the other arts—especially architecture."[85]

In a broader context, art instruction plays an important role in "general education," according to Kandinsky, in that it helps develop the capacity to think both analytically and synthetically. The same modes of thinking are needed, he believed, in science and technology; and indeed all creative endeavor requires the same combination of knowledge, the ability to think, and intuition. Ultimately, the development one undergoes in art training contributes toward a sense of "integration" and fosters a " 'worldview' of an internal nature, [a] 'philosophy' to establish the meaning of human activity."[86] Thus, the student of artistic principles learns basic humanistic concepts and values.

Kandinsky's advocacy of the relevance of artistic theory met with opposition at the Bauhaus, on both ideological and practical grounds. Probably the most vociferous instance of this came at the height of the controversy over Hannes Meyer's encouraging of left-wing politics at the school. In July 1930, the last month of Meyer's directorate, a group of leftist students published the "Demand for the Abolition of the Preliminary Course," in which Kandinsky's course was severely criticized. This proclamation decried the formalist orientation of the course, particularly analytical drawing, which could only lead to "individual, abstract creative work. . . . This kind of drawing is entirely unsuited for the work in the workshops, since it does not allow for an objective approach." More fundamental ideologically perhaps was the attack on Kandinsky's view of the historical development of art "according to the point of view of an abstract painter," to which they counterposed the Marxist conception of historical development based on social and material factors.[87] This position, of course, was diametrically opposed to Kandinsky's spiritual and psychological conception of art.

For the remaining two years of the Dessau Bauhaus, under Mies, Kandinsky continued to teach his theory and painting courses. However, with the closing of the school by the Dessau City Council and its move to Berlin as a private institution, the teaching of art was endangered by Mies's desire to focus on training in architecture and applied design. Kandinsky again had to defend the role of art education. This he did in a letter to Mies of September 29, 1932, in which he stressed that an understanding of contemporary art, particularly painting, and its connections with both spiritual and material aspects of nature contributed significantly to the education of students, including those training in architecture. Again he referred to the Bauhaus goal of the synthesis of the arts, and he cited in addition the widespread student interest in painting. Mies yielded to Kandinsky in this dispute, and fine art was retained as a specialized area of study in the Bauhaus curriculum for the brief remainder of the school's existence.[88]

Functionalism and Art

Dedicated as he was to artistic expression achieved through an integration of theory and intuition, Kandinsky was naturally opposed to the increasing emphasis at the Bauhaus on functionalism and design for industrial production. In the early Weimar years of the school there had been general agreement among Gropius and the masters that theory generated by artists in the context of their own work, typically painting, would beneficially train fledgling designers in basic principles and ways of thinking that could be applied in the making of practical art.[89] By the mid-twenties, however, a more utilitarian point of view was gaining ground, and with the socially conscious, politically left-wing orientation of Hannes Meyer, this tendency was considerably strengthened. The balance in Gropius's famous maxim of 1923, "Art and Technology—a New Unity," was tipped in favor of the technical. Kandinsky opposed this tendency from a very early date—no doubt it seemed like a continuation of the struggle with the Productivist faction in Russia around 1920—and as already indicated, he defended the teaching of artistic theory throughout his time at the Bauhaus. As early as October 1922, within four months of his arrival at the school, he spoke at a meeting of the masters' council "against the violation of inner experience through the cult of the machine."[90] In spring of 1924 in his statement on "The Work of the Wall-Painting Workshop," he advocated that the production work of the workshops, even the practical outside commissions of the Bauhaus, should take second place to the more ideal program of study, such as the analytical and compositional experiments. This reorientation of priorities was urged in order to foster "the ultimate goal of the Bauhaus—the development of the idea of a synthesis in art."[91]

In his fourth-semester course on Artistic Creation, offered from spring of 1928 to early 1930 (i.e., during the period of Meyer's directorate), Kandinsky frequently discussed the question of functionalism. He believed that the notion of practicality or utility as sole criteria was mistaken, because it didn't take into consideration important human psychological and spiritual concerns, and because in fact utilitarian designs that are satisfying are so for aesthetic reasons.[92] Clarity and precision in the use of simple elements and in formal structure are the aesthetic qualities in question. As examples, Kandinsky compared images of Borsig locomotives from 1841 and 1922, in which the development was to a more complete organization of the elements, a more precise scheme, while accomplishing the practical goal of increased speed.[93] Automobiles and Junkers airplanes—the latter manufactured in Dessau—were among other examples Kandinsky used in discussing the formal qualities of utilitarian products. Showing that his ideas concerning pictorial tensions could be applied to objects for use, he compared armchairs by Marcel Breuer and Mies with a traditional "club" armchair. Whereas the latter emphasized the downward pull of weight, the modern designs counteracted the sense of gravity and expressed an upward movement. Kandinsky's S-shaped diagram for Mies's chair indicates it was a version of the design for the Weissenhofsiedlung apartment house of 1927. Its use of bent tubular steel and its springiness evidently suggested weightlessness and ascent to Kandinsky, who commented that the chair transformed the "material" character of the seated position into an "abstract" quality.[94] The Breuer armchair was doubtless the famous tubular steel design of 1925, one of which Kandinsky had enthusiastically purchased, along with two other metal chairs by Breuer, when they were first exhibited. The designer returned the compliment decades later by naming the armchair the "Wassily" model when it was again produced in the 1960s.[95]

Kandinsky's essentially aesthetic approach to utilitarian design is exemplified by his specifications for dining room fur-

18 Marcel Breuer. Dining-room furniture for
Kandinsky's Masters' House, Dessau, 1926.
Musée National d'Art Moderne, Centre
Georges Pompidou, Paris

niture for the Dessau Masters' House.
Since at that time he considered the cir-
cle to be the dominant form in his art, he
had Breuer design chairs with circular
seats and cylindrical legs, the tops of
which were exposed and painted white,
so that the chair appeared as a composi-
tion of five circles (Fig. 18). Even his
classroom analysis of the locomotives
was related to artistic questions. He com-
pared the 1841 model to children's draw-
ings and naive art and the 1922 model to
Byzantine mosaics in Ravenna to show
that the latter examples were similarly
more clearly and schematically organ-
ized, though composed of complex ele-
ments. His ultimate point was that both art
and technology involved logical construc-
tion to serve a function.[96] In art, function-
alism applied psychologically, while in
the case of practical objects it applied
physically. The utility of art, therefore, is
that it communicates, that it expresses a
creative idea.[97]

That there is truly an elemental human
need for art was forcefully discussed by
Kandinsky in a public lecture given in
Dessau in early 1930. According to the
newspaper's paraphrase, in addressing
the question "Why Art at the Bauhaus?"
he asserted:

"It escapes human life-functions . . . to
remove itself from the realm of real data to
another world. Not only the artistic instinct
but also the inclination to participate in art
is born in every person and expresses
itself already in earliest youth in children's
play, in singing, dancing, inventing fairy
tales, painting, forming, and building."[98]

Kandinsky, therefore, turned around the
criteria of necessity and function to argue
for the vital importance of art for the hu-
man being.

punkt

linie

fläche

19 Oskar Schlemmer. *Point-Line-Plane (Kandinsky),* 1928. Illustration from Schlemmer's chronicle "Nine Years of the Bauhaus," presented in honor of Walter Gropius at his farewell party, 1928. Oskar Schlemmer Archive, State Gallery, Stuttgart

Synthetic Work

Kandinsky's continued adherence to the idea of a grand synthesis of the arts connected him, as we have seen, with the Romantic and Expressionist idealism of the earliest period of the Bauhaus, but concomitantly, it put him out of step with the subsequent evolution of the school's aims and policy. Indeed, he explicitly counterposed this ideal to the increasing orientation toward the utilitarian and technical. During his years at the school, he was able to practice what he advocated only to a limited extent. As Form Master of the Wall-Painting Workshop from summer of 1922 to the closing of the Weimar Bauhaus in spring of 1925, he directed the work of the students in one of the areas of what he called "Monumental Art." In his own work he realized three major projects related to these aims: the wall-paintings for a reception room of a projected museum of modern art, exhibited at the 1922 Jury Free Exhibition in Berlin; the ceramic murals for a music room, part of the 1931 German Building Exhibition in Berlin; and his design of a staging of Mussorgsky's *Pictures at an Exhibition* in Dessau in April 1928. In fact, these were the only opportunities he had during his long career to achieve his continuing desire for a large-scale synthetic art.

Kandinsky's activities at the Bauhaus did not offer him much opportunity to pursue his long-standing interest in theater as a nexus for the various arts. He discussed the relevant issues in his teaching and in some of his writings of the period, as mentioned above. For instance, the essay "Abstract Synthesis on the Stage" appeared in *Staatliches Bauhaus Weimar* of 1923, and a short excerpt was

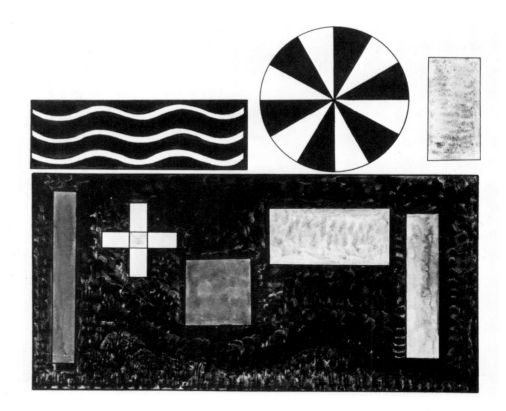

20 Wassily Kandinsky. Stage design for Picture VII, "Bydlo," from Modest Mussorgsky's *Pictures at an Exhibition*, 1928. Theater Museum of the Institute of Theater Studies, University of Cologne

published in the Bauhaus journal in 1927, along with a section from his theater-piece *Violet,* originally written in 1911.[99] This work, in fact, was announced as a forthcoming volume in the series of Bauhaus Books. His concern with theater thus was represented in the school's publications. He did not, however, work with the Bauhaus stage, which was primarily the domain of Oskar Schlemmer, and accordingly he wasn't involved with the students in practical theatrical projects.[100]

The unique chance to design a theatrical presentation was offered to Kandinsky by Georg von Hartmann, the manager of the Friedrich theater in Dessau. The choice of Mussorgsky's *Pictures at an Exhibition* provided the opportunity to create a whole series of scenes combining painted sets, moving abstract shapes and, in two of the scenes, two costumed dancers (Fig. 20, 21). Color played a major role in both the decor and the lighting, which included the play of spotlights. Kandinsky carefully plotted and choreographed the movements and timing, in accordance with the musical score. In this production, there-

fore, he was able to create his own version of the *Gesamtkunstwerk,* which united painting, the three-dimensional environment of the stage, ballet, and music.[101]

In wall painting Kandinsky not only realized two of his own projects but had a major influence on the development of the medium at the Bauhaus. As with theater, his interest in uniting painting and architecture had its beginnings earlier in his life. He reminded Will Grohmann of this fact in a letter of July 1924: "Synthetic work in space, and thus united with building, is my old dream."[102] His formative experience with a total design environment had occurred thirty-five years before in Russia. It was on his trip to the Vologda region in 1889, where he had gone as a law student to conduct anthropological research into peasant law. In his autobiographical essay, "Reminiscences," of 1913, he described the impact of walking into one of the wooden peasant houses, which was full of brightly painted furniture, its walls covered with folk art and icons: "In these magical houses I experienced something I have never

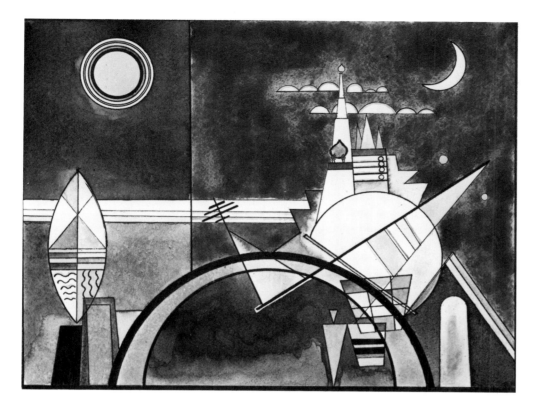

21 Wassily Kandinsky. Stage design for Picture XVI, "The Great Gate of Kiev," from Modest Mussorgsky's *Pictures at an Exhibition,* 1928. Theater Museum of the Institute of Theater Studies, University of Cologne

encountered again since. They taught me to move within the picture, to live in the picture."[103] This experience and others of Russian churches and Bavarian and Tirolian chapels developed in him the desire to achieve a similar effect in his own work: "For many years I have sought the possibility of letting the viewer 'stroll' within the picture, forcing him to become absorbed in the picture, forgetful of himself." While this could be achieved in an illusionary way in his easel paintings, the compelling feeling of being surrounded on all sides by the painting and thus being truly within it was created more fully and literally by a large mural project such as that for the Jury Free Exhibition (Fig. 22–24).

This was actually one of Kandinsky's first undertakings at the Bauhaus. Having painted the maquettes, small gouache sketches on cardboard, he asked a group of students, Herbert Bayer among them, to transfer the designs to the large pieces of canvas using casein paint.[104] This they did by spreading the canvas panels on the floor of the Bauhaus auditorium. Though the finished work has long since been lost, its extraordinary effect and large scale can now be experienced through the reconstruction at the National Museum of Modern Art at the Centre Georges Pompidou in Paris.[105] Its dimensions—over four meters high, with the longer walls over seven meters and the corners of this octagonal room over a meter-and-a-half wide—make for an impressive encounter with Kandinsky's synthetic ideal.

The approach to architectural painting, in this case, was essentially pictorial, utilizing a combination of freely arranged, irregular forms and occasional geometric shapes—the style that preceded the more thoroughly geometric compositions of Kandinsky's developed Bauhaus period. The large wall with no doorway especially has the character of an independent picture, like a greatly enlarged easel painting. The quality of compositional separateness is possessed by the other walls as well, though there are some interconnections and formal echoings between neighboring images. Some aspects of the designs do establish relationships with the architectural features of the room:

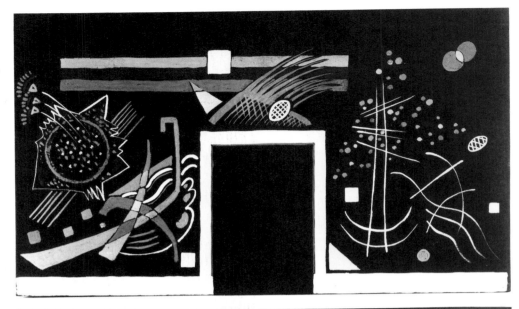

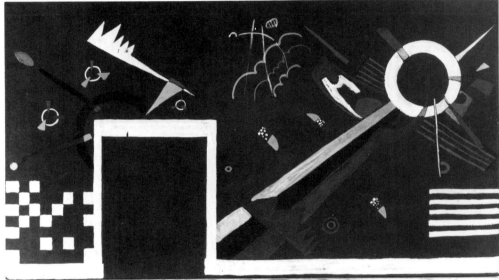

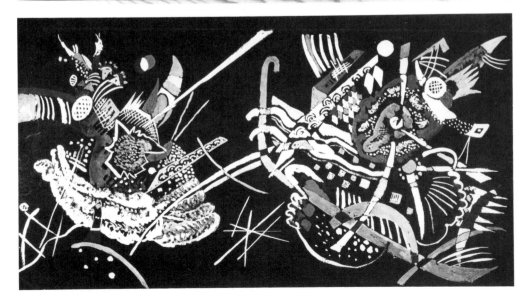

22–24 Wassily Kandinsky. Designs for murals for the Jury Free Art Exhibition, Berlin, 1922. National Museum of Modern Art, Centre Georges Pompidou, Paris

the flat black or dark ochre backgrounds, the white bands that surround the doors and border the floor, and some of the formal constellations such as horizontal bars echoing floor and ceiling, or diagonals connecting corners of the wall planes. But the looseness of arrangement, the perspective effects of the forms, and the spatial illusions created by the strong color contrasts all help create a dynamism that tends to dissolve rather than integrate with the architecture. Certainly the viewer's experience is that of being immersed in a vivid, illusory pictorial world. Though smaller in scale, Kandinsky's later music room continued this approach, in that it consisted of picturelike mural compositions (Fig. 25, 26). The medium here, however, was ceramic tile, and the pervasive grid provided thereby emphasized the flatness and shape of the walls. The vertical and horizontal alignment of the compositional elements reinforced this more architectural quality.[106]

Kandinsky's influence on wall painting at the Bauhaus can be seen in the student works executed for the Bauhaus Exhibition of 1923. Though the major single work was the ambitious decoration of the vestibule of the Workshop Building by Oskar Schlemmer, Kandinsky was responsible for the overall supervision of the numerous mural projects for the occasion. He prepared a memorandum in June 1923 outlining the different undertakings: the simple painting of the various parts of the main building, special painting and sculptural treatment of walls in the Workshop Building, demonstrations of techniques and materials, and displays of theoretical charts concerning color and form.[107] Kandinsky's pictorial conception of wall painting was seen in the murals by the students of the workshop, and he influenced as well the use of abstract geometrical imagery, though the presence of Itten, Klee, and Moholy-Nagy was also felt in these works.[108] Herbert Bayer's design for the small staircase of the main building exemplified Kandinsky's theory of correspondences between

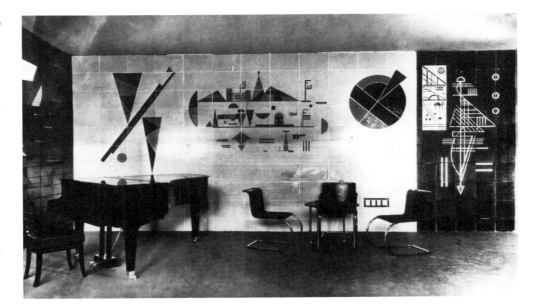

colors and forms, as will be discussed later. While each of the three ascending walls bore its own independent composition, the color sequence, blue to red to yellow, provided a logical order relating the three of them and also created a chromatic equivalent of the upward movement of the stairs, rising from dark to light.

Two other students, Peter Keler and Farkas Molnàr, designed the treatment of a corridor leading to one of the entrances to the building, in accordance with a conception of a more integral relationship of painting and architectural space (Fig. 27).

25 and 26 Wassily Kandinsky. Music room for the German Building Exhibition, Berlin, 1931.

RAUMGESTALTUNG EINER DURCHFAHRT

Maßstab 1:66

| SEITE | DECKE | SEITE |

27 Peter Keler and Farkas Molnàr. *Spatial Design for a Passageway,* 1923

The design was reproduced in the book published in conjunction with the exhibition and shows the two predominantly yellow walls, on either side, with the blue and black ceiling in the center.[109] All three planes are directly related, both formally and chromatically, creating a composition not just on the two-dimensional surfaces but across the space of the corridor. The colors are used for spatial effect, so as to alter the feeling of the tall, narrow passageway, the dark blue and black lowering the ceiling and the yellow expanding the lateral space. This must be due to Kandinsky's influence, illustrating the eccentric action of yellow and the contraction of blue. The fully three-dimensional character of the design and its dominant rectilinearity, however, show the influence of the Dutch De Stijl movement, which was strongly felt at the school at the time.

While he was Form Master of the Wall-Painting Workshop, Kandinsky wrote a statement concerning its work, which he submitted to the Masters' Council in early April 1924, as mentioned earlier.[110] The principles that he formulated applied not only to pictorial murals but also to the nonpictorial approach that predominated later in Dessau, when Hinnerk Scheper was in charge of the workshop—a mark of Kandinsky's significant contribution. He stressed color as the primary material of mural work, and indeed, from 1923 to 1928 the workshop was designated by the title Color. Its activities Kandinsky divided into two categories: "technical work" and "speculative experiments." The first treated the materials that were employed, pigments and binding agents, and the procedures for their application.

42

28 Wassily Kandinsky and Vladas Svipas. *Design for Kandinsky's Studio in Dessau,* 1926

The second area of investigation concerned the "psychological properties of color." This study must have included the way individual colors affect the viewer, both synaesthetically and physiologically. Such phenomena offered evidence as to the psychological effects of colors applied to interiors, the way they influence the mood or sense of well-being of the occupants.

The most important attribute of color, as studied in the workshop, was its ability to alter forms, which of course was another of its psychological characteristics. Kandinsky based this part of the program on his theory of the correspondence of colors and forms, and he outlined two kinds of relationships between the two: concurrence, whereby the color enhances the form; and divergence, whereby the form is transformed. Just as these effects take place in two-dimensional compositions, they also act in the three-dimensional context of architectural environments. Color, therefore, can affect the way space is perceived; it can be said to "mold" space, as in the case of Keler and Molnàr's corridor design. This spatial function of color in architecture became one of the primary concerns of the Wall-Painting Workshop in the Dessau Bauhaus. Indeed, part of the workshop's program of study came to be called "spatial design in color."[111]

During this later period, the nonpictorial

concept of wall painting that gained ascendancy had as its purpose to interact with the architecture more directly. Whole walls or large parts of the walls were given a single color so as to articulate the planes of the building as well as to act spatially. Kandinsky participated in this direction in one noteworthy instance, the color design of his apartment in the Masters' House that he and his wife shared with Paul Klee and his family. A proposal for his studio was designed jointly with the student Vladas Svipas, understandably in that the color schemes of the Masters' Houses were meant to be collaborative works of the Wall-Painting Workshop (Fig. 28). The use of different shades of blue and of gray, in addition to black and white, in the studio exemplifies the aim of both differentiating and interrelating the various major surfaces. This design, however, was evidently not followed, and the room was painted a light gray.[112]

Kandinsky discussed his own design of the rooms with his class, describing the relationships and effects of the colors.[113] In the dining room he had used a contrast between black and white for the architectural planes. The effect, he said, was one of clarity and conciseness, expressive of the contemporary Zeitgeist. He seems also to have intended a distinction between relative simplicity and functionality in the setting and the richer, freer charac-

43

ter of his paintings. Certainly the image of one of his paintings set against the black wall of the dining room is one of vivid contrast.[114]

The living room was more complicated in its color scheme. The walls were predominantly light pink, creating an effect of softness and immateriality, he said, and countering this was the cold contrast of the black doors and ivory-white wall behind the divan. In addition, the ceiling was painted gray, which he felt was less heavy than white, while a niche was covered with gold leaf, adding a sense of weight. It's clear, therefore, that Kandinsky conceived the color treatment of the room as a complex three-dimensional composition, in which the synaesthetic qualities of colors, as in paintings, had an effect on the viewer—cold, soft, light, heavy, etc. Indeed, color could play a part in the inherent relationships in an architectural interior, the "tensions" between the four walls, the ceiling and floor, and even among the various rooms.[115]

The overall impression of the color schemes Kandinsky designed has been described by Nina Kandinsky. The black-white contrast of the dining room, contrary to the expectation that it might be "dismal," created "a gay atmosphere." In general, as she has characterized it, "Due to this felicitous color design, our Dessau apartment seemed agreeably airy and large scale—each room had an architectonic individuality."[116]

As Kandinsky discussed the use of color in architecture in his teaching, however, his own goal was not only to create a mood or define the character of a particular space, though these were certainly among his objectives. He saw color as lightening and relieving the sense of materiality of architecture, transforming it by producing an illusionary, abstract spatial quality. This dematerialization he considered to be expressive of the Zeitgeist, and he saw this quality in modern architecture in its use of glass, as well as color, its diversity of materials, and its tendency toward height.[117] Thus, though the style of his color designs for his Dessau apart-

ment was similar to that practiced at the time by the Wall-Painting Workshop, the development of which he had helped shape, his aims were quite different. His approach was not primarily to articulate the architecture itself, nor was it functionalist. Of course, it also diverged from the formalist, purist tendency in the mid-1920s to eliminate color from buildings and use white exclusively, so as to focus more directly on the plastic relationships in the architecture. He was well aware of this viewpoint, held especially for exteriors by Gropius.[118] Kandinsky's position was consistent with his continuing belief in the transcending of the material character of forms and media and in the expressive value of artistic elements. As he advocated in his defense of the teaching of art and theory at the Bauhaus, he was applying his artistic principles to the practical realm. By the way it used color in a three-dimensional environment, therefore, the color design of his apartment created the kind of synthetic work of art that he insisted should be the goal of the school's program.

Color Theory

By the summer of 1923, after one year at the Bauhaus, Kandinsky evidently had determined the basic conceptual shape and range of his teaching of color. This is shown by his article "Color Course and Seminar," included in the book *Staatliches Bauhaus Weimar 1919–1923,* which appeared in conjunction with the Bauhaus Exhibition held in the late summer. As further demonstrated by his teaching notes from the Dessau years, much of the specific material on color derived from *On the Spiritual in Art,* although he had elaborated on that basic core of ideas in the years since the December 1911 publication of the book. The teaching notes contain extensive additions to the earlier treatment, including numerous scientific references; and part of the concept of a hierarchy of artistic elements and functions, outlined in his "Color Course and Seminar," seems to date from the years Kandinsky spent working on the pedagogical programs for the Russian institutes of art education.

In general, the conceptual framework of his approach to color, and the other artistic elements too, was to progress from the simplest phenomena to the more complicated, a process that involved a shift from analytical to synthetic methods of study.[1] This approach was propounded by Kandinsky as essentially scientific, providing a way to achieve the science of art. As we have seen, he took Goethe as his mentor in this endeavor, just as he had incorporated many scientific features of the poet's *Theory of Colors* in *On the Spiritual in Art* and in the later teaching notes. Thus, for example, Kandinsky's list of physical sciences to be used as a basis for the study of color—physics, chemistry, and physiology—accords with the first three sections of the *Theory of Colors,* and his fourth science, psychology, for dealing with the internal effects of color, corresponds to Goethe's sixth section, "Sensuous and Moral Effects of Color."

The first appearance of this list of sciences was in Kandinsky's 1920 plan for the Institute of Artistic Culture (Inkhuk) in Moscow. Here medicine, including ophthalmology and psychiatry, was also cited, along with occult knowledge.[2] Indeed, it was in Russia that he had begun to elaborate the systematic aspects of his color theory, in the interest of increased objectivity and pedagogical applicability, a direction that he continued at the Bauhaus. His teaching notes show how he had developed his theories in the years since *On the Spiritual in Art* and the Russian proposals, in response to several factors: the opportunity and challenge provided by regular teaching, the exposure to his Bauhaus colleagues and students, and the increasing demands at the school for a more scientific approach to the practice of design. In particular, he

had newly incorporated many diagrams demonstrating the characteristics of color and had added a wide range of details and references to scientific as well as art historical material.

The 1923 article, "Color Course and Seminar," while brief, is conceptually complex, outlining the different ways of investigating color, the hierarchy of the color elements and their interrelationships in formal and expressive uses, and the practical problems of color usage. Kandinsky's theoretical organization of the material on color is more fully indicated by the outline of his first-semester course, Abstract Form Elements, from the early days of the Hannes Meyer era at the Bauhaus. This was one of the descriptions of Bauhaus courses published in the catalogue of the 6th International Congress for Art Education, Drawing and Art Applied to Industry, held in Prague in 1928. Included in the outline is "Theory of colors: isolated color, system of colors, interrelationships, rules of tension, affinities, effects and utility"; and in addition, "Theory of form and color: relationships of color and form, variability of these in tension and effect."[3] This listing is schematic, not describing the actual sequence in which he taught the subject of color, but providing an abstract ordering of the material, from individual elements to chromatic interrelations and the interactions of colors and forms, and from systematic theory to practical application.

In the course on the abstract elements of form, Kandinsky treated color itself in a substantial series of lectures, apparently the largest block of classes in the course. This was followed by a shorter sequence on form that included the relationships between colors and formal elements.[4] Subsequently, in the second-semester continuation of that course, the fourth-semester course on Artistic Design, and the Free Painting Seminar, he dealt with the subtler and more complicated questions of the role of color in pictorial compositions. While this overall sequence follows the basic character of his course descriptions, the way he organized the groups of lectures devoted specifically to color is rather different from the outline. The colors were treated as pairs, except for red, to which an entire class was devoted: first, yellow and blue, as the most important polar opposition among the spectral colors; second, red, distinguishing its warm and cold variants; third, white and black; fourth, returning to yellow and blue in combination with each other and with white and black; fifth, green and gray; and sixth, orange and violet. There is a developmental logic in this sequence, from the fundamental color elements to their combinations and mixtures. In each of the lectures, however, he used a multiple approach, treating the visual and expressive effects of the individual hues, the schematic ordering of the colors as by color scales ("system of colors") and the interactions of juxtaposed colors, that is, their tensions and affinities, which of course affect their usage.

The breadth of Kandinsky's approach and the range of his interest in color are indicated by the first of these lectures, which he began with general remarks on the nature of color. He referred to its appearance in nature, in the animal world, where it functions for protective coloration or to attract the attention of others of the species, and where it appears in its purest manifestation as the rainbow. This led to a distinction between the hues inherent in light, revealed by decomposition through the prism, and pigment colors, which are "transpositions" or mere approximations of the spectral colors. Thus the colors considered by physics were differentiated from those treated by psychology, and it was the latter, of course, that were the chief subject of Kandinsky's discussion, being those used by the artist. Then, following the tradition of Goethe, Runge, and earlier theorists, Kandinsky distinguished the primary colors, yellow, red, and blue, from their mixtures, the secondaries. This brought him to the major subject of the lecture, yellow and blue.

46

The Fundamental Pair: Yellow and Blue

Kandinsky designated this the greatest opposition, comparable only to the opposition of white and black. As he had characterized them in *On the Spiritual in Art*, yellow and blue are the embodiment of "the two great divisions" of color: warm versus cold and light versus dark. This elementary conception of the basic colors was the starting point for the systematic consideration of color, the ordering of its major relationships, and he followed it in the brief presentation of color in *Point and Line to Plane*.[5] In this book, which treated color only in relation to the linear and planar aspects of form, Kandinsky considered the yellow-blue opposition to be a chromatic equivalent to the contrasts of straight and curved lines and triangular and circular planes. His schematic view of the realm of color thus involved a reduction of its range and variety to fundamental elements and polar relationships—a theoretical formulation that Kandinsky applied in his own art, with its predominant use of spectral colors, plus black and white, and strong contrasts. While he did include in his teaching the subtler nuances of color mixtures, gradations and tertiaries, as will be seen, his emphasis was on the elemental features. This selective approach was markedly different from that of Klee, with his interest in the whole range of intermediary colors, or Itten, who covered a fuller series of gradations and types of contrast.[6]

That Kandinsky had maintained his polar conception of color since his Munich days is a mark of his continued allegiance to Goethe's theory. The concept of the polarity of *plus* and *minus*—terms specifically mentioned in Kandinsky's teaching notes—constitutes the core of the theory as adopted by Kandinsky. Yellow and blue were the chief representatives of this opposition, and Goethe associated with them a series of contrasting characteristics: "effect-deprivation, light-shadow, bright-dark, strength-weakness, warmth-cold, proximity-distance, repulsion-attraction, affinity with acids-affinity with alkalies."[7] "Active" and "passive," a polarity implicit in this list, were also terms used by Goethe.

All these essential features of the yellow-blue pair—qualities of forcefulness, lightness, chromatic temperature, spatial position, and even the association of sourness with yellow—were carried over by Kandinsky into his color theory.[8] Indeed, among the extensive quotes from Goethe included in his teaching notes are statements relating to the plus-minus polarity: yellow "is the color nearest the light. It appears on the slightest mitigation of light, . . . always carries with it the nature of brightness . . ."; and blue "always brings something of darkness with it . . . ," it "flees" and "draws us after it," and it provides "a feeling of cold, . . . shade."[9] Accordingly, in his summarizing list of the characteristics of yellow and blue, Kandinsky adopted and elaborated on those qualities proposed by Goethe. Yellow is warm, light, eccentric, advancing, ascending, and active; blue is cold, dark, concentric, receding, descending, and passive.[10]

He demonstrated the nature of the two colors by diagrams and exercises assigned to the students. The affinities to white and black were shown in a stepped arrangement, with white placed above yellow and black below blue, indicating the ascending and descending character of the colors as well (Lang C. 93; Neuy Fig. 29, C. 109).[11] Additional diagrams, to be discussed later, were concerned with other spatial effects. In order to show the range in value of yellow and blue, Kandinsky assigned an exercise of seven-stepped gradation series, with space allowed in the center of the study for similar sequences in warm and cool red, to be done in conjunction with the following class (Lang Fig. 164, C. 97). This demonstrated, moreover, the practical fact that yellow cannot be shaded with black without losing its chromatic character and becoming greenish and murky.[12]

29 Heinrich Neuy. *Stepped Color Scale,* 1930 (C. 109)

More important, as completed with the two sequences of red, the chart embodied Kandinsky's more general, theoretical statement of the universal character of the "two great divisions" of color, temperature and value: "For every color there are four main sounds: (I) warm, and either (1) light, or (2) dark; or (II) cold, and either (1) light, or (2) dark."[13]

Synaesthesia and the Inner Effects of Color

Kandinsky's ideas about the multiple characteristics and effects of the primary colors, especially yellow and blue, were directly tied to his interest in scientific and pseudoscientific investigations of psychological and physiological phenomena. Central to his conception of color as it influences the human body and psyche was the theory of synaesthesia, to which other theories and experimental findings can be related. Synaesthetic experiences involve a kind of crisscrossing of stimuli and sensations in the sense faculties, so that one kind of stimulus, in this case visual, provides another kind of sensation, such as the tactile feeling of temperature.

Psychologists in the nineteenth century had been greatly interested in these effects, particularly in the linking of colors and sounds, called *audition colorée*. Kandinsky himself had had a vivid experience of this kind early in his life, as he reported in his autobiographical essay "Reminiscences": on hearing a performance of Wagner's *Lohengrin,* in Moscow, he had fantastic visions of color and lines.[14] In addition to personal experiences, Kandinsky may well have been aware of scientific theories on the subject, as suggested by the art historian L. D. Ettlinger. He seems to have known of the unresolved controversy among psychologists over the explanation of the phenomena, as indicated by his statement in *On the Spiritual in Art*: "Whether this . . . consequence is in fact a direct one . . . or whether it is achieved by means of association, remains perhaps questionable."[15] Kandinsky himself did not accept the associationist explanation as the ultimate one, and perhaps he was even acquainted with the theory that one sense directly stimulated another, as proposed by the late-nineteenth-century psychologist Francis Galton.[16]
His own way of explaining synaesthesia was through a generalized metaphor, that

the impression provided by one sense is communicated to the organ of another sense as in the case of sympathetic vibrations in music—one instrument echoing another without itself being touched, or one part of an instrument causing the other parts to reverberate.[17] In his teaching at the Dessau Bauhaus, Kandinsky used this analogy, citing as an example two pianos, a note struck on one causing the other to produce the same sound. Further, he explicitly compared the nerves with the strings of the piano, so that a visual impression can cause the "cords" of other senses to vibrate. In this discussion, however, he again introduced the question raised in On the Spiritual in Art, concerning "the role of the association of ideas[.] Yellow, is it 'sour' because the lemon is sour?"[18] Apparently Kandinsky wished to encompass such mental connections too in the arsenal of color expression.

Yet evidently he maintained his belief in the directness of the synaesthetic phenomenon, and in his teaching notes he included sensations of taste in the list of the impressions made on the various senses by the visual stimuli of yellow and blue.[19] Accordingly, the contrast is that between sour and flat. The tactile feeling aroused by yellow is hard, resistant, sharp, and prickly, while blue is soft, unresistant, and velvety. In smell, the contrast is piquant versus aromatic, and in hearing, sharp and penetrating versus low and self-contained. Exemplifying the opposing audial qualities are the trumpet fanfare and the deep sound of an organ, or among the vowels, i and u.[20] Kandinsky also listed qualities involving a sixth sense, kinesthesia, the internal awareness of bodily movements and tensions, though he did not use this term. Thus he connected yellow with broken, jerky, and short movements and blue with movements that are rounded and slow. Finally, he added a diagram indicating the relationship between yellow and angular lines and blue and rounded ones, demonstrating that his theory of the correspondences between colors and forms was also based

in the phenomenon of synaesthesia.[21] The wide range of sensory qualities connected with yellow and blue therefore exemplifies the great importance of color in both its expressive and pictorial functions in art.

Kandinsky's belief in the direct effect of color on the other senses was rooted in the evidence offered by the occult science of chromotherapy, which through the use of colored light could alter bodily states and treat mental illness. He felt that such effects helped disprove the associationist theory. As he reported in On the Spiritual in Art, "red light has an enlivening and stimulating effect upon the heart, while blue, on the other hand, can lead to temporary paralysis."[22] In his Bauhaus teaching he cited the uses of color for nervous ailments: blue or pale blue light and surroundings for the manic; red or pink for the depressed. Yellow also was used, in curtains and window panes of German clinics, for its stimulating effect; and in hospitals, a distinction was apparently made between the corridors, painted yellow, and the rooms, painted in the more restful color blue.[23]

Many of these effects of color were implied in Goethe's plus-minus polarity, with its sets of attributes, especially action and passivity, effect and deprivation, strength and weakness. He had classified as belonging to the "plus side" the colors yellow, orange, and yellow-red, characterizing them as "quick, lively, aspiring"; while on the "minus side" are blue, red-blue, and blue-red, which provide a "restless, yielding, yearning feeling."[24] This basic concept of the division of the colors was presented by Kandinsky in his Bauhaus teaching, though he added red and green to the respective categories and changed the attributed effect of blue from anxiety-inducing to calming—a beneficial effect.[25] Thus the red-orange-yellow span is positive and stimulating whereas the green-blue-violet group is negative and calming.

This is, of course, the distinction between warm and cold colors. A testimony to the

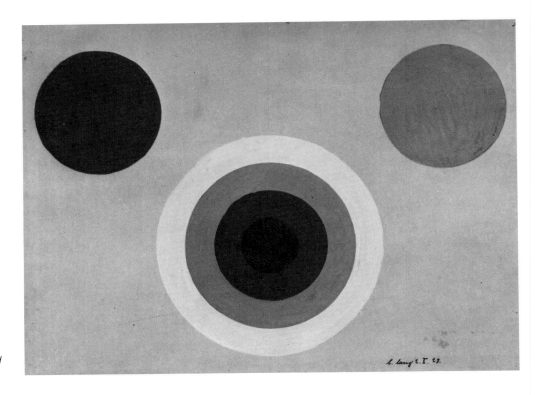

30 Lothar Lang. *Spatial Effects of Yellow and Blue,* 1927 (C. 92)

importance he assigned their polarity, as well as to his interest in scientific sources, is that in his later teaching he added material on the subject from the 1932 volume of *Neue Psychologische Studien.* He was impressed that the notions of warm and cold colors were accepted by physicists and psychologists, as they were by artists. Thus he cited, from Felix Krueger's article on August Kirschmann, the psychologist Wilhelm Wundt's attribution of "exciting" and "calming" or "depressing" to this chromatic opposition.[26] Further, he quoted more extensively Krueger's description of the work of the Dutch psychologist Zeilmans van Emmichoven, who

". . . found the greatest qualitative differences of emotional effect between goldyellow, yellow and on the other hand two kinds of blue, while red, in opposition to green, increases the intensity of feelings to the utmost."

The Dutch scientist equated the warmcold polarity not only with activity and passivity but also with "acceleration and slowing down of the whole 'psychic tempo.' " Kandinsky must have been pleased by these confirmations of ideas he himself had long held, and by the very language encountered in Krueger's summary of scientific findings. "Psychic tempo" in particular not only has a musical association but also recalls the phrase Kandinsky used in *On the Spiritual in Art,* "spiritual vibration," albeit translated into more psychological terms.[27]

Spatial Phenomena

Apart from the emotional effects of the warm-cold polarity, there are the purely visual phenomena that it causes, among the most important of which are the changes in apparent size and spatial position of colored shapes. These involve the two kinds of movement that Kandinsky had treated in *On the Spiritual in Art*: the first, the advancing and receding character of warm and cold colors; the second, their eccentric and concentric movements.[28]

One of the diagrams in Kandinsky's first class on color, the lecture concerning yellow and blue, used identical circles representing these hues in order to show the types of movement. The schema is a clear realization of a statement in his book, which reads virtually like the description of a psychological experiment:

"If one makes two circles of the same size and fills one with yellow and the other with blue, one notices after only a short period of concentrating upon these circles that the yellow streams outward, moves away from the center, and approaches almost visibly toward the spectator. The blue, however, develops a centripetal movement . . . , and withdraws from the spectator."[29]

A student exercise, labelled "The Basic Color Tension—Yellow Advancing; Blue Receding," juxtaposes the yellow and blue circles with white and black ones, to demonstrate Kandinsky's idea that the latter colors exhibit the same movements, "although not in dynamic, but in static, rigid form" (Kessinger Fig. 31, C. 29; see also Lang Fig. 30, C. 92 and Kessinger C. 34). The other diagram for demonstrating the spatial movements is a series of concentric rings, shrinking and receding from white on the periphery, to yellow, blue, and black in the center (Lang C. 92, C. 110).

These effects were explored further in another color exercise, for which a description is provided by the caption to an

example by Hans Thiemann (Fig. 32, C. 125):[30]

"Yellow forms on a blue ground and blue forms on a yellow ground. . . . The yellow forms step forward, appear larger (eccentric), whereas the blue seems to lie behind the actual ground plane. In the second instance, the yellow seems to lie in front of the actual ground; the blue forms step back and appear smaller."

Thiemann's study shows the phenomena quite effectively, with the identical small horizontal and vertical bars and motif of squares repeated in reverse on the different grounds and a cross-section diagram at the right to indicate the spatial position of the forms.

More frequently used, however, was the much simpler format of a small square placed in the center of a larger square, as found in Kandinsky's own teaching diagrams. This standardized arrangement could be utilized to study the interactions of other color pairs, as it was with black-and-white and with red-and-blue, -yellow, or -green, etc.[31] It is like a psychologist's chart in the way it narrows the range of variables and can be employed with different color combinations. Indeed, a possible source is the American scientist Ogden Rood's well-known *Modern Chromatics,* published in Germany in 1880, whose chapter "Contrast" contains numerous instances of this format.[32] Kandinsky, however, may have adopted it from examples of student exercises done at the early Bauhaus, such as Vincent Weber's *Color Study (Square Forms)* of 1920, done for Itten's Preliminary Course (Fig. 33).[33] In each of the three sheets, one of the primary colors is placed against five different backgrounds, to show the effects of various kinds and degrees of contrast.

Another early Bauhaus student, Ludwig Hirschfeld-Mack, had made a series of studies in which he used the square-in-square schema (Fig. 34–36). These works were from the workshop in color theory that he led as part of Itten's Preliminary

31　Friedly Kessinger-Petitpierre. *The Basic Tensions of Colors,* 1929/30 (C. 29)

32　Hans Thiemann. *Yellow Forms on a Blue Ground and Blue Forms on a Yellow Ground,* 1930 (C. 125)

33 Vincent Weber. *Study from the Itten Preliminary Course: Color Contrast with Yellow*, ca. 1920

34 and 35 Ludwig Hirschfeld-Mack. *Gradation Study in White and Black with Concentric Rectangles*, 1922

36 Ludwig Hirschfeld-Mack. *Study of the Weight of Colors and Forms*,1922. Busch-Reisinger Museum, Harvard University, Cambridge, Massachusetts

Course, and they formed part of the group of "instructional charts on the theory of light and dark and of colors" that occupied an entire room in the 1923 Bauhaus Exhibition.[34] The formats of some of these charts were apparently employed by Kandinsky to demonstrate color characteristics he had long been interested in, since the time of writing *On the Spiritual in Art*. In the particular studies by Hirschfeld-Mack just mentioned, the square-in-square arrangement is used in order to show the interrelationships of black, white, and gray. Each of the three colors is repeated on backgrounds of the other two, arriving at six studies exhibiting apparent dissimilarities in size, lightness, and spatial position due to lighter or darker backgrounds. Hirschfeld himself was indebted to Kandinsky for some of his underlying ideas, as is made clear by the caption to another set of studies, with concentrically placed squares graduated from white to black through two shades of gray. It is entitled *Investigation of the Spatial Movement . . . of Black and White,* and adopting Kandinsky's characterizations, it designates white as "aggressive, coming toward us, eccentric, dynamic" and black as "passive, retreating from us, concentric, static."[35]

An example of student work from Kandinsky's own early color seminar was Rudolf Paris's study *Spatial Effects of White and Black, on Gray* (Fig. 37), illustrated

in the 1923 book *Staatliches Bauhaus Weimar*. . . . This, however, employed small circular forms on the gray backgrounds.[36] By 1924, on the other hand, Kandinsky was using the square-in-square format to demonstrate the differing effects of yellow-on-blue versus blue-on-yellow, as well as the interrelationships of white and black. Then in his Dessau course, it was assigned as an exercise in spatial effects, which he explained as the cold colors supporting the warm ones and thereby allowing them to advance, while the warm colors "swallow" the cold ones.[37] These spatial illusions had been well known by artists and scientists alike. For instance, in the popularizing account written by the physicist Wilhelm von Bezold, *The Theory of Color in Its Relation to Art and Art-industry* (1874), there is a discussion of the "projecting and receding colors," the warm and cold hues.[38] As mentioned below, von Bezold's work was known at least indirectly at the Bauhaus, through the presence of several pupils of Adolf Hölzel, including Hirschfeld-Mack and Itten.

Kandinsky's second category of spatial movement—the apparent expansion and contraction of yellow and blue or black and white—can be identified with the phenomenon of irradiation, the term used in perceptual psychology. Goethe had observed these effects: "A dark object ap-

34

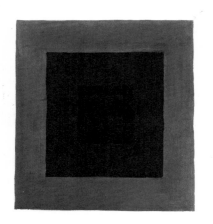

35

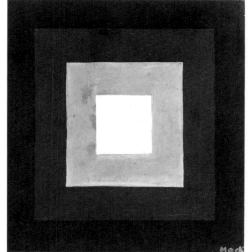

36

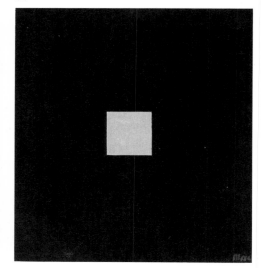

37 Rudolf Paris. *Spatial Effect of White and Black on Gray,* 1923

pears smaller than a bright one of the same size"; whereas a luminous image seems to expand, and even, "acts . . . as energy beyond itself; it spreads from the center to the periphery." He also included among the plates pertaining to the *Theory of Colors* a diagram with identical circles of black and white against the opposite backgrounds.[39] Kandinsky adopted Goethe's active characterization of bright images and the demonstration using two circles, in the account quoted above from *On the Spiritual in Art*. Furthermore, the diagrams by Paris and other students may derive, at least partially, from Goethe's.

The language of Kandinsky's descriptions—"yellow streams outward," and "leap[s] over its boundaries"—indicates his awareness of the psychological concept of irradiation. His source may have

been Hermann von Helmholtz's popular lectures, "On the Relation of Optics to Painting," to which he specifically referred in his teaching notes.[40] Helmholtz described the phenomenon as when a bright object spreads its light or color into the surrounding field, and he recommended it as one of the subjective appearances to which artists should pay special attention, so as to render it objectively in painting.

Kandinsky's characterization of the yellow-blue pair went beyond the concept of irradiation, which concerns luminous colors, in attributing to the darker color blue the opposite but still active role of retreating into itself. This animation of color relationships may have been influenced by the theory of kinetic empathy developed by the psychologist Theodor Lipps, whose work Kandinsky would have come to

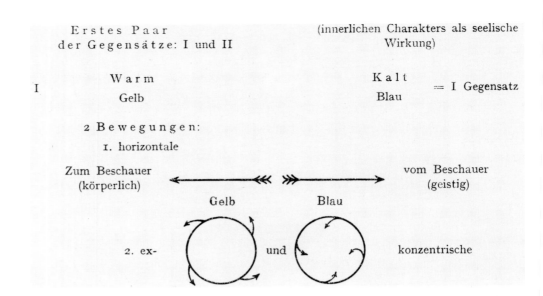

38 Wassily Kandinsky. Diagram for the
Contrast of Warm/Yellow-Cold/Blue, 1911

know during his Munich period. Lipps wrote about the apparent expansion and contraction of colors and forms and the reciprocity of their movements and countermovements.[41] The particular notion of eccentric and concentric movements, however, derives from still another source, the theory of chromotherapy, as shown by the scholar Sixten Ringbom.[42] Kandinsky owned a copy of a booklet by A. Osborne Eaves on the healing power of color, *The Powers of Color,* in which the author discussed red and blue as the two most effective colors in therapeutic applications. Regarding blue he wrote, "Its effect is cooling, quieting, contracting, soothing and inhibiting." Prompted by the word "contracting," Kandinsky drew in the margin of the booklet a small diagram of concentrically spiralling arrows. He added a diagram for red illustrating the opposite movement by lines and arrows curving outward from the center. These doodles he adapted to represent the eccentric and concentric movements of yellow and blue in the diagram included in *On the Spiritual in Art* (Fig. 38). His formulation of this "second movement" of color, therefore, shows the complexity of his relationship to his sources: he freely adapted and synthesized materials ranging from Goethe to more recent perceptual psychology and including both established and occult science.

Simultaneous Contrast

The charts using small single squares or circles on contrasting backgrounds demonstrated another phenomenon generally known as "simultaneous contrast." Rudolf Paris's 1923 study (Fig. 37) makes this especially clear, by the similarity of its format to illustrations in the book by Ewald Hering, *Outlines of a Theory of the Light Sense* (1920), a publication known at the Bauhaus in the early twenties.[43] In his treatment of "simultaneous brightness contrast," the psychologist described the appearance of a small gray field as darker on a white paper and lighter on black paper. Paris reversed the relationship, using small circles of white and black on backgrounds of the same gray, but still causing changes in their apparent value.

The term "simultaneous contrast" and the effects it denoted were best known to artists through the work of the French chemist Michel Eugène Chevreul, whose major publication, *The Laws of Contrast of Colors,* appearing first in 1839, influenced several generations of nineteenth- and early-twentieth-century French painters. His is the classic description of the phenomenon in which two contiguous colors will appear as dissimilar as possible in both their hue content and their degree of lightness. Thus, the effect on juxtaposed colors is to make them tend toward their opposites. If they differ in tonal value, the lighter color will appear even lighter and the darker color even darker. In hue, a color will tend toward the complementary of its neighbor. Thus, for instance, when yellow and red are juxtaposed, the yellow will look greenish, and the red will look purplish. If the two colors are complementaries, they are intensified by being placed next to each other.

Directly and indirectly, German artists had ample opportunity for acquaintance with Chevreul's ideas, as for example through the translation of his book, first published in 1840 as *The Harmony of Colors,* or through the international Neo-Impression-ist movement. For Kandinsky, an important source was Paul Signac's *From Eugene Delacroix to Neo-Impressionism,* to which he referred several times in *On the Spiritual in Art.* Signac advocated the use of simultaneous contrast to achieve brilliant color effects and discussed its application in the work of Delacroix and the Impressionists, as well as that of the Neo-Impressionists. Indeed, it was for their concern with the "effect of colors" themselves, their pursuit of the "brightness and splendor" of nature, and at the same time, their tendency toward the abstract that Kandinsky cited the Neo-Impressionists.[44] Among the German theorists, Kandinsky may well have known Bezold's book, previously referred to, which adopted Chevreul's theory of contrasts.[45] He certainly was acquainted with the ideas of Adolf Hölzel, whom he knew well personally and whose presence was strongly felt at the Bauhaus through former students.[46] In his teaching and writings of the first two decades of the twentieth century, Hölzel incorporated the findings of Chevreul and von Bezold, featuring simultaneous contrast among his eight categories of color contrast. He called the mutual changes in colors caused by the phenomenon "simultaneous flooding," which he valued for creating "immaterial" effects in painting, the apparent colors superceding the actual, material pigment-colors.[47] This sense of a living quality in color would certainly have appealed to Kandinsky.

Although he didn't use the phrase *simultaneous contrast,* perhaps avoiding it as a term derived from positive science, Kandinsky amply described its effects in his teaching as well as in his writings.[48] In particular, discussing the square-in-square studies, he listed the changes in the colors due to the juxtapositions: yellow appears brighter on blue, while blue on yellow becomes darker. On white and black backgrounds, these colors are altered in purity or saturation: on white they are dulled, on black clarified—effects he had referred to in *On the Spiritual in Art.*[49] He also described the "strife at the

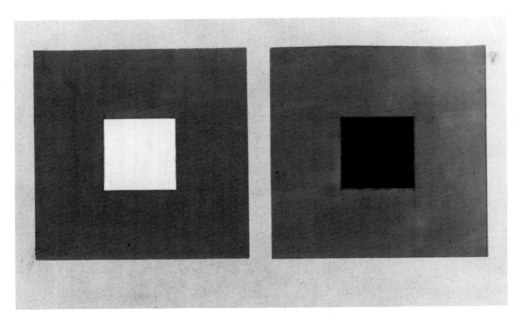

39 Bella Ullmann-Broner. *Color Studies,*
1931 (C. 159)

boundaries" of the colors, a distinct characteristic of simultaneous contrast effects, whereby along the edges of the color the complementary of the neighboring hue seems to appear. As Kandinsky saw it, red appeared on both sides of the boundary of yellow and blue, that is, the two colors were tinged respectively orange and purple. In *On the Spiritual in Art* he had written eloquently of these mutual alterations of neighboring colors, citing "the overriding of one color by another, . . '. the sounding forth of one color from another," and he emphasized the effects at borders, such as "dissolution" or "bubbling over," recalling Hölzel's use of the term *flooding*.[50]

With regard to the changes in hue involving chromatic temperature, Kandinsky's observations did not consistently follow the principle of complementary colors being elicited by juxtapositions. Thus, while blue on yellow becomes warmer or somewhat more reddish, tending toward violet, the complementary of yellow; yellow on blue, according to Kandinsky, becomes colder or greenish. This effect of the blue bringing out in the yellow its tendency or susceptibility to green may be explained as the result of comparing the two colors and perceiving an inherent similarity—"the sounding forth of one col-

or from another"—or as a kind of optical mixture of the two colors. Kandinsky indicated the latter cause in saying that the cold blue background extends into the yellow form, just as a warm yellow background extends into a blue form. Thus, rather than simply working out the logical effects of the "law" of simultaneous contrast, he pursued his own personal, empirical study of chromatic interactions and encompassed divergent characteristics and phenomena in his account of them. His list of the alterations in colors included effects on dimension and form at boundaries, increased tensions, and the changes in temperature and lightness.

His assignments concerning color juxtaposition utilized the primary colors, including red, plus the secondaries green, orange, and violet, combined with each other and with white, black, and gray.[51] Surviving student exercises show many of these combinations and demonstrate that the square-in-square format was the vehicle for these studies (Kessinger C. 35–37; Ullmann C. 157, 158, Fig. 39, C. 159). One by Eugen Batz effectively presents the phenomena with all three primary colors, showing the possible combinations in six identical squares and thus their various spatial, dimensional, tonal, and chromatic effects (Fig. 40, C. 11). Surely one of the purposes of this grouping of hues was to study the more moderate character of red as compared to the strong opposition of yellow and blue. As Kandinsky had said concerning red-blue juxtapositions, the same phenomena occurred as with yellow and blue, but with less contrast and therefore reduced intensity. This intermediary nature of red was an important part of the lecture he devoted to this hue.

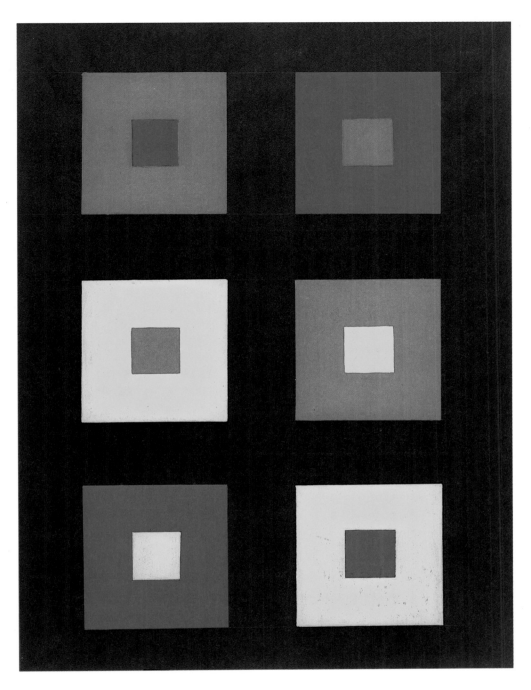

40 Eugen Batz. *Color Contrasts*, 1929/30 (C.11)

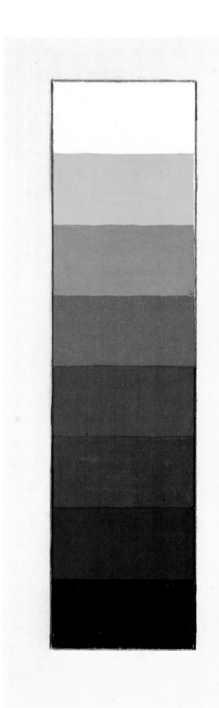

41 Eugen Batz. *Color Ladder,* 1930 (C. 2)

Red and the Color Scale

In his discussion of this hue, Kandinsky moved from the concept of opposition embodied in yellow-and-blue to that of progression, and therefore the device of the color scale became crucial. His starting point was Goethe's notion of a "gulf between yellow and blue," a condition for which red provides "the true mediation."[52] This conception is based in what Goethe called the "primal phenomenon," the effects caused by turbid media: when light is seen through a semitransparent medium, it appears yellow, and even orange or ruby red as the medium becomes denser or thicker. On the other hand, darkness seen through such a medium, which itself is illuminated, appears blue, progressing to violet as the medium becomes thinner.[53] Noteworthy instances of these phenomena in nature are the yellow, orange, and red colors produced at sunset and the blue or lavender appearance of distant mountains—both caused by atmospheric turbidity. Goethe designated the progression from yellow and blue to red "increase," and in a passage quoted by Kandinsky, he concluded: "And thus, in physical phenomena, this highest of all appearances of color arises from the junction of two contrasted extremes which have gradually prepared themselves for a union."[54]

Basing his conception of red on Goethe, Kandinsky considered it the bridge between yellow and blue, and the perfect equilibrium between the light and dark poles. The concept of "increase" lies behind his characterization of red as possessing the greatest chromatic intensity and forcefulness, by which he explained its common use in signals and its appearance in the costumes of primitive peoples, folk ornaments, and early religious images. In support of this primacy of red, he even cited ethnographic evidence that it was the earliest color used in the development of primitive art, as well as in neolithic and early Greek painting; and he added the etymological information that

the word *red* derives from the Sanscrit root meaning "light," indicative of the characteristic brilliance of this hue.[55]

In Kandinsky's teaching diagrams and in the student exercises, the sequencing of colors from white and yellow to blue and black, with red as the intermediary, received a great deal of attention.[56] The most basic of these is the horizontal color scale included in Hans Thiemann's study, *Color Scales and Color Circles*, where the sequence is captioned "from warm to cold" (Fig. 43, C. 124). This diagram succinctly indicates the progression from light to dark among the fundamental chromatic elements, as well as their respective degrees of temperature. It had been included in *Point and Line to Plane*, along with a stepped version, which Kandinsky identified as representing "a slow, natural slide from top to bottom" (Batz Fig. 41, C. 2; Thiemann Fig. 43, C. 124; Ullmann C. 53).[57] Another interesting format for the basic color scale was an elongated isosceles triangle, with white at the broader end, black at the narrow point, and between them the three primary hues (Ullmann Fig. 44, C. 160). This gradual narrowing through the sequence of colors represented the progression of light and chromatic warmth from fullness to extinction.

The concept of the color-value scale itself goes back to Goethe and earlier.[58] Regarding "the dark quality of every color," he had concluded:

"From a yellow that is very near to white, through orange, and the hue of minium to pure red and carmine, through gradations of violet to the deepest blue which is almost identified with black, color ever increases in darkness."

At about the same time, Runge proposed a simple scale of the three primaries between white and black, or light and dark, identical in its basic concept to Kandinsky's, though the latter added the notion of temperature.[59] Finally, Ostwald presented the idea: "The hues, like the bright-

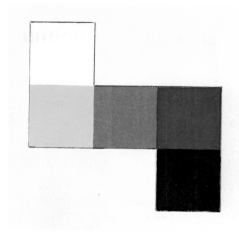

42 Eugen Batz. *Stepped Color Scale,* 1930 (C. 5)

ness steps of the achromatic colors, form a constant series. . . . We choose as a starting point of the hue series the lightest point, a pure yellow. . . ." He followed the tradition of Goethe and Runge, furthermore, in considering blue to have the least luminosity.[60]

The stepped scale—captioned in Thiemann's exercise *Representation of the Descent*—also indicates this reduction in value and temperature. Moreover, by separating white and black from the triad of primaries, it clearly differentiates the two categories that scientists had designated "achromatic" and "chromatic" colors. In his teaching, Kandinsky used the term *achromatic colors,* though in *Point and Line to Plane* he had called it "somewhat awkward," preferring to call white and black "silent colors," as he had in *On the Spiritual in Art*.[61] His statement, "these two colors . . . until recently were called noncolors," shows his awareness of the view of perceptual psychologists, notably Ewald Hering. This scientist considered colors as psychological phenomena and included black, white, and gray among them, since lightness and darkness are properties of colors as visual qualities.[62] Ostwald promulgated this position, using the terms *achromatic* and *chromatic colors*. He explained that the achromatic should be regarded as colors since they are experienced as constituents of our visual field as much as the chromatic, and indeed they are present

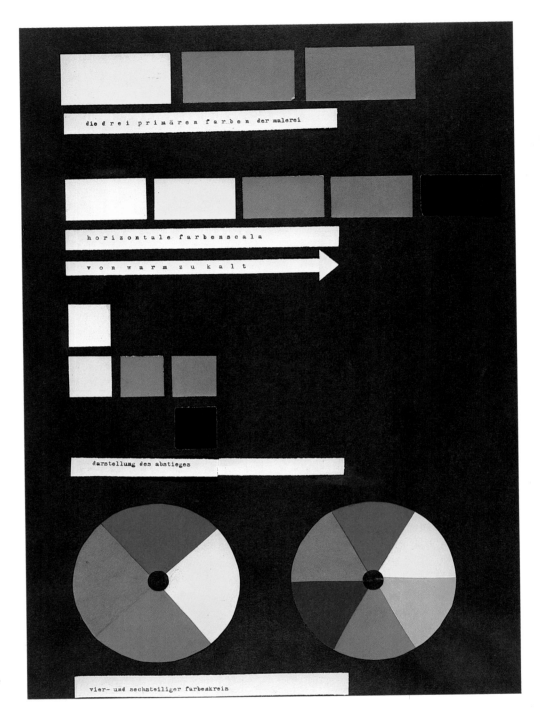

43 Hans Thiemann. *Color Scales and Color Circles*, 1930 (C. 124)

in all of the colors that we actually perceive.[63]

Although as visual sensations black and white are colors, in the physical sense they are not, as Kandinsky was well aware. He made the distinction, as had Ostwald, between material color or pigments and prismatic color or colored light, which is in the domain of physics.[64] In art, he affirmed, we are not involved with the physical properties of colors but rather with their effects on us, their tensions or internal values. Since "tensions" for Kandinsky were primarily perceptual phenomena, his view essentially conforms with that of the psychologist, in spite of its additional expressionist implications. Nevertheless, he did accommodate the physical view to some extent, in stating in *Point and Line to Plane,* "Black and white lie outside the color circle." This comment is accompanied by a footnote referring to *On the Spiritual in Art,* where he had shown these two colors placed to either side of the ring of spectral colors.[65] But apart from this theoretical conceptualization of the abstract relationships of colors, Kandinsky was interested in black and white as the artist actually encounters them, that is, as pigments. In this respect, they are never absolutely pure, and they vary in their degree of purity. The different blacks, accordingly, can be deeper or warmer, and whites too can vary in temperature, zinc white being cold and silver-white warm. In this connection, Kandinsky suggested the juxtaposition of cold white on warm white, in his discussion of the square-in-square exercises.[66] Generally, however, he considered the internal value of white to be warm and black cold, and this is part of the significance of their positions at the ends of the color scale: they respectively adjoin yellow and blue. The stepped scale, therefore, expresses both the differences and the continuities between the achromatic and the chromatic colors.

Another function of the color scales is to indicate the spatial action of the colors, as the caption of Bella Ullmann-Broner's triangular scale shows: *White Advanc-*

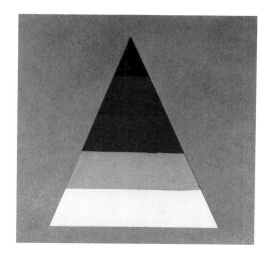

44 Bella Ullmann-Broner. *White Advances—Black Recedes,* 1931 (C. 160)

es—Black Recedes. In addition, there are the effects of rising and falling that Kandinsky ascribed to the warm and cold ends of the series, interpreted in reference to the stepped scale as a "slide from top to bottom." In relation to such tensions, red is intermediary and thus relatively static: neither eccentric nor concentric, neither advancing nor receding, neither ascending nor descending.[67] As Kandinsky characterized it in *Point and Line to Plane*: "Red is distinguished from yellow and blue by its tendency to lie firmly upon the surface." While possessing neither the expansive nor contractive action of the other two primaries, it has "an intensive, inner simmering and [a] tension within itself."

A diagram of concentric rings was also frequently used to demonstrate the sequence of three primaries between white on the periphery and black in the center (Batz Fig. 45, C. 4; Kessinger C. 30; Lang C. 94). Like the triangular schema, it shows reduction of values as well as spatial contraction and recession. It creates a tunnellike effect, moving back toward the center. This format had first been used at the Bauhaus by Hirschfeld-Mack in a pair of studies in the spatial and other tensional qualities of black, white, and ten intermediary gradations of gray (Fig. 46, 47).[68] He in turn seems to have been inspired by a nearly identical image found in Hering's book, demonstrating simultaneous boundary contrast.

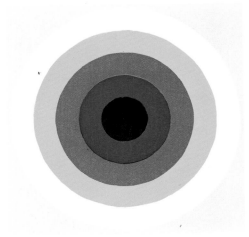

45　Eugen Batz. *Color Scale, Arranged in Concentric Circles,* 1930 (C. 4)

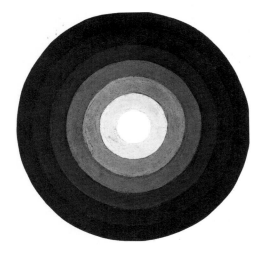

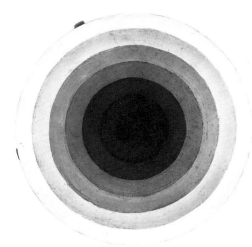

46–47　Ludwig Hirschfeld-Mack. *Gradation Studies with Concentric Circles,* 1922.

Kandinsky elaborated the straight color scale by dividing the red into warm and cold hues, emphasizing these two aspects of red in his teaching in order to convey its role as a bridge between yellow and blue (Kessinger C. 32). In spanning the distance between the other primaries, red possesses the greatest range and the most numerous gradations of all the colors, as Kandinsky had asserted in *On the Spiritual in Art.*[69] He cited "the infinite range of different reds"; and concerning its warm and cold variations he said, "nowhere does one find so great a contrast as in the case of red." In his teaching, furthermore, he listed the nuances from the lightest and warmest to the darkest and coldest: red lead through vermilion and carmine to dark madder. This sequence, of course, parallels the temperature and value progression in the color scales.

Another indication of the importance Kandinsky assigned to red and its broad range was the exercise in which the tonal gradations of warm and cold reds were placed between tonal scales of yellow and blue. Finally, he utilized an expanded color sequence that included orange and violet in addition to the two reds. This version of the scale is the fullest representation of the progressive movement expressed in Goethe's principle of "increase" from the poles of yellow and blue. The importance of this concept lies behind the frequency of color scales in Kandinsky's teaching and the student exercises, as opposed to the relative infrequence of color circles, the more common diagram of the range of color. Indeed the color scales so far discussed include all but one of the major hues usually found on color circles, namely green. This exclusion can also be explained by reference to Goethe's theory, which opposes the merely physical "mixture" of yellow and blue that produces green, to the more noble "increase," a realization of the "primal phenomenon."[70]

The inclusion of orange and violet in the expanded color scale suggests, in addi-

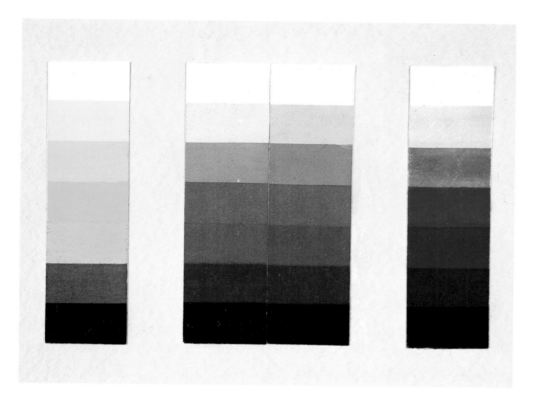

48 Bella Ullmann-Broner. *Beginning with White and Progressing Through the Colors to Black,* 1931 (C. 150)

tion, the dynamic quality of color transitions, befitting again the connotation of "increase." As intermediaries between the primaries, these two hues have a potential for moving either way. Kandinsky had expressed this active character in *On the Spiritual in Art,* in the way he described the colors: "Warm red, when heightened by the use of related yellow, becomes orange"; and violet is "a cooled-down red."[71] Moreover, being mixtures of red with either yellow or blue, these hues

"are made up of an unstable balance of forces. In the mixing of colors one notices their tendency to lose this equilibrium. One has the feeling as of watching a tightrope walker, who has to take care to maintain his balance on both sides continually. Where does orange begin, and red and yellow stop? Where is the borderline that divides violet strictly from red or blue?"

Here Kandinsky may have been thinking of another theoretical source, Philip Otto Runge and his idea of the "mobility" of the

secondary colors, which had so influenced Klee's conception of the dynamics of color.[72] In his own paintings, Kandinsky used these transitions along the color scale and sometimes even based the essential structure of the picture on the whole chromatic sequence, as will be seen.

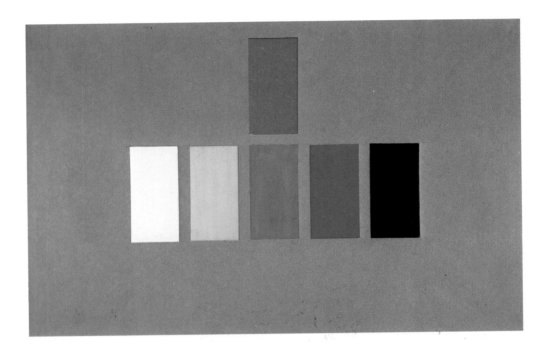

49 Heinrich Neuy. *Color Ladder,* 1930
(C.112)

The Mixtures and the Color Circle

Kandinsky's final subjects in the series of color lectures were the secondary and tertiary, mixed colors and also gray.[73] The chief diagram was still the color scale, but at the very end he dealt with color circles as a way of showing the complementary relationships between primary and secondary hues. Green and gray he treated jointly, as equivalents to red in being intermediary in value between the light and dark poles of the scale. Green, in fact, could take the place of red in the diagram, fitting between yellow and blue as a result of their intermixture (Neuy Fig. 49, C. 112). The inherent parallels between these three colors, mentioned by Kandinsky in *Point and Line to Plane,* were quite literally and beautifully represented in a value-scale exercise done by Lothar Lang (Fig. 50, C. 101).[74]

The shared characteristics of these colors included especially their relative neutrality with regard to spatial tensions, neither expanding nor contracting, advancing nor retreating, rising nor falling. However, among the three there is a gradual development toward the complete passivity of gray. While red has an inner movement, green is immobile; red actively imbeds itself in the ground plane, but green simply identifies itself with the plane. Gray is absolutely stable and tensionless, and as Kandinsky implied in *On the Spiritual in Art,* it lacks even the potential activity that green possesses as the product of two active colors.[75] Another, livelier kind of gray can be achieved by the optical mixture of red and green. This was an effect that he associated with Delacroix, whose use of the combination to produce lustrous grays he had learned about in Signac's book. Kandinsky distinguished the deadness of gray produced by physically mixing white and black from the effect of optical mixture: in the latter case, as also with a lightened gray, "we feel a breath of air, the possibility of respiring."[76]

The spatial characteristics of red, green, and gray were explored in an exercise assigned by Kandinsky, with small simple shapes of the three colors, in equal number.[77] The purpose was to control the intensities of the colors by adjusting the size and arrangement of the forms, so that they would not develop eccentric nor concentric tensions and would remain

50 Lothar Lang. *Color Scale,* 1926/27
(C. 101)

integrated with the plane. In this way, balance and a simple harmony would be achieved. A perhaps somewhat elaborated example of this assignment is a set of three studies by Eugen Batz, in each of which one of the colors is used as a background for small shapes of the other two (Fig. 51–53, C. 6–8). This allows for a full comparison of the possible interrelationships. In each of the studies two forms are placed near the corners, diagonally opposite each other, the rectangular shapes aligned with the edges of the sheets. This method of arrangement helps stabilize the compositions and keeps them flat.

Kandinsky realized that equal tonal value was crucial to maintaining the state of equilibrium among the three colors. Of course, this equivalence is the normative characteristic represented in color scales such as that by Lang, but variations in the

51–53 Eugen Batz. *Color Studies,* 1929/30
(C. 6–8)

lightness of actual pigments could throw off the effect of stasis and flatness. The closeness in value of red and green is an important aspect of their relationship, since it completes the balance inherent in their chromatic complementarity. This feature makes the combination an especially controlled instance of the effects of simultaneous contrast, no real alterations in hue or tone being possible, only an enhancement of their redness and greenness.[78] In combination with red and green, gray acts as a neutral, particularly if it is the same value as the others. Kandinsky recommended its use as an intermediary or transition, especially in answer to the problem of maintaining the absolute identity and sonority of the spectral colors when they are brought together.[79] In addition, the phenomenon of simultaneous contrast serves to alter the gray itself in the direction of the complementary of the juxtaposed hue. Thus, in studies like those by Batz, the gray forms look slightly greenish on the red ground and reddish on the green.

As for the different shades of gray, Kandinsky was relatively disinterested in them, unlike the gradations of the primary colors or the value scale of the spectral colors themselves. He did refer to Ostwald's gray scale, recommending it for its precision and usefulness as a method of calculation, that is, presumably, as a measure of the relative values of colors.[80] An example of a gray scale derived from Ostwald is the eight-stepped gradation by the student Ullmann-Broner (C. 152). Kandinsky also cautioned against reliance on this device, however, implying that an intuitive approach to artistic problems was superior to the mathematical or rational.

Kandinsky proceeded to discuss the secondary colors orange and violet, a pair that in *On the Spiritual in Art* he had conceived as one of the major antitheses, along with yellow and blue, white and black, and red and green.[81] He treated the two hues as mixtures of yellow and blue with red, consistent with his interest in the color scale as a representation of

"increase." Since they are connected by red, their contrast is a muted one. He had previously assigned exercises in the juxtaposition of orange and violet, and now he specified studies of orange on yellow and on red, and violet on red and blue. Indeed, it was in this part of this course that Kandinsky considered the varying degrees of contrast, from the strong opposition of the complementary pairs to the weakest contrasts in combinations involving the tertiaries.[82] These relationships played a major role in his conception of painting, contrast superceding harmony as a means of visual and expressive effect. He also introduced the phenomenon of color relativity, likewise an important element in pictorial composition. An example is the effect of violet exhibiting a warmer or cooler tendency when placed in cool or warm settings.

As has been suggested above, Kandinsky, due to his elementary conception of color, was not as concerned with the duller intermediary colors as were his colleagues Itten and Klee. For instance, he never specifically treated the subject of the variations in chromatic saturation or purity, as did Klee in his use of Runge's color sphere as a model of the infinite variety of colors. Nevertheless, Kandinsky did discuss the muted colors on a few occasions and devoted a small part of his last color lecture to the tertiaries. His assignments in the gradations of yellow, warm and cool red, and blue, of course, involved diluting the chromatic intensity of these hues. He considered the deepening of the primaries by the addition of black to be a transition to the tertiaries.[83] Dissimilar effects are achieved, yellow and warm red being more distorted than cool red and blue, as with the change of yellow to a dull greenish color when mixed with black. The true tertiaries are the products of mixing the secondaries: rust from violet and orange, citrine from green and orange, and olive green from violet and green. Each of these combinations reveals an extra quotient of the primary color that is shared by the parent secondaries. Thus, rust is reddish, citrine is yel-

lowish, and olive green has a dull bluish cast.

Kandinsky was interested in the effect of these muted variants of the primaries when juxtaposed with their complementaries. They produce minimal contrasts: green with rust, violet with citrine, and orange with olive. Furthermore, the tertiaries can be used to provide smoother transitions, or bridges, between the complementary pairs, as for instance, if rust is placed between green and red.[84]

Kandinsky's interest in chromatic opposition led him to refer to the color circle in his class, and apparently also to assign this diagram as an exercise. Color circles are traditionally constructed on the basis of the complementary pairs, with the primary and secondary hues placed diametrically opposite each other; and the standard sequence follows the natural order of the spectrum, its ends united in violet. This conception, commonly embodied in a six-hue circle, goes back to Goethe and Runge and earlier. Curiously, Kandinsky proposed two sets of complementaries.[85] One followed tradition in naming as pairs yellow-violet, red-green, and blue-orange. The corresponding circle clearly shows the secondaries as intermediaries between the primaries (Batz Fig. 54, C. 3; Kessinger Fig. 149, C. 23; Ullmann C. 149). As he had done earlier in *On the Spiritual in Art,* however, he maintained the yellow-blue polarity in the other set of complementaries, thus arriving at the unorthodox pair orange-violet, in addition to the standard red-green.[86] This makes for an awkward sequence in the color circle, breaking the logical order of the primaries and their mixtures.

A third schema, seen in Thiemann's *Color Scales and Color Circles* (Fig. 43, C. 124), chart, is a four-part circle, formulated according to Hering's four-color theory. According to this, yellow, red, blue, and green are the primary chromatic sensations. This principle, therefore, provided scientific substantiation for the chief polarity in Goethe's theory and in Kandinsky's synaesthetic conception of color. Hering's theory was promulgated by Ostwald, who emphasized the psychological rather than physical grounding of the conception and also explained that Hering considered white and black the third fundamental polarity in visual perception.[87] This too was relevant to Kandinsky's ideas on color.

Ostwald based his own color circle on Hering. Whether in its eight-part or twenty-four-part versions, the distribution of hues governed by the four-color theory provided a broader span for green and its related hues than did traditional circles. According to Ostwald, this was appropriate due to the special sensitivity of the eye to greens.[88] His color circle appears in two of the charts by Kandinsky's students. Hans Schürmann's eight-armed design apparently employs Ostwald's sequence of ultramarine blue, turquoise blue, sea green, leaf green, yellow, orange, red, and purple (violet) (Fig. 55, C. 119). Ostwald's twenty-four-color circle was adopted by Ullmann-Broner (Fig. 56, C. 143). She also followed its sequence, using every other hue, in a beautiful construction of twelve overlapping squares of color, the semitransparent planes producing a wide range of subtle gradations and mixtures (Fig. 172, C. 145).

For Kandinsky, an important application of the polar relationship of colors was their use in the arrangement of pictorial compositions. There were two principles involved: when the members of a pair were separated they provided balance across the surface of a composition, while if juxtaposed, they created emphasis or accent. These functions reflect the two aspects of complementarity. The extreme difference results in strong contrast, and yet the two colors "complete" each other to produce a wholeness. For example, the ingredients of green—yellow and blue—combined with red constitute the full set of primaries. The pair can be matched up by the viewer even when its elements are placed in different parts of a composition, since, as Goethe said,

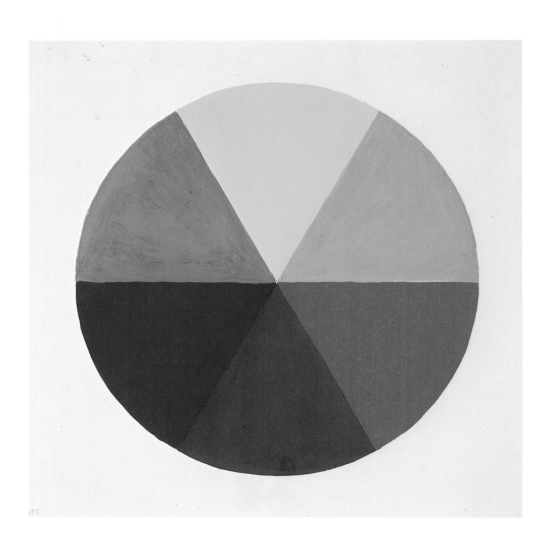

54 Eugen Batz. *Six-Part Color Circle,* 1930
(C. 3)

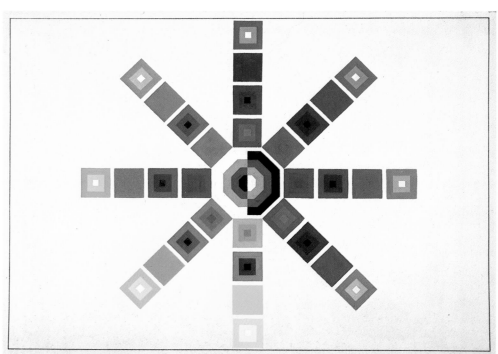

55 Herbert Schürmann. *Color Circle Study,*
1932 (C. 119)

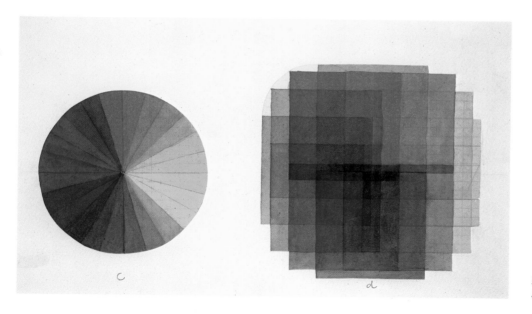

56 Bella Ullmann-Broner. *Color Circle Studies after Ostwald,* 1931 (C. 143)

"The eye especially demands completeness."[89] The idea of the balance thereby achieved is also connected with the concept of complementarity, which traditionally was felt to produce harmony.

An exercise demonstrating these possibilities was assigned by Kandinsky at the conclusion of his first-semester course, utilizing a nine-square grid as its underlying structure, in turn subdivided into eighteen small rectangles.[90] This format is shown in the example by Lang (Fig. 57, C. 100). The study by Thiemann slightly varies the design by leaving two of the large squares entirely gray and further dividing the central field into four small squares of white and black (Fig. 58, C. 121). Nevertheless, the use of color in the latter study, clarified by the appended schematic diagram, shows definitively the principles propounded by Kandinsky. The caption relays the goal of the exercise: *Accenting the Center; Balance, Above and Below;* and the study follows his prescription in using the primaries, secondaries, and white, black, and gray. White and black are used as sharp accents in the center, and as balancing elements along with the other polar oppositions at the top and bottom, while the neutral gray acts as a transition or buffer between the two zones. Interestingly, the arrows in the diagram indicate that orange-violet and yellow-blue were considered as complementaries here. Such is also the case in Lang's study. Two important variations occur here, however, lending additional complexity to the composition. Most of the opposing elements are both directly juxtaposed, creating contrasts, and also placed across from each other to provide balance. Moreover, as indicated by Lang's inscription—*Center Accented by the Blue-Red Opposition*—the central contrast is not complementary but rather a vivid opposition of two primaries that allows for strong effects of simultaneous contrast. The variety of possibilities suggested by this assignment, therefore, indicates the richness of color interactions in pictorial composition as taught by Kandinsky and employed in his own paintings.

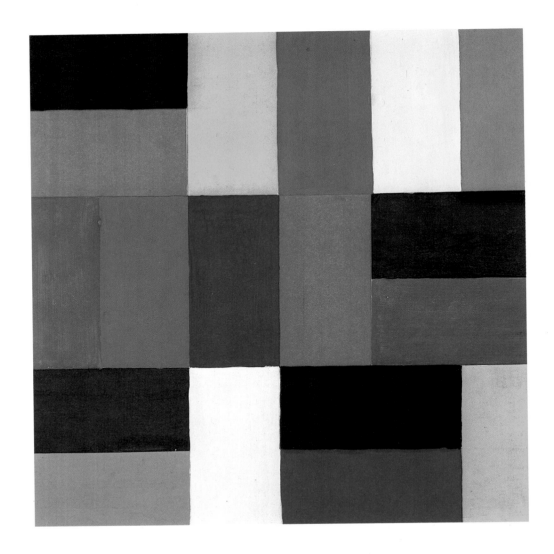

57 Lothar Lang. *The Center Accented by Blue-Red Opposition,* 1929 (C. 100)

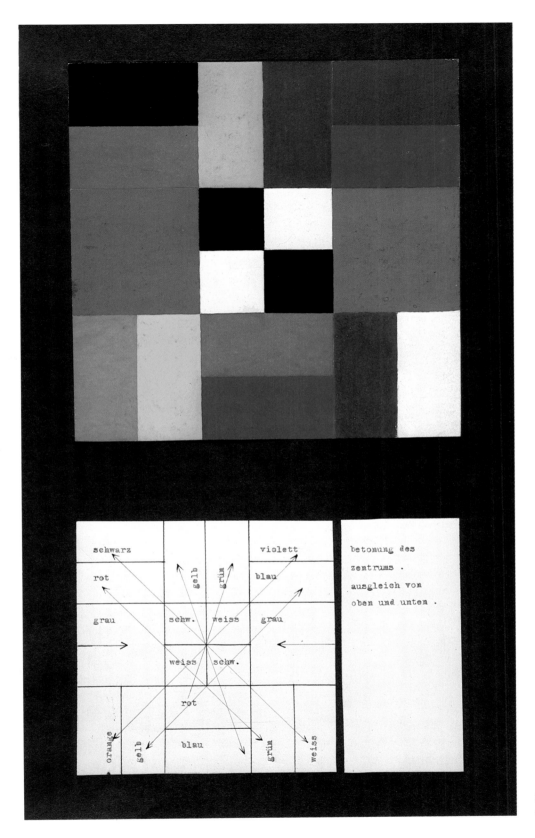

58 Hans Thiemann. *Accenting the Center;*
Balance Above and Below, 1930 (C. 121)

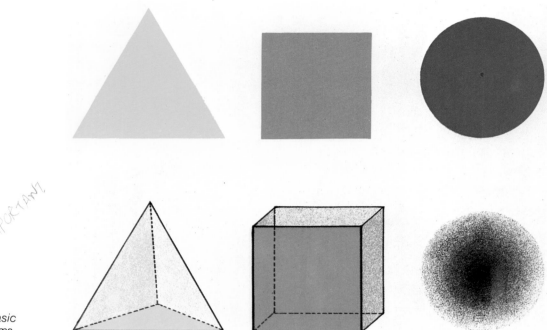

59 Wassily Kandinsky. *The Three Basic
Colors Applied to the Three Basic Forms,*
1923

The Correspondence of Colors and Forms

In perceptual experience, as Kandinsky was well aware, color isolated from form is a virtual impossibility, except under certain experimental conditions.[91] As actually used in art and design, color, of course, is in constant interaction with formal elements. The study of these relationships was important, therefore, in Kandinsky's courses. Indeed, many of the student exercises he assigned concerned the specific affinities between colors and the various kinds of lines and shapes. Such investigations reflect his desire for a synthesis of elements in the visual arts. A statement in *Point and Line to Plane* indicates his belief in the potential offered by an understanding of the affinities of colors and forms: "The natural links between 'linear' and 'painterly' elements . . . are of immeasurable importance for the future theory of composition."[92]
As already suggested, Kandinsky's conception of these correspondences was rooted in the phenomenon of synaesthe-

sia. Thus in his early remarks on the relationships between the basic formal elements and colors, in *On the Spiritual in Art,* he stated:

"At all events, sharp colors have a stronger sound in sharp forms (e.g., yellow in a triangle). The effect of deeper colors is emphasized by rounded forms (e.g., blue in a circle)."[93]

Subsequently he developed his theory considerably beyond such initial suggestions. In the program for the Moscow Institute for Artistic Culture (1920) and his 1923 essay "The Basic Elements of Form," he matched red with the square and applied the form-color correspondences to the basic solid geometrical forms: the pyramid, cube, and sphere (Fig. 59).[94] He felt that this extension of the theory would be important for sculptural and architectural applications and thus for the anticipated synthesis of media in a monumental art. At the Bauhaus, he also suggested formal affinities for the secondary colors, and in *Point and Line to Plane* he treated the relationships of colors to dif-

ferent lines and angles, again starting with their expressive or synaesthetic characteristics.[95]

In 1923, the year of the Bauhaus Exhibition, Kandinsky's correspondence theory provided a kind of leitmotif at the school. Through the Wall-Painting Workshop, of which he was the Form Master, he surveyed the whole Bauhaus community in order to determine their choices of form-color linkages. This procedure fulfilled the shared desire to rely on scientific methods so as to arrive at objective validity. The questionnaire is preserved in the example filled out by Alfred Arndt, and it bears the instructions to color in the three basic shapes with the appropriate primary hues (Fig. 60, C. 1). Evidently the majority confirmed Kandinsky's theory, although some, like Klee and Schlemmer, disagreed about particular combinations.[96]

Among the products of the school during this period are numerous instances linking these shapes and colors. Hirschfeld-Mack executed a series of no less than eight studies experimenting with different correspondences (Fig. 61). The sheets all have the same row of forms—triangle, square, and circle—but the primary

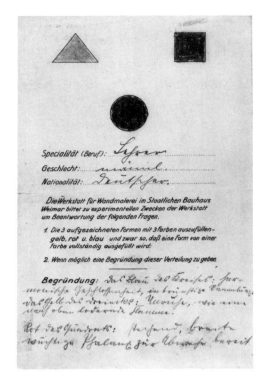

60 Wassily Kandinsky. Questionnaire from the Wall-painting Workshop, filled in by Alfred Arndt, 1923 (C. 1)

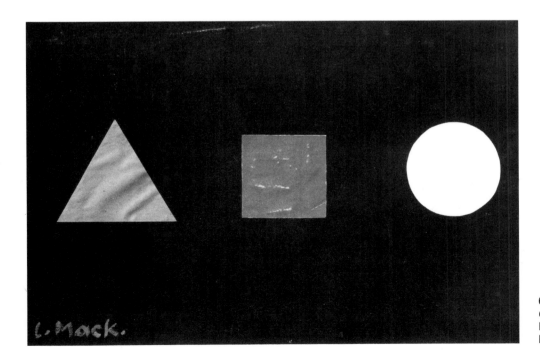

61 Ludwig Hirschfeld-Mack. *Study of Basic Colors and Forms,* 1922. Busch-Reisinger Museum, Harvard University, Cambridge, Massachusetts

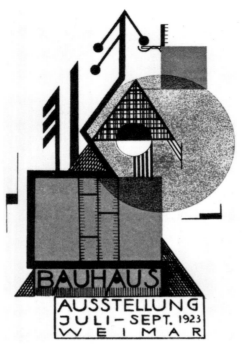

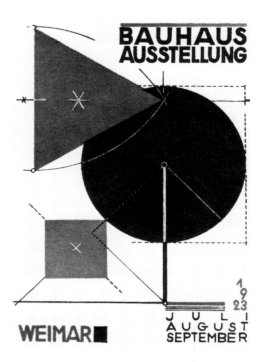

62 and 62 Postcards for the Bauhaus
exhibition, designed by Rudolf Baschant (left)
and Herbert Bayer (right)

hues are applied variously, and the backgrounds are white, black, or gray. Apart from Hirschfeld-Mack's studies, images of the fundamental color-forms provided a prevalent theme at the 1923 Bauhaus Exhibition. Some of the postcards printed to publicize the exhibition are examples: Rudolf Baschant's has red squares and a blue circle (Fig. 62), and Herbert Bayer's also has a canonically colored square, while its triangle is blue and its circle black (Fig. 63). Kandinsky himself accepted such deviant combinations—"incompatibility of a form and a color," which can offer "new possibilities and thus also harmony."[97] He himself, however, provided the standard image in the color plate of the basic elements, illustrating the article in the book that accompanied the exhibition (Fig. 59).

On a monumental scale, Bayer designed the murals in the stairwell of the main building of the school, following Kandinsky's theory (Fig. 64). At the ground-floor level, the wall was decorated with a composition of circles, with dark blue as the predominant color; the first floor had a composition of squares, in bright red; and at the second-floor level, there were triangles, in light yellow.[98] The sequence

of these murals, therefore, was determined by the progression in the tonal value of the colors and their descending/ascending characteristics as well. Finally, a particularly amusing instance of applying the correspondence principle is Peter Keler's cradle, also illustrated in the book *Staatliches Bauhaus Weimar 1919–1923* (Fig. 65).[99] The end boards were yellow triangles, the side panels red rectangles, and the circular hoop rockers were blue. In addition, the two primary achromatic colors were used: black on the dowel at the bottom and white on the inside of the cradle. Even infant Bauhäusler were to have an environment of appropriately matched basic elements.

The interest at the Bauhaus in Kandinsky's conception was due to their desire to arrive at basic principles that would have universal applicability in art and design and would provide effective means for communication as well. Reducing color and form to their fundamentals was, of course, a tendency shared by other contemporary art movements, most notably De Stijl, whose influence was strongly felt at the school around 1923. Indeed, Schlemmer believed that Kandinsky was reacting to the doctrinaire preachings of

the Dutch movement, hoping to counteract the exclusive connection of the primary colors and values with rectangular forms.[100] While Kandinsky's theory predates De Stijl, this observation sheds light on its role in the controversies current at the Bauhaus. In this connection, there is an interesting study by Andrew Weininger, a student who was associated with Theo van Doesburg while the latter was in Weimar from 1921 to 1923 promulgating De Stijl ideas. Entitled *Variation on Kandinsky's Theory of Colors and Forms* (1925), the work combines Kandinsky's colored shapes with gray, black, and white rectangles, as though to amalgamate the opposing theories (Fig. 66).

In *Point and Line to Plane* and in his teaching in Dessau, Kandinsky elaborated aspects of his correspondence theory. Particularly, he based his treatment of the relationships on the affinities between colors and lines.[101] Some of Friedly Kessinger-Petitpierre's exercises demonstrate his initial points quite well (Fig. 67, C. 28; Fig. 68, C. 54). Black and white were associated with horizontal and vertical lines respectively, because of their relative values of coldness versus warmth and their static quality with regard to spa-

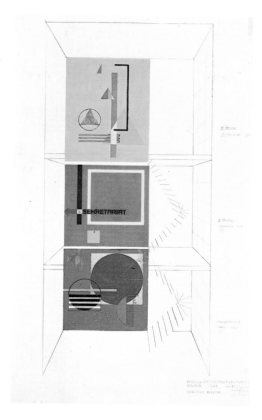

64 Herbert Bayer. Project for a mural design, side staircase in the Weimar Bauhaus building, 1923. Herbert Bayer, Montecito, California

65 Peter Keler. Cradle, 1922. Weimar State Art Collection

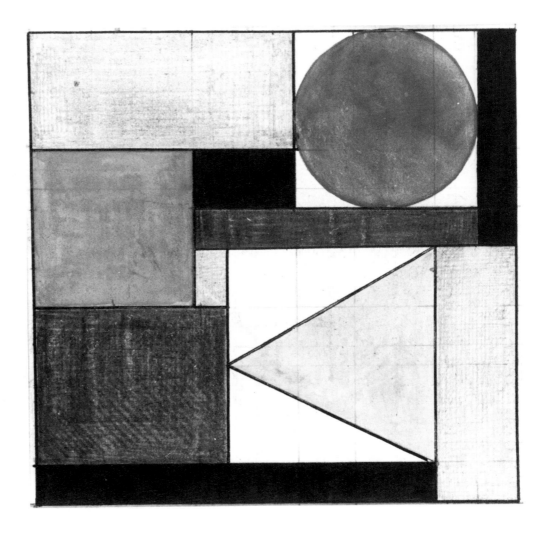

66 Andrew Weininger. *Variations on Kandinsky's Theory of Colors and Forms,* 1925. Andrew Weininger, New York

67 Friedly Kessinger-Petitpierre. *The Straight Line in Relationship to Color,* 1929/30 (C. 28)

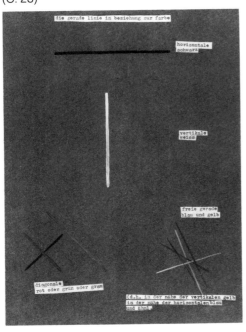

tial tensions. The diagonal is the exact intermediary between those two types of line, balances warmth and cold, and adheres firmly to the ground-plane. Thus, Kandinsky equated it with red, green, and gray, by reason of their intermediary position on the color-value scale as well as their common spatial characteristic. Yellow and blue were assigned to the "acentral independent straight lines," as they share "the tensions of advance and retreat." Kessinger's caption added the qualification that the lines close to the vertical were yellow, while those close to the horizontal were blue.[102]

Kandinsky next considered the different angles in relation to all the major hues in the color scale.[103] The acute angle is characterized as "the tensest . . . thus also the warmest," and therefore it is "highly active" and corresponds to yel-

low. The obtuse angle he regarded as passive and cold and matched with blue. Since it combines vertical and horizontal, the right angle, according to Kandinsky, achieves an equilibrium in temperature and thus is associated with red. Moreover, Kandinsky provided diagrams of angles as they relate to the colors, including the intermediary hues orange and violet. The acute angles are yellow (30 degrees) and orange (60 degrees); the right angle is red (90 degrees); and the obtuse angles are violet (120 degrees) and blue (150 degrees). Student exercises, such as those by Kessinger-Petitpierre, show these correspondences, following the diagram in *Point and Line to Plane,* and including the identification of the horizontal line (180 degrees) as black (Fig. 69, C. 25 and C. 27; Tschaschnig, Fig. 71, C. 136). The graduated shadings

76

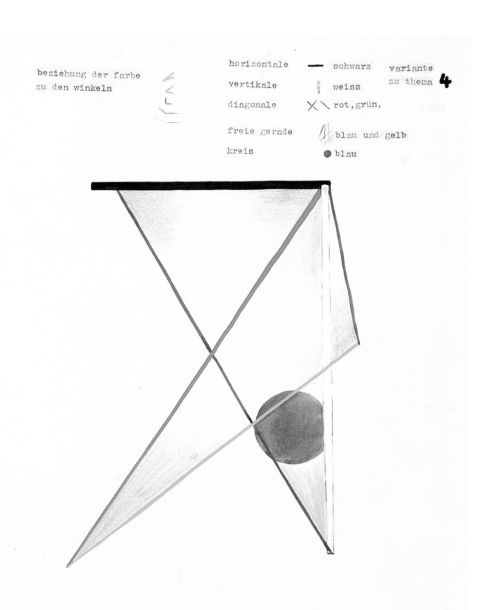

beziehung der farbe
zu den winkeln

horizontale — schwarz variante
vertikale ⬙ weiss zu thema **4**
diagonale ✕ ❵ rot,grün,

freie gerade ⫽ blau und gelb
kreis ● blau

68 Friedly Kessinger-Petitpierre. *Variation on Theme 4*, 1929/30 (C. 54)

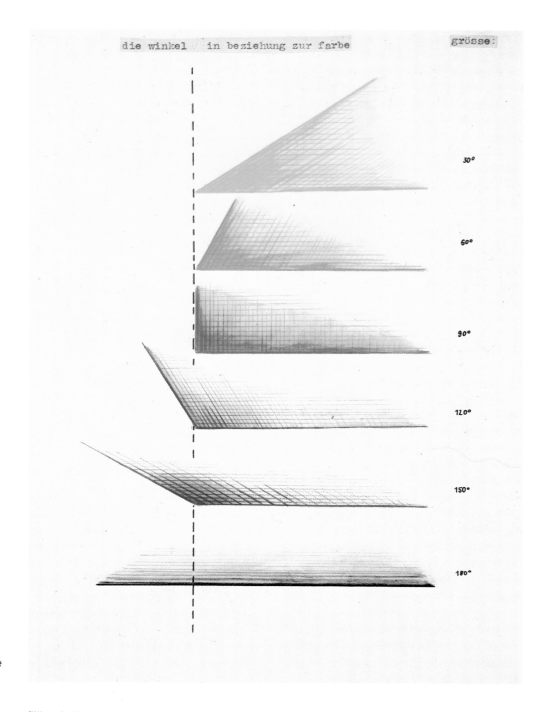

30°

60°

90°

120°

150°

180°

69 Friedly Kessinger-Petitpierre. *The Angle in Relation to Color,* 1929/30 (C. 25).

filling in the angles suggest the transition to the two-dimensional shapes that were the primary focus of Kandinsky's theory. Kessinger-Petitpierre also used this technique in the freer studies of "complex zigzags," as Kandinsky called them (Fig. 70, C. 24 and C. 26). These may be examples of the assignment to paint a compound line that describes a large form.[104] A further application of the color-angle correspondences was in the last

stage of analytical drawing, where the appropriate colors were used to reinforce the structural network, which had been discerned in the original still-life setup (Kessinger, Fig. 68, C. 54).

Curved lines could be related to the angles with regard to their color affinities, as seen in the exercise by Fritz Tschaschnig (Fig. 71, C. 136); and Thiemann's *Representation of a Curve in Color* shows the principles in a freely composed, compli-

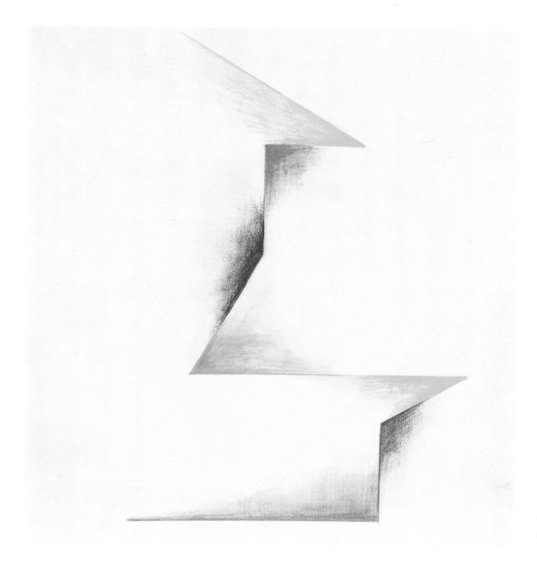

70 Friedly Kessinger-Petitpierre. *Colored Angles and Elementary Colored Relationship,* 1929/30 (C. 24)

cated curving line (Fig. 72, C. 122). The tightness or openness of the curves corresponded to the acuteness or obtuseness of the angles. Furthermore, for Kandinsky, the similarity of the obtuse angle to the arc of a circle provided an indication of the link between that geometrical figure and the color blue. For the other basic shapes, the relationships to colors could be based on similar analogies. The equilateral triangle consisting of acute angles and the square of right angles correspond, respectively, to yellow and red.

In order to derive logically from the basic forms shapes suitable to the secondary colors, Kandinsky suggested crossing two forms. For example, the triangle plus the square would produce the shape for orange, the square plus the circle the form for violet.[105] Students arrived at different solutions. Eugen Batz proposed an orange pentagon, a green form consisting of a semicircle with half a hexagon, and a violet semicircle with half a square (Fig. 73, C. 10). On the other hand, Ullmann-Broner sought to create a set of more regular forms, which she arranged in a color circle, including an orange parallelogram, green rectangle, and violet hexagon (Fig. 74, C. 154). Another approach was to follow the more general principle of progression from acute to obtuse angles, as in Thiemann's study *Construction with Triangles* with its sequence of yellow, orange, red, and violet triangles paralleling a similar white to black series (Fig. 4, C. 123).

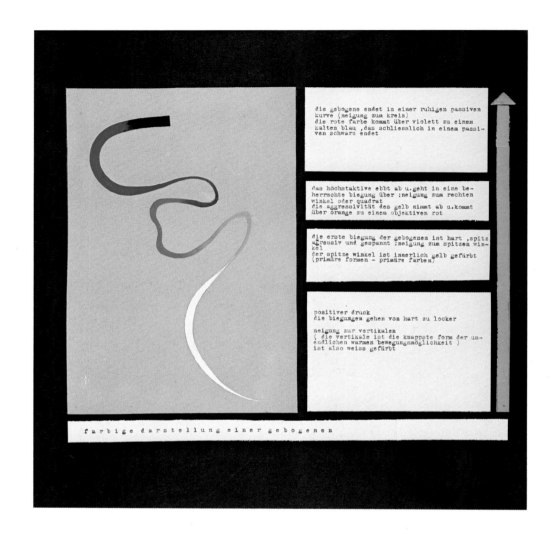

die gebogene endet in einer ruhigen passiven
kurve (neigung zum kreis)
die rote farbe kommt über violett zu einem
kalten blau ,das schliesslich in einem passi-
ven schwarz endet

das höchstaktive ebbt ab u.geht in eine be-
herrschte biegung über :neigung zum rechten
winkel oder quadrat
die aggressivität des gelb nimmt ab u.kommt
über orange zu einem objektiven rot

die erste biegung der gebogenen ist hart ,spitz
agressiv und gespannt :neigung zum spitzen win-
kel
der spitze winkel ist innerlich gelb gefärbt
(primäre formen - primäre farben)

positiver druck
die biegungen gehen von hart zu locker

neigung zur vertikalen
(die vertikale ist die knappste form der un-
endlichen warmen bewegungsmöglichkeit)
ist also weiss gefärbt

farbige darstellung einer gebogenen

72 Hans Thiemann. *Representation of a
Curve in Color*, 1930 (C. 122)

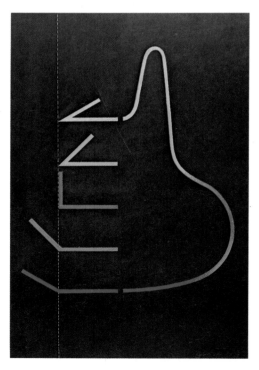

71 Fritz Tschaschnig. *Correspondence
Between Colors and Lines*, 1931 (C. 136)

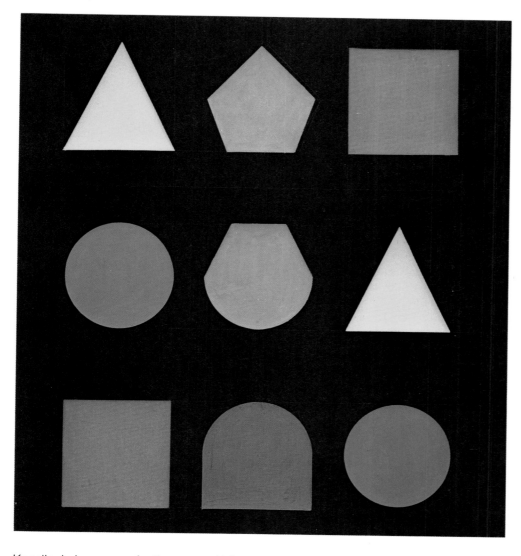

Kandinsky's sources for the general idea of expressive correspondences between colors and other formal elements go back to nineteenth-century French art theory. Most important probably was Signac's *From Eugene Delacroix to Neo-Impressionism,* which presented the earlier painter as a forerunner of the Neo-Impressionists not only in his use of color, but also in his coordination of linear directions and colors to enhance the expression of the subject.[106] In following this lead, the Neo-Impressionist ". . . adapts the lines (directions and angles), the light-dark (tones), the colors (hues) to the character that he wishes to make dominant." Furthermore, Signac's discussion of the major artist of the movement, Seurat, included references to Humbert de Superville and Charles Blanc among his sources, theorists who had been concerned with analogies between colors, tones, and lines. Through Blanc's widely known *Grammar of the Arts* (1867), Kandinsky may well have become acquainted with these ideas.[107] Although in formulating his theory of correspondences he didn't follow the earlier theories in all their details, he probably was influenced by the general conception of formal analogies and their expressive basis. Indeed, there are partial similarities between his concepts and these sources, such as Superville's distinction between vertical, horizontal, and diagonal lines and Seurat's linking of ascending directions with warm, light colors and descending directions with cool, dark colors.[108]

As was usually the case, Kandinsky absorbed such sources into his own thinking, providing his own explanation, as with the synaesthetic connection, elaborating the details, and extending the implications of the concept. The range of his correspondence theory has already been indicated. A particularly interesting ramification was his conception of the role of contradictory uses of the principles. While in theory these rules were absolute, in practice, of course, the colors and forms could be combined in many other ways.[109] Conformity with the rules resulted in harmonious, balanced, and "lyric" effects; whereas deviation produced more complex and dynamic, discordant, and "dramatic" expression. The artist could choose which principle to follow depending on the nature of the work, for its content was realized by organizing within the composition the tensions inherent in the pictorial elements and their relationships, whether harmonious or contrasting. Kandinsky suggested combining the elements in contradictory ways so as to understand better the tensions of colors. As an example, he cited the blue triangle, with two possible interpretations. While yellow and the triangle reinforce each other, blue provides an "additional value," or it may retain the inherent eccentricity of the triangle due to its own concentric nature.[110] Such effects would obtain for the spatial tensions and temperature qualities of the color-shape combinations as well. While the standard affinities, therefore, could be used for the expression of appropriateness or harmony, the theoretically nonconforming combinations would provide internal contrasts, the effects of "counterpoint" that Kandinsky valued for their richness and variety.[111]

Indeed, the theory of correspondences exemplifies the complex relationship that Kandinsky understood to exist between theoretical principles and their actual application in works of art and design. In his own paintings, he used both the appropriate and the discordant combinations of colors and forms, although it is not always possible to be certain that they were intentionally determined in accordance with the correspondence theory. Such usage is clear, for example, in *Composition 8,* No. 260 (Fig. 75), from 1923, the year the theory was so much in evidence at the Bauhaus. Yellow triangles, blue circles, and red squares appear here, but also, these geometrical forms are given other colors. This is especially true of the circles, which are yellow, red and violet, as well as blue. Angles too are used in this painting, somewhat in accordance with the correspondence theory: an obtuse angle is appropriately blue, and an acute angle, while not the canonical yellow, is assigned a warm pink hue. Kandinsky sometimes followed the general outlines of the theory more closely, to give the overall expressive effects in his paintings. This is shown by a comparison of two works from 1926, *Tension in Red,* No. 326 (Fig. 76), and *Calm,* No. 357 (Fig. 77). The title of the latter is confirmed by the predominance of blue and other dark, cool colors along with circular and curving forms, elements that he associated with restfulness. In *Tension in Red,* on the other hand, the recurrent sharp, angular forms and the large pentagonal area of bright warm red that nearly fills the background create a diametrically different feeling of active intensity. The subordinate blues and greenish blues that appear in this painting are given circular forms, providing accenting contrasts to the dominant warmth and angularity and thereby additional "tension."

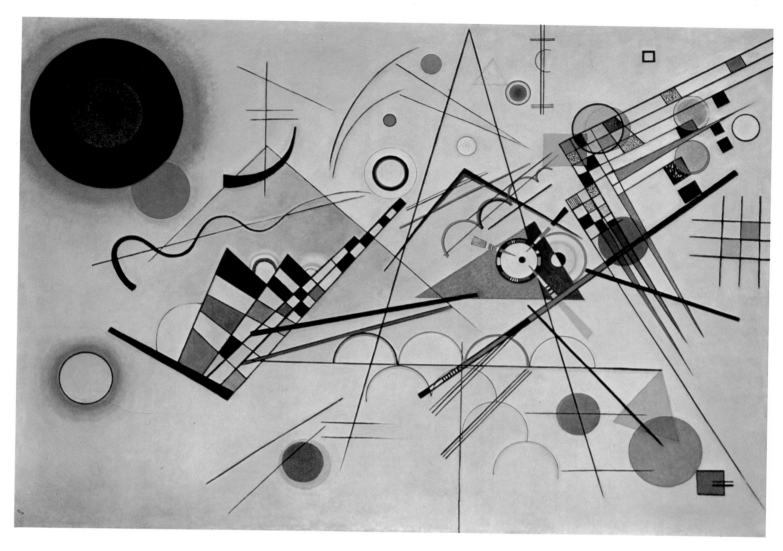

75 Wassily Kandinsky. *Composition 8,* No.
260, 1923. The Solomon R. Guggenheim
Museum, New York

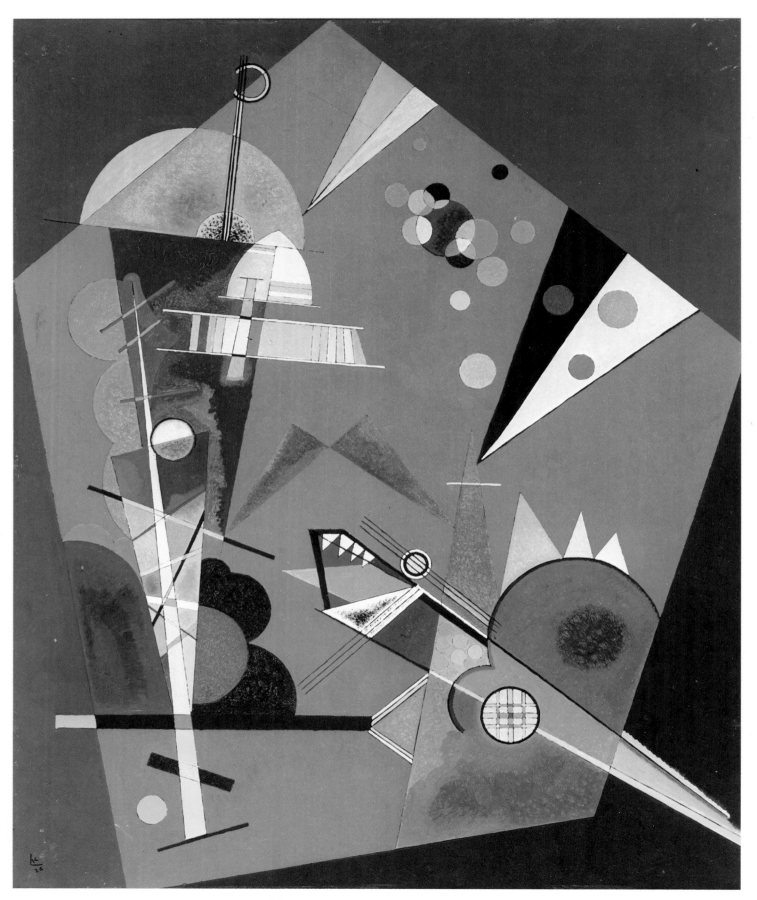

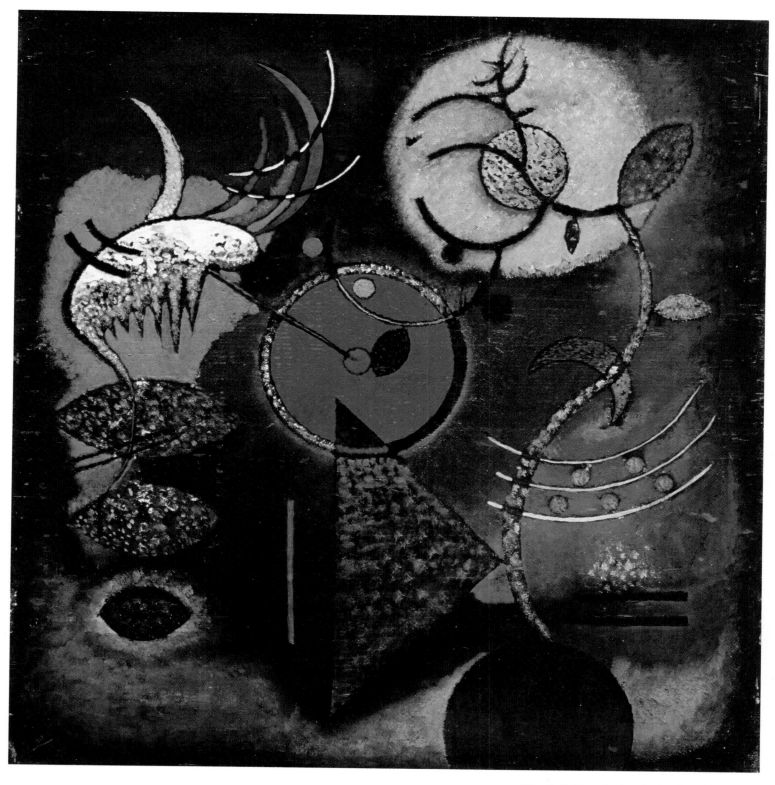

76 (left) Wassily Kandinsky. *Tension in Red*, No. 326, 1926. The Solomon R. Guggenheim Museum, New York

77 (above) Wassily Kandinsky. *Calm*, No. 357, 1926. The Solomon R. Guggenheim Museum, New York

Color in Pictorial Composition

In his "system of colors," Kandinsky reduced the realm of color to basic elements and principles: the fundamental colors, polarities, and the graduated scale. While this conception of color could be embodied in simple diagrams and an ordered pedagogical presentation, in applying it to the practice of painting Kandinsky embraced the variety and complexity of color phenomena. The characteristics demonstrated in the color scales and circles could be utilized in the structure and compositional relationships of paintings, to rich effect. Moreover, as already indicated in the discussion of the correspondence theory, Kandinsky was especially interested in the contradictory uses of the basic principles and in conflicting visual and expressive effects. With regard to the interrelationships of colors and forms, there were also the complex spatial effects that they created. These and the phenomena of simultaneous contrast were the basis for Kandinsky's relativistic view of pictorial elements and his concept of the dynamic nature of the very process of composition.

Such considerations must have been part of his teaching of "free painting,"[111] but his notes on this advanced class are relatively scant and provide little evidence of this aspect of his color theory. On the other hand, Kandinsky's published writings from throughout his career contain numerous discussions of the interactions of colors in pictorial contexts. As for the student exercises, very few of the "free" studies have survived, and most are related to analytical drawing. In any case no clear indications survive as to how they were meant to apply the color principles. Ample evidence of such applications, however, are seen in Kandinsky's own works of the Bauhaus years, which clearly testify to his interest in relating theory to practice.

His elementary conception of color—emphasizing the primary and secondary hues plus black, white, and gray—can be seen in many of his paintings of the Bauhaus period, in their use of these pure, vivid hues and values. Furthermore, he frequently used strong contrasts of yellow and blue, black and white, and the complementary pairs chosen according to both sets of these oppositions as listed in his teaching. In this manner, the different color circles found direct application in his work. He also applied, in particularly clear ways, his color scale, with its sequence of tonal value and chromatic temperature embodying the principle of "increase." Specifically programmatic in this respect is *Yellow-Red-Blue,* No. 314, 1925 (Fig. 79), whose title refers directly to the traditional theory of three primary colors. The major areas of these hues are placed in the same order as in the color scale, thus providing the basic compositional structure of the painting. This sequence is further carried out in the placements of the other colors, the largest areas of white being near the yellow and the strongest accents of black near the blue. The gray forms are appropriately positioned in the center, along with red, as value intermediaries. Transitions between the primary colors are made by purple and violet between red and blue, and by the small orange rectangle and orangish brown areas bordering the yellow. Another way of structuring a painting is by a vertical disposition of the color sequence: for example, in the watercolor *Out of Cool Depths,* No. 272, 1928 (Fig. 80), whose composition is determined by the progression, ascending from bottom to top, of blue to violet, purple, red, and yellow.

Related to this kind of color progression is the principle of modulation of a hue, particularly with regard to its chromatic temperature. In the lecture written at the end of 1913 or the beginning of 1914 for the Art Society in Cologne, Kandinsky had discussed his way of composing a painting, in the process of which he modulated the "color-tones, cooling the warm tones, warming the cold."[112] This can be seen in *Yellow-Red-Blue,* where yellow is made

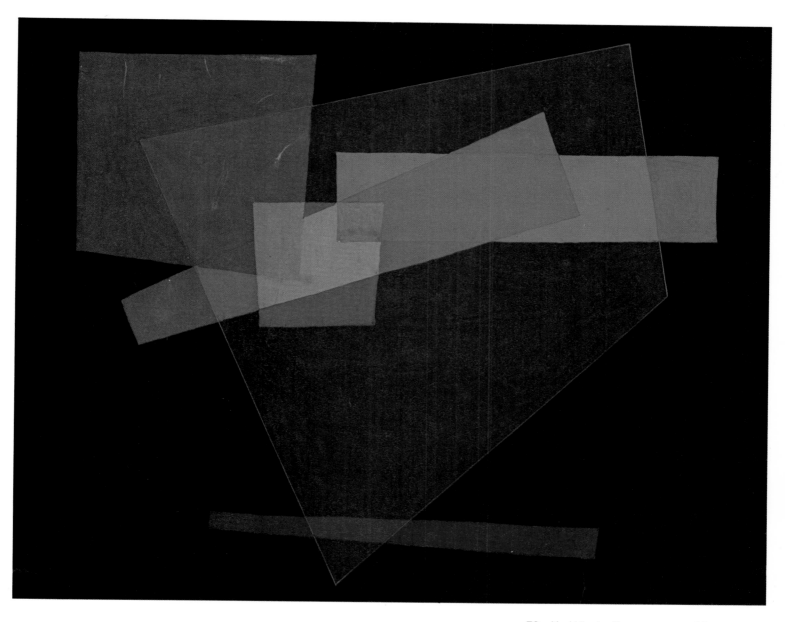

78 Karl Klode. *Transparent and Opaque
Planes with Weight Above*, 1932 (C. 87)

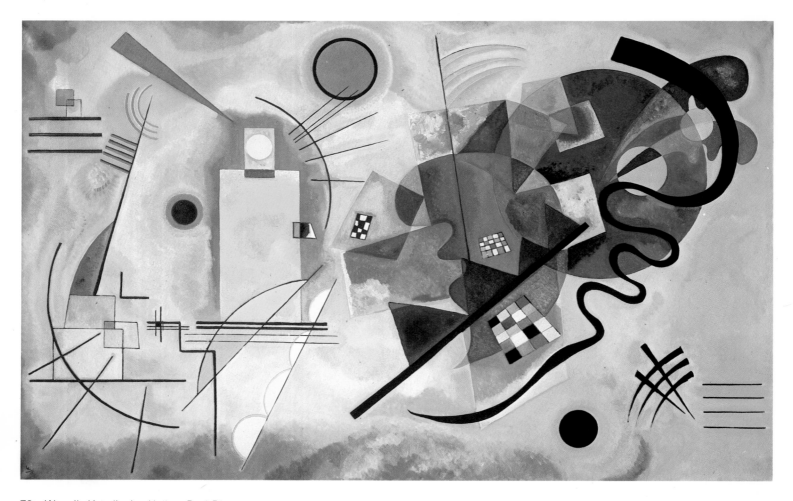

79 Wassily Kandinsky. *Yellow-Red-Blue,*
No. 314, 1925. The National Museum of
Modern Art, Centre Georges Pompidou, Paris

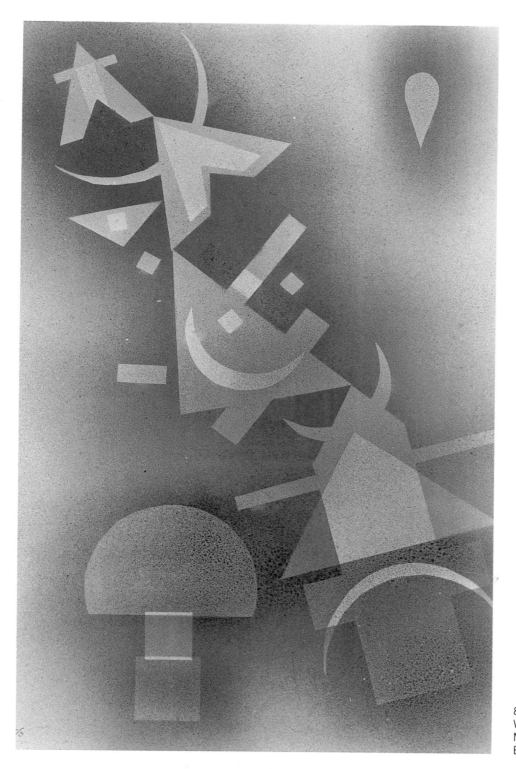

80 Wassily Kandinsky. *Out of Cool Depths,*
Watercolor No. 272, 1928. Norton Simon
Museum of Art, Pasadena, California. The
Blue Four Galka Scheyer Collection.

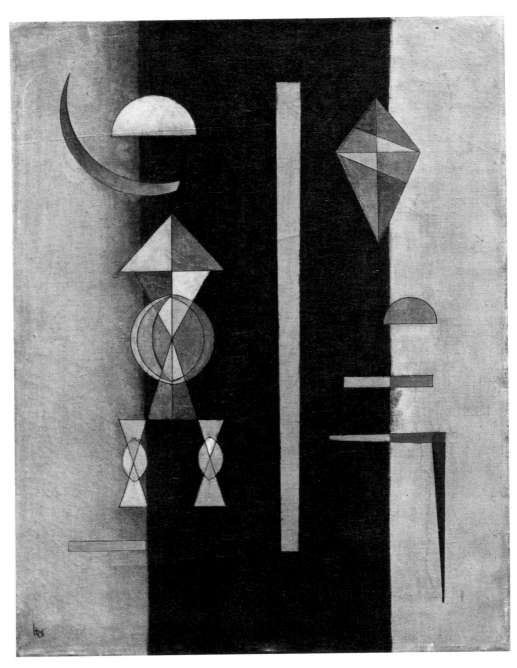

81 Wassily Kandinsky. *Two Sides Red,* No.
437, 1928. The Solomon R. Guggenheim
Museum, New York

greenish, and thus cooler, in the cloudy
area near the upper left and in the geo-
metrical forms that overlap the upper left
part of the blue circle. Here too, the blue
is varied into violet and purple, in this way
"warming" it. This latter modulation can
also be considered a variation of red,
which was the hue that Kandinsky be-
lieved to have the widest temperature
range, as he had stated in *On the Spiritual
in Art.* He used red to make paintings of
which he could say in the Cologne lec-
ture, "one single color was raised to the

level of a composition." An example is
Two Sides Red, No. 437, 1928 (Fig. 81),
where except for a central black band,
the color range consists entirely of reds
and neighboring hues on the chromatic
circle or scale. Red is modulated in small
areas to orange as well as to violet, and in
addition there are variations of saturation
and value, including ochre and brown.
Layers, No. 569, 1932 (Fig. 82), has a
somewhat broader range, distributed in
larger shapes, from red-orange and warm
pink through red, again the dominant hue,

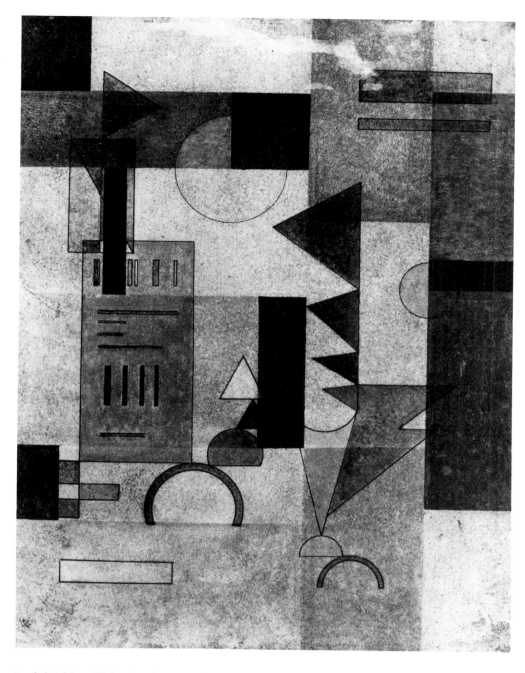

82 Wassily Kandinsky. *Layers*, No. 569, 1932. Nathan Cummings Collection, New York

to violet-blue. This closely constellated chromatic sequence produces a rich overall effect, like a musical chord. Furthermore, the variations in hues give the shapes different spatial positions, advancing and retreating, which provide the theme of the painting *Layers*.

The other important principles used in the organization of pictorial compositions were closely related to the color circles, in that they derived from the complementary relationships, plus the polarity of white and black. These concepts were demon-strated in the student exercises using a grid-based design in which colors were placed diagonally across from their opposites. The examples by Thiemann and Lang have been discussed, their underlying ideas indicated by the title *Accenting the Center; Balance, Above and Below* (Fig. 58, C. 121; Fig. 57, C. 100).

Kandinsky often used these compositional devices in his paintings. *Light Blue,* No. 443, 1929, is a clear example, in which green and red ovals appear diagonally

opposite each other, left and right.[113] Between these forms, near the center, a vertical orange bar is placed against the light blue background as a complementary contrast to provide a central point of emphasis. In addition, another focal accent is created by a grid of black lines on a white ground just above the orange bar. The balancing of the green and red forms is made particularly explicit as the compositional idea of this painting, by long connecting lines that suggest the arms of a scale whose fulcrum or point of support is the orange bar. A dynamic equilibrium is achieved by adjusting the "weights" of the colored forms, as he called them. Thus the red oval can offset by its chromatic intensity the duller and darker green oval, in spite of the latter's larger size.[114]

Returning to *Yellow-Red-Blue* (Fig. 79), one can see Kandinsky's compositional use of contrasting pairs here too. The yellow inside the rectangular area on the left balances the large blue circle on the right. Within these areas, accenting spots of the opposing color are provided: the blue rectangle that overlaps the yellow, and the pale yellow circle within the blue. These hues are also placed in other parts of the picture, and in addition other contrasts are used, such as red and green, and yellow and violet. These additional contrasts provide further accents and complicate the simple left-right, yellow-blue balance.

Of particular interest is the fact that this painting uses both possible complementary pairings of yellow. In addition to the juxtapositions just mentioned, the yellow area at the left is partially encircled by blue, and the blue circle on the right is bordered by yellow, which continues down the side of the painting. These groupings represent the yellow-blue polarity of Goethe and Hering. The entire left-hand part of the picture, however, is edged with violet, supplying the complementary of yellow in accordance with the traditional system of three primaries and three secondaries. By these means Kandinsky seems to have been attempting to recon-

cile the two theories. Indeed, this painting shows that a chromatic combination that accords with one system may violate a rule of the other system. A harmony in one is a dissonance in the other. And the result of using both possible combinations is a balancing of the two "violations" that creates an accommodation between the conflicting systems.

Contrasts, for Kandinsky, were of prime importance in painting not only for their compositional role but also for their general visual liveliness and expressive potential. Indeed, he advocated the use of contrast as a modern alternative to traditional harmony.[115] In *On the Spiritual in Art,* he had written that "clashing discords" were essential to modern art: "Our harmony is based mainly upon the principle of contrast." Traditional harmony could not satisfy his goals, because, as he asserted, "Beauty of color and form . . . is not a sufficient aim of art." On the other hand, contrast, created by the juxtaposition of at least two distinct elements, could create dynamic movement and expression, thereby forming the basis of successful compositions.[116]

Kandinsky rejected the established rules of harmony in part because of their rigidity. This attitude was due to his belief that artistic creation should instead be determined primarily by feelings, intuition and spiritual considerations, and that the actual composition should result from a series of empirical decisions as to the relations of the elements. While of course he considered theory to have a place in both the training of the artist and the process of conceiving an individual work, he warned against the application of strictly calculated "proportions and scales." As a parable, he cited a story from D. S. Merezhkovsky's romanticized book on Leonardo:

"Leonardo da Vinci devised a system or scale of little spoons for measuring out the various colors. One was supposed to be able to achieve an automatic harmony by this method. One of his pupils went to a lot of trouble to learn how to apply this method and, disheartened by his lack of

success, asked another colleague how the master managed with these measuring spoons. 'The master never uses them,' replied his colleague."[117]

In discussing traditional color usage, Kandinsky specifically mentioned "the permeation of a particular tone-color," which he also called "harmonization on the basis of single colors."[118] He further explained the procedure as creating a "bridge" between colors by mixing a small amount of one color into all the others. The result, however, is a dullness of the colors and a monotony in the work as a whole, and he rejected this kind of harmony as inappropriate to the contradictory, experimental and tumultuous nature of the modern era.[119] In his teaching notes, Kandinsky cited as examples the use of yellow as the dominant tone in Rembrandt's paintings, blue in early Picassos, and green in Trübner's works. Harmonizing by means of gray he particularly criticized as characterizing periods lacking in inner feeling, referring to Whistler as an example from the nineteenth century.[120] Furthermore, he quoted Goethe's opposition to "broken" colors. This reference suggests that he had in mind the poet's discussion of "false tone" and "weak coloring," in which he described the uniformity produced by a "veil of a single color [usually yellow] drawn over the whole picture." "Broken" colors tending toward gray may have a pleasant harmonious effect, "but without spirit," according to Goethe.[121]

While criticizing traditional harmony in *On the Spiritual in Art,* Kandinsky cited favorably the combination of red and blue as producing a strong effect, a pair that had been "long considered disharmonious."[122] Noncomplementary combinations such as these are strongly opposed, but they juxtapose colors that are "physically unrelated": that is, colors that do not have a common ingredient, as orange and green do not, for instance; nor do they have a balanced relationship, so that when mixed they would produce a neutral gray, as do complementaries. Kandinsky's valuing of starkly contrasting noncomplementaries probably relates to both Goethe and Chevreul. The red-blue pair exemplifies what Goethe called "characteristic combinations," which create strong visual and expressive effects.[123] This kind of color combination, furthermore, provides the strongest effects of simultaneous contrast, as discussed by Chevreul. Complementary colors, being already as dissimilar as possible, will intensify each other; in a noncomplementary pair, however, one color is altered toward the complement of the other, creating illusory, unstable changes in the appearance of the hues. This dynamic opposition and lack of balance provided by near-complementaries were valued by Kandinsky.

Kandinsky advocated the use in painting of the widest possible range of color interactions, many of which are due to simultaneous contrast. This variety is indicated in the last sentence of his discussion of harmony and contrast in *On the Spiritual in Art,* partially quoted above:

" 'Permitted' and 'forbidden' combinations, the clash of different colors, the overriding of one color by another, or of many colors by a single color, the emergence of one color from the depths of another, the precise delimitation of an area of color, the dissolution of simple or complex colors, the retention of the flowing color area by linear boundaries, the bubbling over of the color beyond these boundaries, the intermingling [of colors], [their] sharp division, etc. etc.—all this opens up purely painterly (= coloristic) possibilities in an infinite series stretching into the unattainable distance."[124]

The effects of simultaneous contrast cited here include the way one color can dull another or can bring out a chromatic tendency in another color. He also mentioned the relationships of color and outline and the effects of colors at their borders with neighboring colors: spreading or aureole effects, smooth transitions between similar colors and hard boundaries between highly contrasting ones.

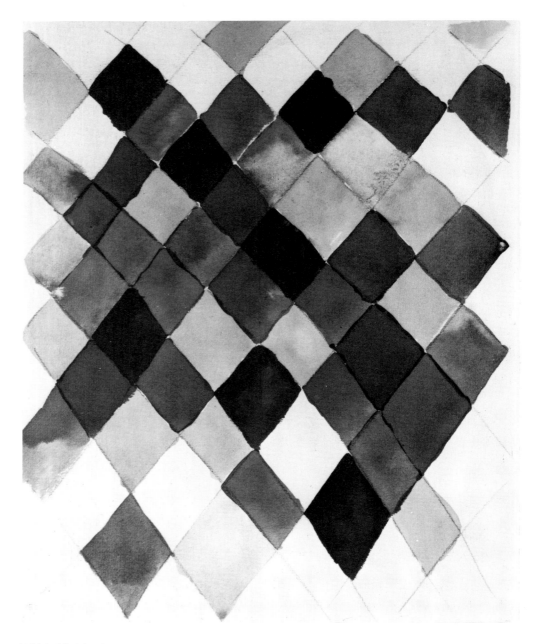

83 Wassily Kandinsky. *Color Study with Lozenges,* ca. 1913. Lenbachhaus Municipal Gallery, Munich

Within his Munich period, Kandinsky studied many of these effects in a group of watercolors unique in his work for their primarily experimental or theoretical character. The *Color Study with Lozenges,* ca. 1913 (Fig. 83), juxtaposes diamond-shaped blocks of yellow, blue, red, and green, the components of the two major chromatic antitheses as outlined in *On the Spiritual in Art*.[125] The irregular arrangements of these hues within the checkerboard-like pattern, plus the variations in intensity due to the watercolor technique, allows for various combinations and degrees of contrast. Other stud-

ies, with concentric rings of color, were intended particularly to deal with the effects at the borders of the bands (Fig. 84). As indicated by Kandinsky on a related sheet of diagrams, sequences of colors without shared ingredients produced clear demarcations, such as cinnabar, blue, white, and green. On the other hand, if colors with a common bond were juxtaposed, as in the series pink, orange, green, and blue, the effect was of loosened boundaries or even of overflowing.[126] The concentric sequences also produce complex spatial illusions that differ depending on the progression of

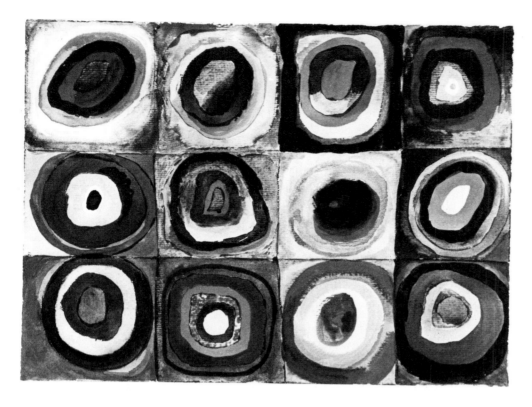

84 Wassily Kandinsky. *Color Study: Squares
with Concentric Rings,* ca. 1913.
Lenbachhaus Municipal Gallery, Munich

colors and degree of contrast. These studies, therefore, anticipate the Bauhaus student exercises using square-in-square and concentric formats, though the later works are more controlled and systematic, and accordingly less rich in their effects.

Kandinsky sustained his interest in color interactions throughout his career, and it profoundly influenced his conception of the nature of pictorial composition. The complexity of chromatic phenomena, he believed, precluded strict categorization, in contrast to Johannes Itten's view, for example, that they could be classified according to six pairs of contrasts.[127] As Kandinsky asserted in an essay written late in his career, in discussing color harmony,

" 'Absolute' means do not exist in painting; its means are relative only. . . . It is from relativity that the unlimited means and inexhaustible richness of painting arise."[128]

This attitude must certainly have influenced his Bauhaus colleague Josef Al-

bers, as it underlay both his own art and his teaching. This was conveyed in his statement, "Color is the most relative medium in art."[129]

In the effect of form on color, "relativity" played a major role, as expressed in a recurrent theme in Kandinsky's writings, the phenomenon of a spot of color losing its apparent intensity when enlarged. Having first mentioned this in 1912, he discussed the subject again in the last essay he wrote in Dessau, "Reflections on Abstract Art" (1931).[130] In the realm of color, he said, " 'mathematical' mathematics and 'pictorial' mathematics belong to completely different realms." For example, when apples are added to apples, a countable increase in their number results;

"But when to yellow one keeps adding more and more yellow, the yellow will not increase, but decrease (what we have at the beginning and what remained at the end cannot be counted)."

This situation indicated for Kandinsky the insufficiency of reason in the creative process, and he went on to criticize artists

such as the Constructivists for relying exclusively on the intellect.

Subsequently, in 1939, he elaborated on this perceptual phenomenon, citing a reason for it:

"Addition in art is enigmatic. Yellow + yellow = yellow2. Geometrical progression. Yellow + yellow + yellow + yellow + . . . = gray. The eye grows tired of too much yellow: psychological limitation. Therefore the increase becomes a decrease and arrives at zero."[131]

In this statement, therefore, he acknowledged the scientific explanation, that large surfaces of strong colors cause a "fatigue" of the retina, as he may well have learned from Helmholtz's On the Relation of Optics to Painting. The physiologist had even described the diminution in sensitivity toward the color as causing it to appear grayish.[132]

Not only can the size of an area of color affect its chromatic character, but the reverse often occurs, the color altering the apparent proportions of forms. Kandinsky saw the expansion and contraction of yellow and blue as prime examples of this. In his essay of 1931, he concluded that such phenomena show artistic elements to be "living things," exemplifying " 'pictorial' mathematics." Returning to this subject in 1939, he wrote:

". . . Colors change dimensions. A very simple example: a black square on a white ground gives the impression of being smaller than a white square on black. Optical proportions destroy mathematical proportions and replace them. The effect of a painting—unhappily or happily—is of an optical nature."[133]

For Kandinsky, this further supported his conception of the compositional process as an intuitive and empirical handling of formal and chromatic interactions.

In his paintings of the Bauhaus period, Kandinsky used a number of means to exploit the effects of color relativity. The simplest, found in many examples, is the use of white or black backgrounds, demonstrating that colors look different against them, tending to appear pale on white and chromatically intense on black, as he had characterized the effects in On the Spiritual in Art. The formal and chromatic complexity of his paintings allows for a rich play of color relationships. Moreover, the hard boundaries and simple geometrical shapes that predominate in his works after 1921 provide especially clear demonstrations of mutual chromatic effects. Certain design motifs and devices present these interactions most effectively. Scale - like series of rectangles or stripes allow the viewer to compare the effects of contrasts at the different boundaries of a color. Checkerboard arrangements can provide even more varied relationships. The frequent use of striped and checkered formats in Bauhaus student exercises, and in works by other Bauhaus masters such as Itten and Klee, was similarly for the purpose of effective presentation of color interrelationships (Fig. 86). Kandinsky's Balance—Pink, No. 583, 1933 (Fig. 85), shows these formal devices, whereby one can observe how a color appears quite different when juxtaposed to various neighbors, or when it recurs in a different size or proportion. Exercises by his students demonstrate these effects by systematically placing a given hue against varying backgrounds, as already seen (e.g., Batz Fig. 51–53, 40; C. 6–8, 11). In an example of a "free" exercise, by Lothar Lang, complex rectangular designs are repeated using different colors, with some slight alterations in the proportions of the forms, presumably in response to the nature of the colors (Fig. 88, C. 90). Comparison of the three narrow vertical designs in the upper part of the study shows that they are based on complementary contrasts (with both possible pairings for yellow), subjected to variations in intensity and lightness. The left-hand design contains the greatest light-dark contrast, with blue and yellow, black and white, while the middle one opposes red to two pale greens and white

to two grays. The right-hand design has the least intense complementary combination, with pale yellow opposed to pale violet and purple. The varying proximity of the complementaries to each other, the differences in size of the areas they are allotted, and the changing degree of intensity create markedly different effects.

Other works by Kandinsky indicate the many ways in which color relativity can be used in painting. *Layers,* for example, shows alteration in the temperature of the colors, as where the cool pinks seem warm next to the violet-blues. In *Decisive Rose,* No. 573, 1932 (Fig. 87), he deliberately represented the effect of simultaneous contrast by intensifying and slightly darkening the pale yellow background where it meets the edges of the small forms. This practice followed Helmholtz's recommendation that the artist should objectively render such subjective phenomena, in order to recreate with the relatively dull pigments available to painters the intense visual experiences afforded by the bright colors in nature.[134] Other effects in *Decisive Rose* are left to the viewer's perception, such as the different qualities of the pink when it appears in large and small rectangles, or of the light green when placed against pink or against yellow. Furthermore, a subtle brightness is elicited from a pure yellow rectangle by being situated on the slightly duller yellow background.

Among the most important effects of color in pictorial composition, for Kandinsky, were the spatial illusions it could create. As has been discussed, the basic phenomena were investigated in student exercises, like those presenting the color value scale in targetlike designs or the ones that placed yellow forms against blue and blue against yellow (e.g., Batz Fig. 45, C. 4; Thiemann Fig. 32, C. 125). In treating the use of these illusions in paintings, Kandinsky emphasized the multiple and contradictory effects that could be achieved. This aspect of his teaching has been described by Ursula Diederich Schuh, who studied painting with him in

1931. Writing about a class on the problems of color-space, she recounted:

"He has brought along a great variety of rectangles, squares, disks, and triangles in various colors, which he holds in front of us to test and to build our visual perception. In one combination, for instance, yellow is in front and blue in back. If I add this black, what happens then? Etc., etc. For the painter this is a never-tiring game, magic and even torture, when one, for instance, 'cannot get something to the front.' "[135]

In the interrelationships of shape, size, placement, and the exact hue and shade of color, therefore, the normative spatial positions do not necessarily hold. Kandinsky's interest in such complexities is further indicated by the fact that he assigned student exercises in the reversal of the "natural" spatial effects of colors.[136]

The clearest example is that by Tschaschnig, in which a deep blue diamond is superimposed on a yellow circle made up of colored vertical lines (Fig. 90, C. 137). These narrow stripes become green where they border the blue, suggesting a shadow mixing the two colors, and therefore indicating a definite spatial separation between the forms. This beautiful study is a good example of the use of a very simple image consisting of large-scale geometric shapes, characteristic of many of the student exercises. The black background promotes the effect of the luminous yellow and glowing blue forms. In conjunction with the green lines, these elements create convincing qualities of light, shadow, and space, exemplifying the aesthetic success of many of the studies.

Overlapping was used to demonstrate spatial position in other exercises as well. The relationships were presented in some with a diagram of colored lines as well as a cluster of colored shapes. In the impressive example by Batz, the linear diagram shows the standard sequence, the yellow triangle in front, the red square as

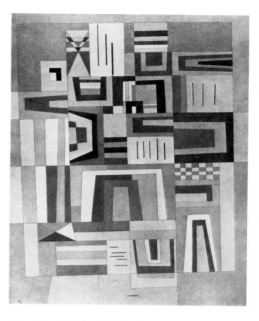

85 Wassily Kandinsky. *Balance-Pink,* No. 583, 1933. National Museum of Modern Art, Centre Georges Pompidou, Paris

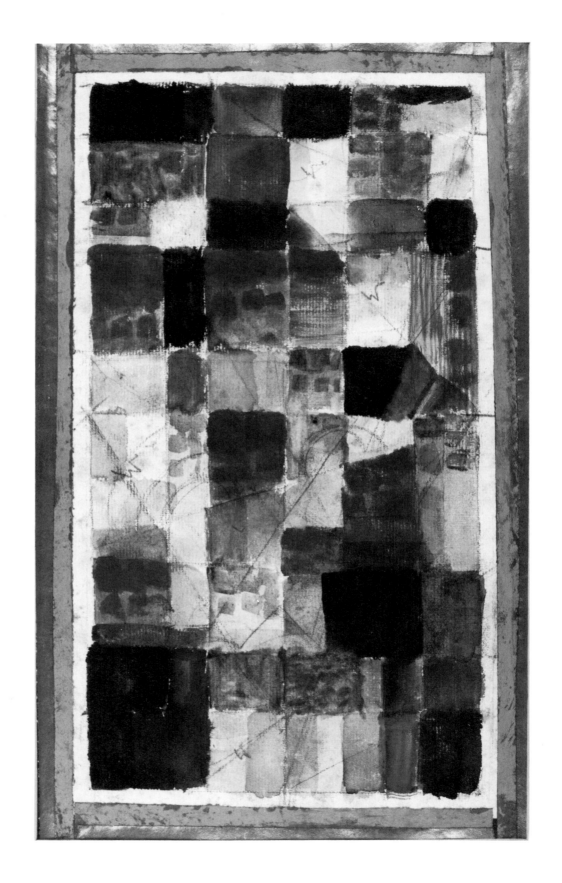

86 Attributed to Johannes Itten. *Colored Composition,* ca. 1917. Bauhaus Archive, Berlin

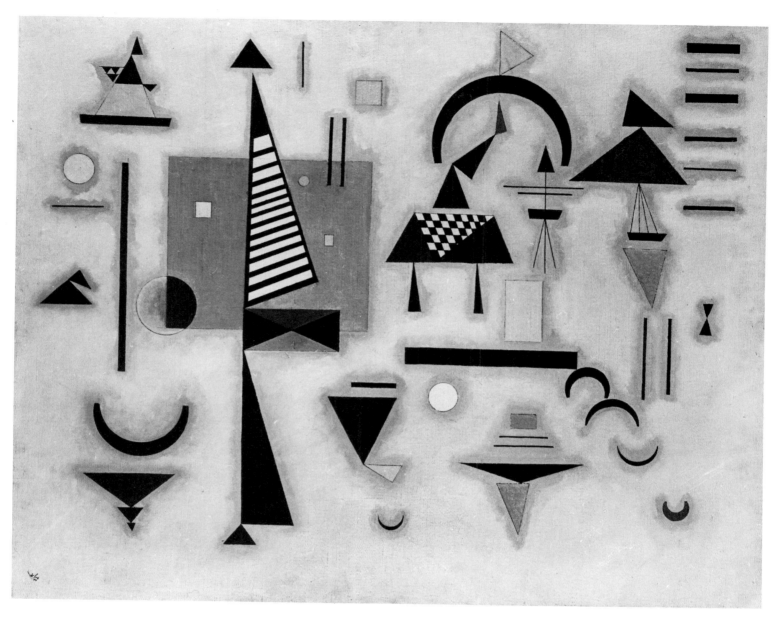

87 Wassily Kandinsky. *Decisive Rose*, No.
573, 1932. The Solomon R. Guggenheim
Museum, New York

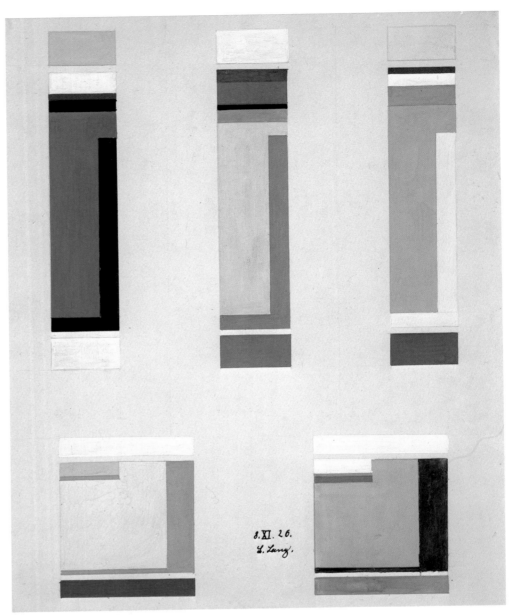

88 Lothar Lang. *Free Color Study*, 1926
(C. 90)

89 Fritz Tschaschnig. *Spatial Effect of Colors
and Forms*, 1931 (C. 137)

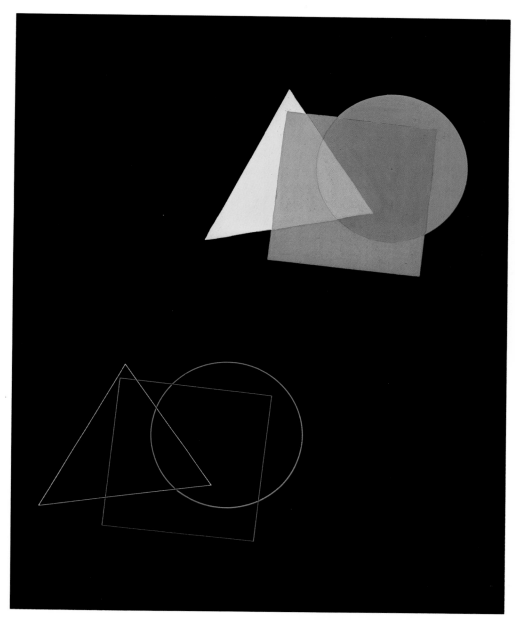

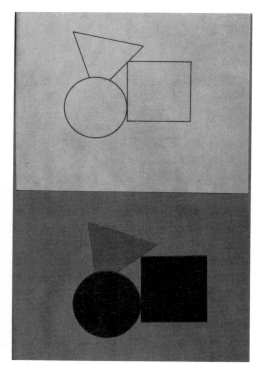

92 Bella Ullmann-Broner. *Composition of the Basic Forms, Treated in Line and Color,* 1931 (C. 156)

90 Eugen Batz. *The Spatial Effect of Colors and Forms,* 1929/30 (C.12)

91 Eugen Batz. *The Spatial Effect of Colors and Forms,* 1929/30 (C. 13)

intermediary, and the blue square behind (Fig. 90, C. 12, Tschaschnig, C. 135, and Ullmann-Broner, Fig. 92, C. 156).[137] The upper, filled-in representation is ambiguous, however, because of the interaction of factors such as the lightness of the hues, the placement of the shapes, and the overlapping of chromatic mixtures. The blue circle can be located behind the red due to its position to the upper right; but its lightness places it in front, as does the pervading blueness of the violet mixture, making it seem that the square is seen through the circle. The yellow turns an orange that is close to the red, so that it seems that the square is in front of the triangle. Thus the spatial sequence has been effectively reversed. Further complicating the situation, finally, is the green mixture created by the overlapping of the triangle and circle. This makes them appear to be in front of the square, creating a kind of ironic spatial twist. In another of Batz's studies, the relative size of the shapes is an important factor (Fig. 91, C. 13). The large blue circle may be read as the foreground form, with the small triangle and square lying behind its semitransparent plane. But the effect of interpenetration created by the striped character of the smaller forms suggests that they lie on the same level in space. Contrarily, the intensity and warmth of the yellow and red pull them forward of the somewhat pale disk. Batz successfully demonstrated, therefore, the integration of formal and chromatic characteristics in producing spatial ambiguity, for usage in pictorial compositions.

In his own paintings, Kandinsky of course used the spatial characteristics of colors, combining them with formal devices in both logical and contradictory ways. Some of these pictures utilize his color scale as the basic compositional device. In the watercolor *Into the Dark,* 1928 (Fig. 93), for example, the pigment is sprayed onto the paper, creating progressions from warm yellow and rose in the lower area through violet in the middle to the cooler green and dark blue near the top. The

placement of these colors, therefore, creates a foreground-to-background relationship. The chief forms in this work are provided by a set of triangular shapes that is repeated in rose, violet, and green, progressing into the illusionary background; but since the set of shapes isn't decreased in size, the chromatic perspective is counteracted, and the composition is flattened out. Other works, such as the color lithograph *Violet,* 1923 (Fig. 94), and the watercolor *Out of Cool Depths* (Fig. 80) employ forms that progressively diminish toward the top of the picture and thus recede in depth, but they counter such traditional perspective by their use of the color scale, moving from blue and violet at the bottom to orange and yellow at the top.

A more complicated example of these interactions between formal and chromatic effects is *Composition 8* (Fig. 75) In the lower left corner, a yellow circle seems to advance spatially due to its warmth, intensity and lightness contrasting with its black rim and surrounding blue aureole. A blue circle recedes behind a black overlapping line, almost seeming to be a hole in the pink surrounding circle. On the other hand, the yellow triangle in the upper right is forced behind an overlapping black line, while a free blue circle, immediately to its right, seems to float forward. In a complex grouping in the upper left corner, consisting of several circles, the central violet disk appears in front of its surrounding black circle, due to color as well as superimposition. However, the warm red circle overlapped by the black must be read behind, causing a tension, since its intensity and temperature tend to bring it forward.

Kandinsky valued such interactions of color and form both for their visual interest and richness and for their expressive potential. The combination of these effects was part of his goal of synthesis in art. As he had written in *On the Spiritual in Art,* "Color . . . will give rise, in combination with drawing, to that great pictorial counterpoint, by means of which

painting also will attain the level of composition. . . ."[138] The spatial illusions created jointly by abstract form and color are often elusive and shifting, imparting a dynamic quality to paintings, in contrast to the more definite and static sense of three-dimensionality given by traditional linear perspective and light-to-dark modelling. Moreover, these spatial effects help overcome the kind of ornamental flatness that Kandinsky considered a danger in abstract painting because he felt it resulted in superficiality. Illusions of three-dimensionality transform the actual surface plane of the painting, creating "an ideal plane"; and color effects in particular, due to their elusiveness and immeasurability, can suggest a transcendence of the material world: ". . . Color . . . can turn the picture into a being hovering in mid-air. . . ." The integration of formal and chromatic phenomena gives to paintings, therefore, a high degree of complexity. Kandinsky expressed this in the statement: "The unification of these two kinds of extension in harmonious or disharmonious combinations is one of the richest and most powerful elements of linear-pictorial composition."

The spatial illusions created by the abstract elements and their transcendence of the literal and material are themes to which he returned in his later writings. In *Point and Line to Plane,* he wrote about the pictorial elements and their possible relationship to the "ground plane":

"They are so loosely associated with the GP that it . . . disappears, so to speak, and the elements 'hover' in space, although it has no precise limits (especially as regards depth)."[139]

Subsequently, he again described the elusive quality of this kind of pictorial space, in an article of 1935: "The 'action' in the picture must not take place on the canvas surface, but 'somewhere' in 'illusory' space."[140]

Finally, Kandinsky's conception of the nature of creative activity was deeply influenced by his understanding of the com-

plexity of chromatic and formal interactions, epitomized by his notion of "relativity." He considered the compositional process to be an intricate procedure of adjusting the interrelationships between the pictorial elements and thus coordinating all the phenomena and principles of color. As he had written in *On the Spiritual in Art,* this activity could be a delicate one:

". . . The conditions always differ. . . . Nothing is absolute. And formal composition, which is based upon this relativity, is dependent (1) upon the variability of the combinations of forms, and (2) upon the variability, down to the tiniest detail, of every individual form. Every form is as fragile as a puff of smoke: the tiniest, barely perceptible alteration of any of its parts changes it *essentially*."[141]

His analyses of his own paintings, written around 1913, indicate that an important part of the process lay in balancing the contrasting colors and forms, particularly in relation to two or three focal centers. He thought of the various formal elements, and especially colors, as having different inner weights, which needed to be balanced, an idea he restated in *Point and Line to Plane*.[142] In the lecture to the Cologne Art Society, he discussed his way of composing a painting, with regard to the inner qualities of the colors:

"I distributed my weights so that they revealed no architectonic center. Often, heavy was at the top and light at the bottom. Sometimes, I left the middle weak and strengthened the corners. I would put a crushing weight between parts that weighed little. I would let cold come forward and drive warm into the background. I would treat the individual color-tones likewise, cooling the warmer tones, warming the cold, so that even one single color was raised to the level of a composition."[143]

As already discussed here, the manipulation of the spatial illusions in contradic-

93 Wassily Kandinsky. *Into the Dark,* watercolor, 1928. The Hilla von Rebay Foundation. Solomon R. Guggenheim Museum, New York

103

tory ways and the modulation of chromatic qualities such as temperature were problems that Kandinsky assigned as student exercises, and which he explored in many of his Bauhaus period paintings.

In his conception of the compositional process as a delicate and complex procedure, Kandinsky must have been influenced by the French painter Henri Matisse, who had written eloquently of composition as consisting of relational adjustments. Matisse had stated his ideas on this subject in his essay of 1908, "Notes of a Painter," which was published in German the following year. Kandinsky referred to this publication in *On the Spiritual in Art,* where he praised the French artist's work, particularly with regard to his use of color.[144] Another avenue of influence would have been Kandinsky's friend and fellow Russian Alexei Jawlensky, who had worked with Matisse and had been influenced by his paintings.

In "Notes of a Painter," Matisse described the process of making a picture, starting with the color red: "A relationship is established between this red and the white of the canvas."[145] As soon as he adds other colors, additional relationships are created:

"But these several tones mutually weaken one another. It is necessary that the various elements that I use be so balanced that they do not destroy one another. To do this I must organize my ideas; the relation between tones must be so established that they will sustain one another. A new combination of colors will succeed the first one and will give more completely my interpretation."

In order to achieve, finally, the relationship he desires, he must go through a series of "successive modifications" of the forms and colors. This process is one of progressive alterations and transformations of the elements and their relationships.

Kandinsky shared a sense of this kind

of compositional procedure. A statement in an essay of 1935 is particularly close to Matisse's conception: "To submit means to show respect. Every new spot of color that appears during work on the canvas submits itself to the previous spots. . . ."[146] This recalls, in positive form, the sentence in "Notes of a Painter":

"If upon a white canvas I jot down some sensations of blue, of green, of red—every new brushstroke diminishes the importance of the preceding ones."[147]

The role of color in pictorial composition, therefore, was conceived by Kandinsky to involve ultimately all the chromatic characteristics, effects, and interrelationships. These included the basic phenomena and principles he taught in his Bauhaus classes, as well as the complex interactions and the aspects of the creative process that he considered in his published theoretical writings and embodied in his own paintings. As discussed here, the important pictorial effects were the illusions of space, subtle alterations of the apparent hue, intensity, temperature and size of colors, and affinities between colors and forms. Furthermore, compositional organization could involve the use of chromatic scales, the modulation of colors, the juxtaposition of contrasts to form focal centers and the balance of contrasts across the surface of a painting.

In Kandinsky's view, the painter needs to understand these fundamental artistic resources both theoretically and from practical experience. In addition to these intellectual and empirical ways of apprehending the pictorial means, however, a higher level of individual insight and feeling comes into play in the coordination of the compositional procedures and effects. Therefore, the painter's responses to the relativity of those "living things," colors and forms, involves especially his intuition, ultimately the most important creative faculty. By this overall process—synthesizing theory, practice, intuition, and feeling—the artist could make color a

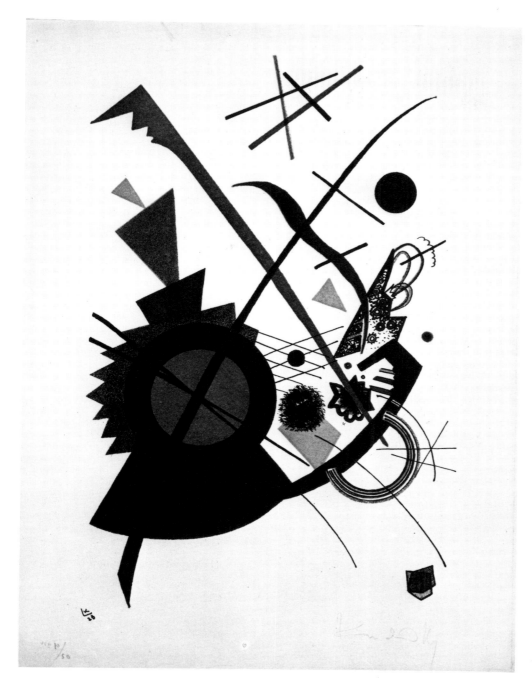

94 Wassily Kandinsky. *Violet,* color
lithograph, 1923. Norton Simon Museum of
Art, Pasadena, California. The Blue Four
Galka Scheyer Collection

rich and subtle element in abstract paint-
ing, as can be seen in Kandinsky's own
works.

Analytical Drawing

As an adjunct to his class on Abstract Form Elements, Kandinsky taught Analytical Drawing, all as part of the program of basic instruction for first-semester students. While the first of these consisted of lectures on his theories of form and color, in addition to the student exercises and class discussion, the drawing instruction was evidently simply a studio course, constituted by student work and the comments of Kandinsky and the class. Accordingly, no lecture notes exist for these sessions, though there do survive outlines of the principles and methods, occasional references to the class in his notes, a few brief descriptions by former students, and a substantial group of exercises.[1]

The class work was, therefore, primarily an empirical investigation of visual principles, but it had significant connections with Kandinsky's formal theories and applications in his teaching of pictorial composition. Although in the whole range of his artistic theory, analytical drawing would seem a limited subject, it is significant in that it shows the influence of a wide range of artistic and theoretical sources. Furthermore, the student exercises offer a fascinating view of diversity of individual approach, even in some cases in the treatment of the same motif, as well as demonstrating an analytical design process in a clear, step-by-step manner. Kandinsky's conception of analytical drawing, indeed, is paradigmatic of his art pedagogy. It entailed training the student to see, think logically, and execute the work with care. It combined both analytical and synthetic processes, calculation and intuition, especially in the advanced stages. Finally, the skills and principles involved could be utilized in painting and the other arts and presumably in practical design as well. This aspect of his teaching, therefore, exemplifies many of the general concepts and features of his approach to art instruction that have been discussed here in Section I.

Analytical drawing as taught by Kandinsky was an investigation of the structural relationships among objects, following a series of stages that, briefly stated, involved progressively the simplification, analysis, and transformation of the graphic characteristics presented by the motif. Appropriate to the primary nature of the program of basic instruction and true to Kandinsky's own conception of art education, this was an ideal approach to drawing, rather than a practically or technically oriented one. It would not provide the beginning student with a specific skill to apply subsequently in one of the workshops, as might be claimed for mechanical or projective drawing. These technical procedures were included as adjunct areas in the preliminary program.[2] Kandinsky succinctly explained the pur-

95 Charlotte Voepel-Neujahr. *Analytical Drawing with Schemata*, ca. 1927/28 (C. 193)

96 Charlotte Voepel-Neujahr. *Color Composition after an Analytical Drawing*, ca. 1927/28 (C. 188)

97 Charlotte Voepel-Neujahr. *Color Composition after an Analytical Drawing,* 1927/28 (C. 198)

Adopting some of Kandinsky's Theory.

98 Bella Ullmann-Broner. *Representation—Geometric Network With Centerpoint—Depiction of Main Tension,* 1929/30 (C. 163)

pose of his course in his brief article "Analytical Drawing," published in the Bauhaus journal in 1928:

"The teaching of drawing at the Bauhaus is an education in looking, precise observation, and the precise representation not of the external appearance of an object, but of constructive elements, the laws that govern the forces (= tensions) that can be discovered in given objects, and of their logical construction."[3]

Some of its general principles he had expressed a bit more specifically in introducing the course to the students in September 1926. The training, he asserted, would develop their ability to perceive the abstract, the essential form, undistracted by secondary aspects or insignificant features. This would lead to an understanding of certain basic structural laws: principles of equilibrium, parallel construction, and major contrasts. He cited the example, on another occasion, of an equilibrium of vertical and diagonal accents, with the diagonal slightly predominant—presumably a way of achieving a balance that was not static.[4] The other principles, of parallelism and contrast, are referred to in Max Bill's description of the products of the course as

"studies in which only the horizontal or only the vertical or diagonal elements were represented, variously emphasized according to their importance. Or else the round and the angular forms were contrasted to each other."[5]

By the evidence of the surviving examples, his use of the word *only* seems to be an exaggeration, but the main directions were often strongly emphasized through the repetition, length, and weight of the lines.

The actual subjects of this analytical enterprise were rather restricted, consisting of still lifes set up by the students. These were quite different from traditional still lifes, in part because they were not intended as subject matter that would be expressive of an ambiance or lifestyle. As a rule these didn't employ small-scale objects such as the fruit and utensils so often seen in earlier compositions; and they were quite unlike the Cubists' arrangements of objects that evoke an intimate world of Bohemian leisure moments—the musical instruments, newspapers, and aperitif bottles of their studios and cafés. Instead, the materials were mostly gathered from around the school and its workshops. Chosen for their large, simple shapes, they were ar-

ranged to create clear axial and geometric relationships. Thus, when they are recognizable, in the earlier stages of the analytical process, the objects do refer to the environment and suggest the spirit of the Bauhaus, in spite of the fact that such was not the intention behind their selection.

Simple furniture was often used—tables, chairs, stools—and hanging or draped curtains or cloth. Another category was building materials and related tools: lumber, molding, a sawhorse, stepladder, and saw.[6] Essentially abstract elements were also included: cylindrical tubes and canisters, hoops, simple wheels or disks, spheres, rectangular boxes or bases, and plain picture frames and stretchers. Two special objects appear in the student works: a bicycle supported at the rear end by a stool, in Bella Ullmann-Broner's study (Fig. 99, C. 162); and a grinding wheel in its stand, seen in the drawing by Erich Fritzsche illustrated in Kandinsky's article, as well as in several other studies (Fig. 108).[7] Typically the objects were compactly grouped, often on a table, platform, or base, and sometimes tilted, frequently forming overall rectangular or triangular silhouettes. Against the strict geometry of most of the forms, the draped pieces of cloth provided irregular curves as a counterpoint. A good example of such setups is provided by the composition recorded in a photograph, on which Hannes Beckmann based a series of four drawings in 1929 (Fig. 100, 101).[8] Here a chair, table, and stepladder serve as background and supports for a grid-patterned tablecloth, a wastepaper basket, and a breadbasket. This nonfunctional arrangement positions the objects sideways or frontally, so as to provide the clearest possible view of what could otherwise be a confusing set of relationships. The organization renders this complexity susceptible to resolution in a two-dimensional, linear design, ultimately abstract in character.

The importance that Kandinsky assigned to still life as a pedagogical tool dates back to his first teaching experience, at

99 Bella Ullmann-Broner. *Analytical Drawing,* 1929/30 (C. 162)

100 Photograph of a typical still-life construction, 1929

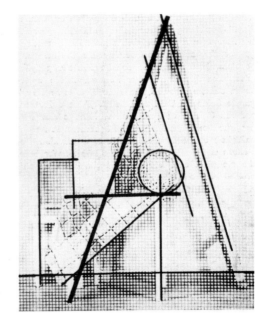

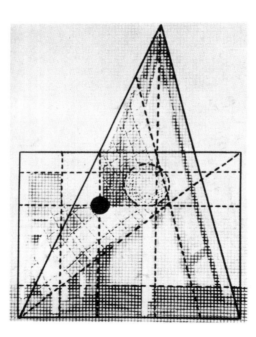
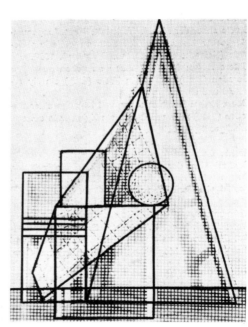

101 Hannes Beckmann. *The Different Stages of Analysis*, 1929

the Phalanx school, which he established in the winter of 1901–2. There he instituted a special class in still life, which evidently was an innovation for that time.[9] Much later, as already mentioned, he recommended still lifes as models for his Bauhaus painting class, to be used as a point of departure and interpreted freely in developing a composition.[10] He conceived of still life as an artistic medium with an important transitional role in the evolution of abstraction, as he made clear in his essay "Reflections on Abstract Art" (1931). He saw a development from imagery of the human figure, to landscape, to still life, in which the progression was toward increasing "silence." The painter, he declared, "needed discreet, silent, almost insignificant objects." The reason was that the outwardly silent forms were felt to be internally resonant with expression. Abstract, geometric forms possessed this quality in full.[11] The Bauhaus analytical drawings, therefore, provide the transitional link between still life and the abstract, through the medium of geometry.

Cubism represented for Kandinsky a key historical intermediary. This he suggested as early as *On the Spiritual in Art*: "Cubism, for example, as a transitional form reveals how often natural forms must be forcibly subordinated to constructive ends. . . ."[12] He made the point more specifically in his Bauhaus teaching in 1931, citing the still lifes of Gleizes, Metzinger, and Braque as utilizing the principles of supporting and accenting lines in their composition. The ultimate importance of such examples was that they pointed toward an abstract, expressive kind of construction, in conformity with the laws of nature. In particular, he mentioned the vertical as a vegetal principle, presumably referring to the upward movement of growing plants.[13]

The question of the "relationships between the laws of art and of nature" was a complex one, concerning which he apparently changed his opinion. In *Point and Line to Plane* (1926), he wrote that the relationship of art and nature lay in the most basic laws, but he also asserted that the laws of these "two great realms" were separate and independent. Instead, it was from the contrast of the two sets of laws that the artist could learn.[14] Nevertheless, he went on to discuss examples from nature of complexes of lines, both in geometric constructions and in loose structures of "free" lines, that paralleled his own account of abstract linear groupings.[15] These would lend substance to his suggestion that for the artist it was important

"to see how the independent realm of nature uses the basic elements: which elements are given consideration, what qualities they possess, and how they are formed into combinations."[16]

By 1931 Kandinsky had resolved this apparent equivocation, writing that the connection between abstract art and nature is "greater and more intimate than in recent times." This was due to the development of a new sensitivity, allowing one "to touch under the *skin* of *nature* its essence."[17] The analytical drawings contributed to the formation of this "new faculty," training the student to see both the evident and the hidden relationships among forms, relationships parallel to underlying natural principles.

As outlined in Kandinsky's 1928 article, analytical drawing was a process in three stages, each of which had three subsidiary aspects or tasks. The first stage required the students:

"1. to subordinate the whole complex to one simple overall form, which . . . must be precisely drawn in.
2. to realize the formal characterization of individual parts of the still life, regarded both in isolation and in relation to the other parts.
3. to represent the whole construction by means of the most concise possible schema."[18]

The drawing that illustrated this first stage, by Robert Eduard Kukowka, shows a

102 Robert Eduard Kukowka. *Analytical Drawing of the First Stage with Schema*, 1926

103

104

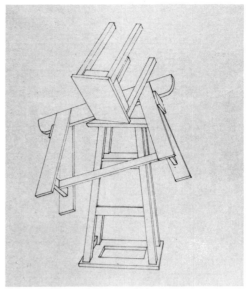

105

103–104 Lothar Lang. *Analytical Drawing of the First Stage,* 1926/27 (C. 102, 104)

105 Hans Thiemann. *Still-Life Drawing,* 1930 (C. 133)

grouping of rectangular C-clamps or braces along with some rods—simple, repetitive forms depicted as flat outline drawings, with no shading (Fig. 102). As emphasized in the accompanying schema, the elements are primarily vertical in their orientation, with horizontals and verticals as subsidiary directions. In his teaching, Kandinsky described such small graphic diagrams as consisting of a few lines representing the axes of the forms and demonstrating the relations between the horizontals, the verticals, and the diagonals.[19] These schemata are seen in a great many of the surviving student exercises.

A particularly fine group of first-stage drawings is made up of six of Lothar Lang's studies from the end of 1926 (Fig. 103, 104; C. 102, 104). Precisely drawn with ink lines of nearly uniform thickness, the objects are two-dimensionalized even in their arrangement, grouped for the most part along a shallow ledge of space parallel to the picture plane. The choice and rendering of the items is informed by a sense of simple geometry, and the alignments are in accord with the three main axes stressed by Kandinsky. An instructive comparison is offered in a drawing by Hans Thiemann representing a small upside-down table and a sawhorse, resting askew on a tall open stand (Fig. 105, C.

133). The setup is obviously for the purpose of studying the forms, but the result is not as ripe for subsequent structural, formal analysis. The relative completeness of the objects, including subsidiary details, and the sense of a fully three-dimensional space, work against the clarity of the overall shape, the "large form," and the relationship of individual elements achieved in Lang's studies. One of the latter's drawings (Fig. 106, C. 108) exemplifies what Kandinsky termed the "gradual transition to the second level." The forms—triangle, disk or sphere, and tall standing cylinder—are more severely simplified, as comparison with Figure 107 shows, and the schema is even more concise and abstract.

The second stage was designated "development of the structural network," in the course outline published in the catalogue of the congress of art teachers in Prague (1928).[20] Kandinsky's article listed its tasks:

"1. making clear the tensions discovered in the structure, which are to be represented by means of linear forms.
2. emphasizing the principle tensions by means of broader lines or, subsequently, colors.
3. indicating the structural network by means of starting or focal points (dotted

lines)."[21]

This phase is the heart of the analytical approach, and many of the surviving student works exemplify it, most clearly the majority of those by Eugen Batz, Friedly Kessinger-Petitpierre, Thiemann, Ullmann-Broner, and Charlotte Voepel-Neujahr. The objects remain at least vaguely recognizable, although not as obviously as in the first stage. The example by Erich Fritzsche that illustrates the article combines a saw, a grinding stone, and a bucket, as specified in the text, their forms rendered almost entirely by diagonals (Fig. 108). Solid lines are used for actual contours of the utensils, while dotted lines indicate the implicit visual connections between key points in the representation, tied together at the lower left in the "point of departure for the structural [network]."[22] The schema shows those contours that form the main axes of the composition, which are given broader lines in the drawing.

It is interesting that another drawing by Voepel-Neujahr, apparently of the same setup, has survived, showing a different way in which the same composition could be analyzed (Fig. 109, C. 186). In general this study presents the objects less recognizably, and integrated more into an overall silhouette of tension-lines, solid and broken. In most of this student's drawings distinctions between the kinds of lines are reinforced by a color differentiation, black pencil lines versus broken blue ones. In a variant based on the analysis of the grinding-wheel still life, the areas are translated into colors—yellow, red, blue, and brown, as well as gray and black (Fig. 110, C. 187). This not only clarifies the separate parts but also creates a color composition suggestive of a general progression: from a solid base—black, browns, and gray—to the vibrant center—blue versus red—to the light, yellow top. A vigorous spiral interprets the shape of the bucket, as seen also in the drawing, and along with the increased abstractness of the color study, this dynamic accent suggests a transition to the

106 Lothar Lang. *Analytical Drawing of the First Stage with Schema,* 1926/27 (C. 108)

107 Lothar Lang. *Analytical Drawing of the First Stage with Schema,* 1926/27 (C. 106)

115

108 Erich Fritzsche. *Analytical Drawing of the Second Stage*, 1927/28

109 Charlotte Voepel-Neujahr. *Analytical Drawing of the Second Stage with Schema*, 1927/28 (C. 186)

110 (right) Charlotte Voepel-Neujahr. *Analytical Drawing with Tensions Translated into Zones of Color*, 1927/28 (C. 187)

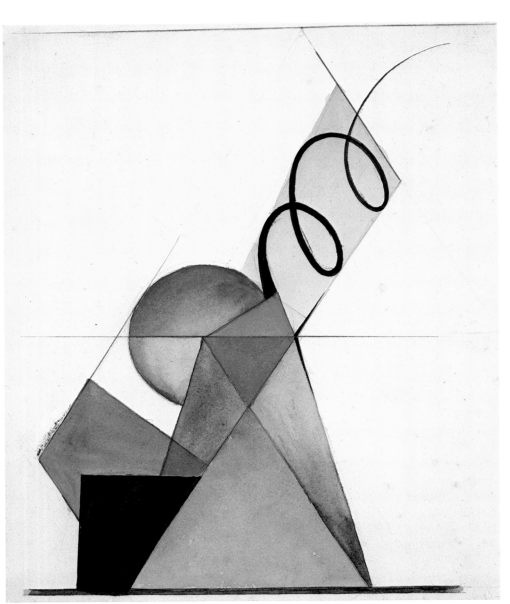

111 Hans Thiemann. *Principal Tension (the Green Triangle) Overlaid with a Network of Secondary Tensions,* 1930 (C..132)

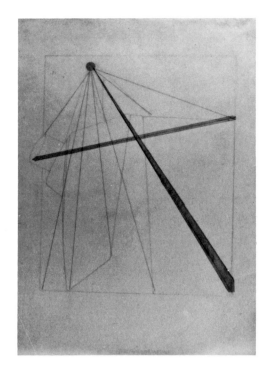

112 Bella Ullmann-Broner. *Representation—Geometric Network—Tension Diagram,* 1929/30 (C. 168)

third stage of analytical drawing. The boundaries between the phases are by no means always clear-cut.

By the winter semester of 1929/30 the use of tracing-paper overlays was introduced, so as to register all of the stages of the analytical process in the same work and yet keep them distinct. The base sheet of opaque paper carried the simplified representation of the still life; and the one or two superimposed transparent sheets bore the linear analysis of the tensions and their relationships, that is, the essential visual structure of the objects as Kandinsky conceived it. Studies of this sort are well represented in the groups of analytical drawings by Kessinger-Petitpierre and Ullmann-Broner. A good second-stage example by Thiemann is captioned *Principal Tension (the Green Triangle), Overlaid with Network of Secondary Tensions* (Fig. 111, C. 132). The base sheet has a diagrammatic representation, which includes a three-legged stool resting on its side on a table or base. The still life is done in blue ink, circumscribed by the green ink line of the triangle, and the overlay has an elaborate set of crisscrossing red ink lines, projecting from and interconnecting parts of the still

life, to show the secondary tensions. The device of the layered analytical drawing in conjunction with different colored inks is indeed well suited for distinguishing the aspects of the analysis, as the labels on many of the studies suggest—for instance, Ullmann-Broner's three-layered work *Representation, Network, Tension Diagram* (Fig. 112, C. 168).

The "representation" here is rendered in black ink. The "network" is a sequence of blue ink lines radiating from a large black dot at the top, the culminating peak of the still life, to various points of intersection or corners of the composition. This pattern is very different from the "network" in another drawing of the same still life setup (Fig. 98, C. 163), which has crisscrossing lines forming a series of triangles. Variations such as this show the thoroughness of the analytical approach fostered by the course. In the present exercise, the "tension diagram" consists of a dramatic crossing of two yellow diagonal lines, the longer of which tapers as it rises from the lower right to the upper left, narrowing to a point where it meets the black dot below. The yellow lines are rendered in transparent ink, thus allowing the dark blue lines of the "network" to

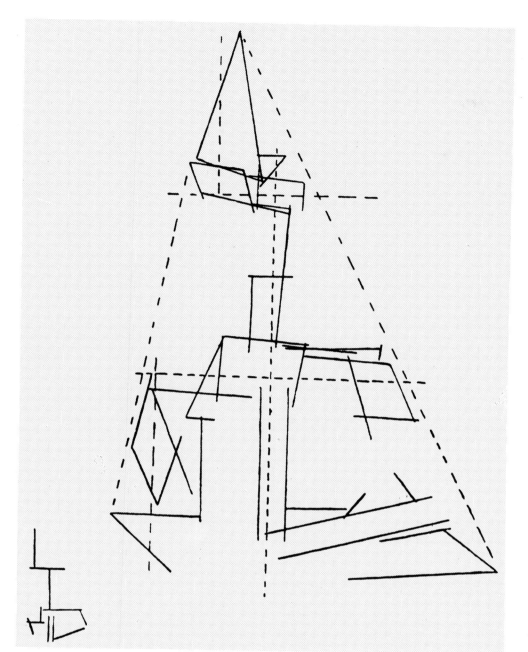

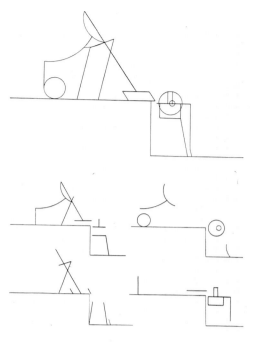

114 Kandinsky instruction. Above, overall
schema; below, construction variations, 1928

113 (left) Fritz Fiszmer. *Analytical Drawing of
the Third Stage with Schema,* 1928

show through, another example of the desire to maintain clarity in the analysis. The transparency of paper and ink, therefore, along with the variation in color, promotes both the differentiation and the simultaneous comprehension of the phases of the process.

The third stage advances the aspects of the second toward more radical, freer abstract solutions. It was termed "translation" in the Prague outline and in Kandinsky's article characterized as:

"1. Objects are regarded exclusively in terms of tensions between forces, and the construction limits itself to complexes of lines.
2. Variety of structural possibilities: clear and concealed construction. . . .
3. Exercises in the utmost simplification of the overall complex and of the individual tensions—concise, exact expression."[23]

The illustrated example by Fritz Fiszmer is a particularly complicated composition of fragmentary triangular planes and parallelograms, the main axes or "larger structure" indicated by dotted lines (Fig. 113). The still-life elements are unrecognizable, appropriately described in the caption as "objects completely transformed into tensions between forces."[24]

The freedom of approach implicit in this stage of the analytical process is demonstrated by another illustration, in which a second-stage drawing, at the top, is interpreted in four different ways. Each of these "constructional variants" focuses on selected parts of the "overall theme," such as the curved, or diagonal, or rectilinear elements.[25]

The top sheets of the three-layered analytical drawings often display the extreme simplicity, selectivity, and expression of energy characteristic of the third stage, as well as revealing an aspect of the hidden construction of the motif. The swooping red S-curve with angled, spiked ends in Ullmann-Broner's analysis of the bicycle-and-stool composition is a good example (Fig. 99, C. 162). It renders the "tensions between forces" and the overall structure of circular and radial elements with great conciseness. In other works this student expressed the movement inherent in the initial representation by means of bold tapering lines—curves and diagonals that intersect, creating their own focal points (Fig. 115, C. 165 and 163). These are like the small schemata of the first- and second-stage drawings but larger in scale and more dramatic.

Kessinger-Petitpierre did some "free

115 Bella Ullmann-Broner. *Analytical Drawing,* 1929/30 (C. 165)

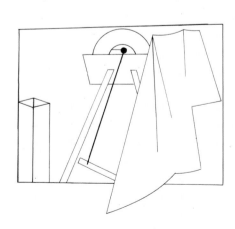

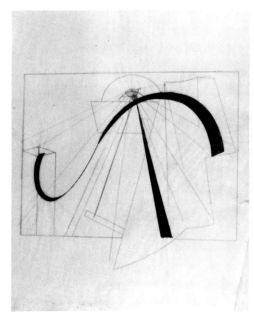

116

118

117

119

116 Friedly Kessinger-Petitpierre. *Theme 1;
Main Tension and Geometric Network;
Triangular Division,* 1929/30 (C. 48)

117 Friedly Kessinger-Petitpierre. *Free
Variation on Theme 1,* 1929/30 (C. 49)

118 Friedly Kessinger-Petitpierre. *Theme 2;
Main Tension—Secondary Tension,* 1929/30
(C. 50)

119 Friedly Kessinger-Petitpierre. *Variation
on Theme 2: Inner Tensions,* 1929/30 (C. 51)

variations" based on analytical drawings, which are more complex than the diagrams by Ullmann just considered. In two of these the triangular relationships between still-life objects are translated into completely abstract images (Fig. 117, 119; C. 49, 51). In the initial study for the first, the still life was analyzed as a series of outlined triangles, with one of the angles drawn with thicker lines, providing the form of the schema (Fig. 116, C. 48). *Free Variation on Theme 1* takes this cipher as its dominant form (Fig. 117, C. 49). Utilizing the outlines in the original network drawing, Kessinger-Petitpierre

built up a set of triangles with differently spaced vertical lines, creating a series of transparent planes that have a fugal, musical quality. The second variation, captioned *Inner Tensions,* has a more energetic quality (Fig. 119, C. 51, cf. Fig. 118, C. 50). It consists of an elaborate constellation of crisscrossing diagonals that connect the key points in the initial drawing, and as such it is like a second-stage constructive net raised to the level of an independent composition. Compared to the study just discussed, this one is further from the network diagram on which it is based, and it transforms the rather flat

120 (left) Friedly Kessinger-Petitpierre. *Theme 6: Main Tension—Secondary Tension— Point Distribution,* 1929/30 (C. 57)

121 (right) Friedly Kessinger-Petitpierre. *Continuation of Theme 6: Point Distribution Copy—Sum of Lines,* 1929/30 (C. 58)

122 Friedly Kessinger-Petitpierre. *Free Variation on Theme 6: Free Depiction of Planes—Free Curves,* 1929/30 (C. 59)

analytical still-life drawing into a more spatial image.

The most extensive and fully worked out of the variations are those that Kessinger-Petitpierre derived from her analytical drawing of a setup containing two stools on bases, flanking a long curving curtain (Fig. 120, C. 57). On the top overlay of this drawing, labelled *Point Distribution,* the intersections of the primary and secondary tensions on the two under-sheets are marked by a set of points. The first variation, entitled *Continuation of Theme 6,* transposes this set of points (*Point Distribution, Copy,*) rendering it as a clearer pattern of small, uniform black circles; then it is resolved into a coherent abstract figure by a continuous series of connecting lines, the *Sum of Lines* (Fig. 121, C. 58).

Finally, a three-layer work, *Free Variation on Theme 6,* presents an elaborate arrangement of circles, triangles, and linear groupings whose positions and contours were suggested by the elements in the foregoing studies (Fig. 122, C. 59). Needless to say, all traces of the initial still life have long disappeared, but the basic axes and their terminal points, as registered in the original analytical drawing, are evident in the multicolored abstract composition that is the underlying sheet

of the *Free Variation*. Like other works by Kessinger-Petitpierre, most notably the drawings in the portfolio *The Square,* this picture is very close to the style of Kandinsky's paintings from his Bauhaus years. His influence is seen in the small-scale geometrical shapes drawn toward the center as if in a magnetic field of force, the sets of parallel or radiating lines, and the floating quality of the placement of the forms, with its attendant spatial ambiguities. The first overlay, the *Free Structure of Planes,* is a constellation of intersecting planes that also seems to hover in midair and is closely derived from the *Continuation* study (Fig. 121). The top layer, labelled *Free Curves,* joins all the positions of the *Point Distribution, Copy* with a set of animated, almost biomorphic, irregular curved lines, ultimately related to the freely undulating curves discussed by Kandinsky.[26] The resulting pattern oddly recalls the *Sum of Lines* of the *Continuation* study: both images possess an almost comic quality, though inflected differently by the separate curves and the abruptly angular continuous line.

This fascinating sequence shows the extension of third-stage principles to the creation of pictorial compositions. Furthermore, it reflects important aspects of Kandinsky's ideas concerning the role of visual structures in paintings. In perceiving the set of linear relationships in the motif and determining the points of their intersections, the student revealed a structure. Then she used that geometrical order to suggest a composition that in turn, however, veiled the structure. Kandinsky

had recommended the "hidden construction," in *On the Spiritual in Art,* as offering the richest or most expressive possibilities.[27] Subsequently in *Point and Line to Plane* he effectively showed how a regular pattern of points could be utterly transformed into an "independent linear structure," thereby concealing its original geometrical organization.[28] Kessinger-Petitpierre obviously derived her design from Kandinsky's diagram or similar ones demonstrated in class.

A number of other studies by Kandinsky's students have the appearance of free compositions but are ultimately based on analytical drawings. Two by Voepel-Neujahr derive from a rather abstract drawing, translating in different ways its basically triangular silhouette and prominent wavelike curve (Fig. 95–97, C. 193, 188, 198). The lines indicating tensions and structural relationships in the original are selectively followed in both variations to create the basic forms and areas for color. The less elaborate version, although it is the more forceful of the two, retains the character of a free-standing nonrepresentational figure, as in the original analytical drawing (Fig. 96, C. 188, cf. Fig. 95, C. 193). The other variation, however, goes further, developing the broken lines that indicate the inherent structure, as well as the solid tension-lines of the drawing (Fig. 97, C. 198). The composition has, thereby, become more two-dimensional, albeit ambiguously so, with the primary figure more integrated with the surrounding areas. Thus achieving a more fully abstract and pictorial image, this

study is another example of the use of the principles of analytical drawing in free compositional studies.

In these studies the viewer can nevertheless still imagine elements of the kind of still life assembled in Kandinsky's classes, but in other student works even those suggestions are eliminated. Ullmann-Broner's *Colored Treatment of a Network* was produced by filling in the network from one of her analytical drawings with flat areas of color (Fig. 98, C. 163, first overlay, and Fig. 124, C. 174). The resulting composition, primarily of triangles, is an extremely flat image that fills the rectangular field, in no way suggesting the solid objects that made up the original still life. Instead, it exploits the diagonal in the initial "representation," which was emphasized in the drawing of the "principle tension," and renders the set of abstract relationships diagrammed in the "network."

In a number of other cases, the absence of the initial analytical drawing makes it impossible to tell whether a study is a variation or a truly independent work. Fritz Tschaschnig's dynamic gouache drawings on black paper, for instance, may be completely abstract compositions to which the analytical procedure was applied in the tension diagrams on the transparent overlays (Fig. 125, C. 139).[29] Like the paintings done for Kandinsky's free painting course, these studies show the range and vitality of images, whether geometricized representations or pure abstractions, that could be ultimately derived from the analytical drawing approach.[30]

The background to this approach lies in Kandinsky's early methods of pictorial composition and in his theoretical sources. Generally speaking, the analytical drawings are geometrical simplifications and abstractions from the motif, and as such they have their roots in both certain nineteenth-century academic drawing techniques and in some of the innovations of the early modern movement. But

126 Wassily Kandinsky. Compositional diagram for *Painting with White Border*, 1913. Lenbachhaus Municipal Gallery, Munich

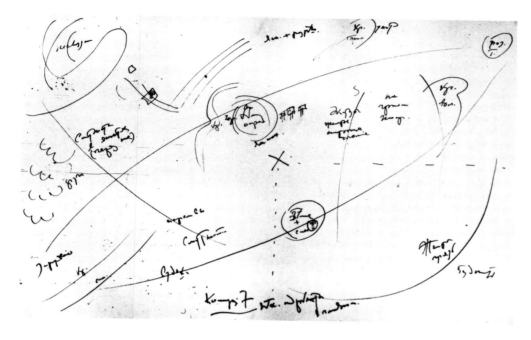

129 Wassily Kandinsky. *Main Lines of Composition 6,* 1913. National Museum of Modern Art, Centre Georges Pompidou, Paris

127 Wassily Kandinsky. Compositional diagram for *Composition 7,* 1913. "Some details in large outlines." Lenbachhaus Municipal Gallery, Munich

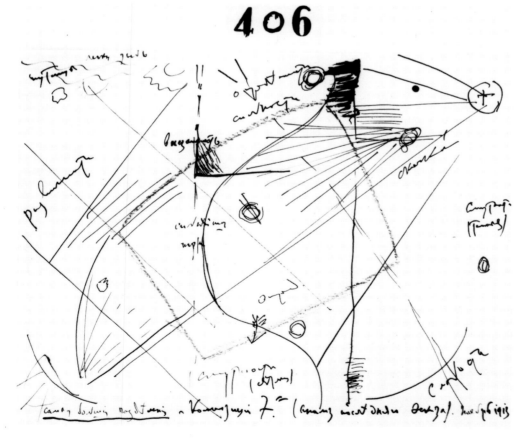

128 Wassily Kandinsky. Compositional diagram for *Composition 7,* 1913. "Rough organization of *Composition 7.*" Lenbachhaus Municipal Gallery, Munich

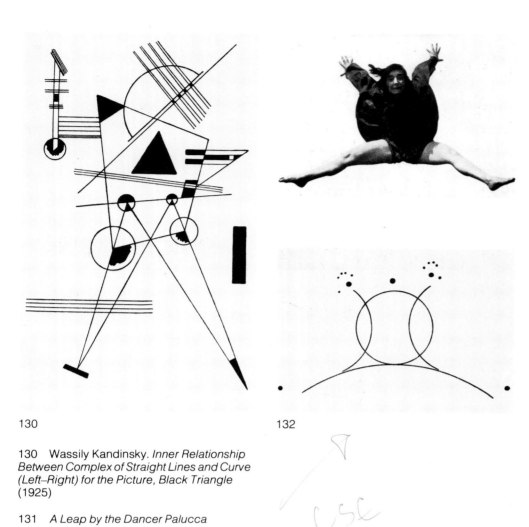

130

130 Wassily Kandinsky. *Inner Relationship Between Complex of Straight Lines and Curve (Left–Right) for the Picture, Black Triangle* (1925)

131 *A Leap by the Dancer Palucca*

132 Wassily Kandinsky. *Diagram of a Leap*

132

their distinctive characteristics are the translation of the analytical observations into dynamic graphic elements and their synthesis of these features in the schema. Kandinsky fused a range of sources and his experience of developing the organization of a picture in conceiving his own analytical method.

In his later Munich years, from 1911 to 1913 when he was working on his important early series of abstract paintings, Kandinsky had already developed the schematic drawing as an aid in the elaborate process of formulating a composition. These sketches are very loose in execution and thus lack the strict geometry of the later analytical drawings, but they show the same interest in essential structure and in the main formal directions or axes linking the forms. A number even have arrows explicitly indicating movement (Fig. 126).[31] Two compositional schemata for *Composition 7* (1913) also have inscriptions that reveal an approach he might well have suggested in later years to his Bauhaus students: "some details in large outlines" and "rough organization of *Composition 7*" (Fig. 127, C. 128).[32] Most of these sketches deal with the overall composition, with loosely defined forms distributed throughout. However, there is one startling example, a

133 Wassily Kandinsky. Graphic diagrams as translations of momentary movements, 1926

sketch of the main outlines of *Composition 6* (1913), that displays the radical simplification of a Bauhaus student's schema (Fig. 129).[33] This bold image consists primarily of a few long, slightly curving lines and a small circle, representing the chief movements and focal point of the composition. In the same period of Kandinsky's career, he wrote the commentaries on several of his paintings which appeared in the Sturm album in 1913. His verbal analyses confirm the visual evidence of the sketches, in that he discusses the balancing of colors and forms in the pictures, especially in regard to two or three focal "centers." His reference to "linear nodes," in particular, suggests the convergence of lines that in a more regularized way creates structural nodes in the Bauhaus analytical drawings.[34] During his Bauhaus years, Kandinsky made schematic drawings in conjunction with some of his paintings, though most lack the conciseness of the schema for *Composition VI* and seem to have been done after the execution of the paintings. The last three illustrations in *Point and Line to Plane* are elaborate in their inclusion of all the essential elements of the paintings and are quite faithful to the actual contours and shapes (Fig. 130).[35] These qualities are well suited to the instructive function of the diagrams, intended to elucidate the linear structures in the pictorial compositions. Their role in a theoretical treatise is very different from that of his Munich period sketches. Much closer to the schemata in the analytical drawings are Kandinsky's spare diagrams of the dancer Gret Palucca, one of which appeared in *Point and Line to Plane,* while the other three illustrated his article, "Dance Curves," of 1926 (Fig. 131– 133).[36] Based on photographs of the dancer performing, these drawings translate the major axes of the body into a simple group of lines, which effectively suggest its energetic movements. As in the analytical exercises, furthermore, the primary and secondary tensions are indicated by variations in the weight of the line.

134 Wassily Kandinsky. *White on Black,* No. 531, 1930. Collection Edward Albee, New York

135 Wassily Kandinsky. *Drawing No. 21, for "White on Black,"* 1930. National Museum of Modern Art, Centre Georges Pompidou, Paris

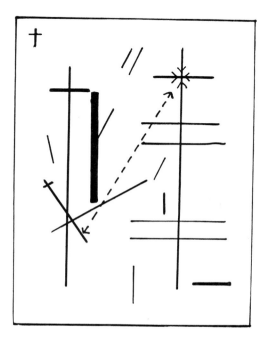

136 Wassily Kandinsky. Schema after the painting *Animated Stability,* 1938

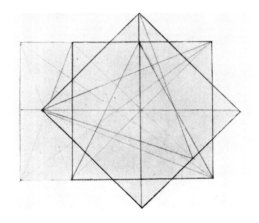

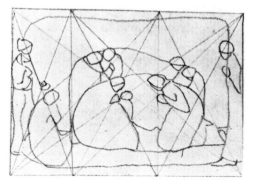

137 Adolf Hölzel. Analyses of a painting, 1911

and horizontal axes, and a dotted diagonal line with arrowheads connects the two major elements, representing the "main tension," as Kandinsky explained in a commentary.[38] It is clear, therefore, that both the reductive diagrammatic quality of the analytical drawings and their emphasis on movement and tension are closely connected with Kandinsky's ideas about his own pictorial compositions.

As mentioned above, there was a substantial tradition for the geometric analysis of objects in the medium of drawing, going back at least to the mid-nineteenth century. French art students were trained to interpret nature by means of the simple geometric solids decades before Cézanne's famous recommendation concerning "the cylinder, the sphere, and the cone."[39] Also at this time, aesthetic theories were developed regarding harmonic proportions in art and nature, including those determined by the Golden Section.[40] In the second half of the century, French academic theory of *dessin* evolved a widely influential method of geometric drawing, which was not only oriented toward the fundamental shapes but utilized a basic grid of horizontals and verticals, concentrated the linear structure of an object on a focal point, and sought to maintain the wholeness of an object's overall outline. As Richard A. Moore has shown in his survey of this method, the development of abstract principles and the achieving of compositional unity were among its ultimate goals.[41] Finally, at the turn of the century, the English designer Walter Crane, whose work and writings were well known in Germany, continued some aspects of this tradition in his book *Line and Form,* the German edition of which appeared in 1901. He too recommended attending to the elementary forms—cube, sphere, cylinder, and pyramid—and proposed two methods of drawing, by ovals and rectangles, with the principle of achieving a single basic formal figure.[42]

Against this general background, at least some of which Kandinsky no doubt was

Among drawings related to paintings, the one for *White on Black* (1930) is most like the analytical diagrams: while it selectively registers some of the horizontal and vertical axes that constitute the obvious structure of the painting, it shows some "hidden" relationships by means of bold curving lines that connect various parts of the gridlike finished work (Fig. 134, 135).[37] Finally, in a later period, Kandinsky returned to the schematic analysis of a completed work, in the sketch after *Animated Stability,* No. 646, of 1937 (Fig. 136). Here the large rectangular forms of the painting are reduced to their vertical

138 Johannes Itten. Analyses of Meister Francke's *Adoration of the Magi,* 1921

acquainted with, there was his exposure, during his formative Munich years, to two influential art teachers. Their abstract geometrical approaches to objects and compositions affected his own ideas. He studied with the Yugoslav Anton Ažbè for two years during the late 1890s, and thus was well acquainted with his "principle of the sphere," whereby this fundamental element was used as an instructive model and as a formal building block. Another abstracting tendency that impressed Kandinsky in Ažbè's teaching was his emphasis on freedom of the "play of lines" observed when working from the model.[43]

The other art teacher to have a significant influence on Kandinsky's conception of geometric analysis was Adolf Hölzel. During the first decade of the twentieth century he published articles in which he analyzed pictorial compositions, including those by old masters (Fig. 137). He used a complex of vertical, horizontal, and diagonal lines, dotted as well as solid, to explain the placement and inter-

relationships of objects and figures in the picture.[44] Johannes Itten was a student of his and described his teaching of composition as involving a geometric network of lines, used to determine centers of gravity for the arrangement of the subject and its surroundings.[45] This system is remarkably like some of the analytical drawings done by Kandinsky's Bauhaus students. Hölzel and Ažbè thus influenced Kandinsky through their ideas concerning the inherence of geometry in both art and nature.

At the Weimar Bauhaus, Itten followed Hölzel's example in using the analysis of old masters as part of his teaching. His own analyses of earlier compositions show a multiple approach, as exemplified by two pages from his article on the subject, from 1921. In his diagrammatic treatment of Meister Franke's *Adoration,* he superimposed a geometric network on a reproduction of the painting, showing the Pythagorean relationships in its structure (Fig. 138).[46] He also made a much freer drawing after the painting, made up pri-

marily of dynamic curves to render the movement of the figures and setting. In addition, he created a small and very simple abstract schema for the main elements and movements—very similar to the schemata in the analytical drawings done for Kandinsky. Though the latter already had made schematic diagrams in his earlier sketches and had been exposed to the pertinent sources concerning geometric analysis, Itten's diagrams may have triggered the consolidation of his thinking on the subject. Itten's schemata are more concentrated and hieroglyphlike than Kandinsky's earlier ones, and may well have influenced him.

Kandinsky evidently began to teach analytical drawing close to the time of his arrival at the school, and though there seem to be no schemata in the first student works, it's clear that his basic ideas were already formulated. The exercises were called "analytical drawing from nature," as seen in the book published for the Bauhaus Exhibition of 1923. The four studies reproduced there reveal by their captions and formal qualities that the basic distinctions between the stages of drawing had already been conceived: *Characterization of Objects, Constructive Analysis, Geometrical Connections,* and *Linear Analysis.*[47] By reference to the categories defined in Kandinsky's article on analytical drawing of 1928, one can identify the first as a first-stage drawing, with some interconnecting axial lines (Fig. 139). The next two belong to the second stage: the objects are less solidly defined, and there is greater emphasis on the network that indicates the interrelationships in the composition (Fig. 140, 141). The fourth drawing, by Ida Kerkovius, is an abstract arrangement of lines, including strong curves, and is flatter and more dynamic than the others (Fig. 142). It thus is an early form of a third-stage study. On the whole, this group of student exercises appears tentative compared to the later, more fully developed examples, but it shows that Kandinsky already was applying in his teaching the concepts and methods discussed here. It also attests to his inventiveness in synthesizing his sources and his own practice, in arriving at his final articulated system of analytical drawing in the mid- and late twenties.

139

139 Gerhard Schunke. *Analytical Nature Drawing: Character of the Objects,* 1923

140 Maria Rasch. *Analytical Nature Drawing: Constructive Analysis,* 1923

140

141 Maria Rasch. *Analytical Nature Drawing: Geometric Connections,* 1923

142 Ida Kerkovius. *Analytical Nature Drawing: Linear Analysis,* 1923

Like Itten, Kandinsky was influenced by Hölzel in the use of the analysis of works of art in his teaching. He had earlier included references to paintings by recent or current artists, Cézanne and Hodler, in *On the Spiritual in Art,* in his discussion of the compositional usage of geometric forms and linear arrangements. In particular, he cited Cézanne's *The Bathers,* now in the Philadelphia Museum of Art, for its use of a triangle for the composition of the whole picture; this shape becomes "the clearly expressed artistic aim," through the subordination of the figures and the parts of their bodies to its axes.[48] In his Bauhaus classes, as his teaching notes reveal, Kandinsky sometimes discussed whole series of old master works, including schemata for some. He analyzed their compositional structure, resolving them to linear networks and nodes, as in the student drawing exercises.[49] He even recommended analytical drawing as a way to fully experience the forces in the works and assigned the exercise of making schemata of some paintings, using tracing paper over reproductions.[50] Thus his ideas concerning the geometry of still life and the organization of a composition converged, through the techniques he developed in his teaching of drawing.

Of crucial significance to Kandinsky's conception of analytical drawing were the qualities of energy, movement, and rhythm that he believed animated the pictorial elements and thus determined the nature of compositions. The dynamic character of the student drawings, distinguishing them from static geometric analyses, is seen particularly in the schemata, the abstract third-stage works, and free studies. It goes back ultimately to the Expressionism of Kandinsky's Munich period and to certain of his theoretical sources of the time. The Jugendstil generation's interest in the expressiveness of pure formal elements has been shown by Peg Weiss to have influenced Kandinsky, and with regard to the characteristics of line, the most important artist-theorist for him was no doubt August Endell.[51] As an indication of the prevalence of ideas concerning the vitality of artistic forms, one might also cite Henry van de Velde's definition of line as "a force borrowed from the energy of him who drew it."[52]

Such notions derive their justification from theories of perceptual psychology, as

143

144

145

146

143 Irmgard Sörensen-Popitz. *The Dynamic Effect of Line,* 1924 (C. 204)

144 Wassily Kandinsky. *Lines and Their Directions of Force,* 1926

145, 146 Wassily Kandinsky. *Planes and Their Directions of Force,* 1926

Marianne L. Teuber has made clear. The Munich psychologist Theodor Lipps had formulated a theory of kinetic empathy that attracted wide attention in the late 1890s and beginning of the twentieth century. His eye-movement theory of perception was particularly relevant for the effects of lines, the qualities of movement the observer could feel in them; and its influence is seen in the Bauhaus theories of both Kandinsky and Klee. The drawings of lines in *Point and Line to Plane,* with arrows indicating multiple directions of force, attest to this (Fig. 143–145).[53] Endell had been very much affected by Lipps' ideas, which he applied to artistic questions, and thus the psychologist's influence may have come to Kandinsky in part through him. In conjunction with the theory of eye movement he developed notions of tension and tempo, which characterized lines and line complexes. Kandinsky's discussion of lines, groups of lines, and their characteristics in *Point and Line to Plane* reveals a debt to these concepts of Endell.[54]

Energy and order were for Kandinsky essential qualities of art, inherent in the objective world as well. The different tensions and kinds of structure that were investigated in the analytical drawings were meant to train students to be aware of these characteristics. Kandinsky's incorporation of his own early schematic approach to composition and his adaptation of a range of theoretical and artistic sources were part of a synthesis that resulted in his conception of analytical drawing. For the students, the task required both the discipline of geometric diagramming and an intuitive grasp of the essential movement in forms.

The principles of abstract composition that were imparted included equilibrium, parallelism, and contrast of directions and centers. The method involved the processes of simplification, analysis, and transformation into abstract constellations of elements. As the surviving studies show, individual perception, intellect, and imagination were brought into play, with the resulting differences in interpretation of the motifs. This variety and the accomplished quality of both conception and execution show that the exercises were effective pedagogical devices. They fostered new ways of seeing and thinking, and even the beginnings of creativity.

The study of the objective motifs, comparable to the study of natural forms, led to abstract compositions in the third-stage drawings and the free studies. Indeed, these investigations helped provide a basis for the theory of pictorial composition, one of Kandinsky's major goals in his teaching and his theoretical work.

Catalogue of the Student Works from Kandinsky's Classes 1922–33, from the Bauhaus Archive and Museum for Design

The individual students' works are subdivided into three categories: the first is concerned with color studies and free color combinations; the second with analytical drawings, formal studies, and compositions based on analytical drawings; the last section is formed of works from Kandinsky's painting class. Exceptions are made for the folders of Kessinger-Petitpierre, Kessler, and Ullmann-Broner, which are listed in their original sequence.

Titles in quotation marks are found on the studies themselves, or on their mats, and are here recorded with the mistakes found on the originals.

Dates are taken from the works themselves. In cases where no date was given and no other clear-cut date was available, *circa* is used before the date presumed to be correct.

The term *India ink* designates black India ink. The word *pencil* indicates a preliminary sketch in pencil.

Unless otherwise noted, the color of the paper or cardboard is white or whitish. The transparent paper used has, today, a yellowish tone. *Typewritten text,* or a similar designation, indicates text typed with a typewriter on white paper, cut out, and then glued to the study.

In the measurements, height is given before width.

Alfred Arndt

1 Completed Questionnaire for the Wall-Painting Workshop, 1923
Printed form on paper, filled in with pencil and colored pencils, 23.3 x 15.1 cm.
Inv. 991; ill. 60, p. 73

Eugen Batz

2 Color Ladder, 1930
Tempera and pencil on cardboard, 30 x 12.8 cm.
Inv. 752a; ill. 41, p. 58
3 Six-Part Color Circle, 1930
Tempera over pencil on cardboard, 18.9 x 18.9 cm.
Inv. 752b; ill. 54, p. 68
4 Color Scale, Arranged in Concentric Circles, 1930
Tempera over pencil on drawing board, 19 x 19.1 cm.
Inv. 752d; ill. 45, p. 62
5 Stepped Color Scale, 1930
Tempera over pencil on cardboard, 19.2 x 19.1 cm.
Inv. 752d; ill. 42, p. 59
6 Color Study, 1929/30
Collage made from various papers, partially painted with tempera; mounted on prepared black photographic cardboard, 30 x 21.2 cm.
Inv. 753a; ill. 51, p. 65
7 Color Study, 1929/30
Materials identical to those in entry 6, 30 x 21.2 cm.
Inv. 753b; ill. 52, p. 65
8 Color Study, 1929/30
Materials identical to those in entry 6, 30.4 x 21.1 cm.
Inv. 753c; ill. 53, p. 65
9 Correspondence Between Color and Line, 1929/30
Tempera over pencil on black paper, 42.4 x 32.9 cm.
Inv. 754a

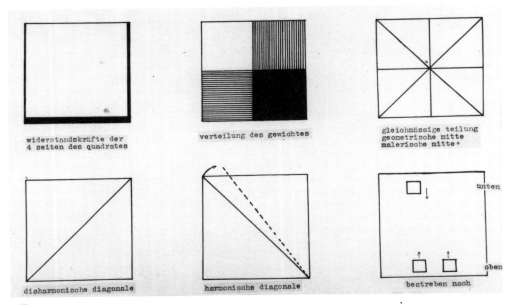

widerstandskräfte der 4 seiten des quadrates

verteilung des gewichtes

gleichmässige teilung geometrische mitte malerische mitte•

disharmonische diagonale

harmonische diagonale

bestreben nach

unten

oben

147

10 Correspondence Between Colors and Forms, 1929/30
Tempera over pencil on black paper, 42.3 x 32.9 cm.
Inv. 754b; ill. 73, p. 81

11 Color Contrasts, 1929/30
Tempera over pencil on black paper, 42.3 x 32.9 cm.
Inv. 754c; ill. 40, p. 57

12 The Spatial Effect of Colors and Forms, 1929/30
Tempera over pencil on black paper, 39.2 x 32.9 cm.
Inv. 755a; ill. 90, p. 101

13 The Spatial Effect of Colors and Forms, 1929/30
Tempera over pencil on black paper, 28.2 x 21 cm.
Inv. 755b; ill. 91, p. 101

14 Color Ladders, 1929/30
Collage made from strips of paper, painted with tempera over pencil, and black and white cardboard, 33 x 42.3 cm.
Inv. 1649

15 Analytical Drawing with Schema, 1929/30
Tempera on black cardboard and tempera on transparent paper respectively, 42.1 x 32.9 cm.
Inv. 1131

16 Untitled Composition, today known as "Yellow Arrow," 1929/30
Oil on pasteboard, afterwards mounted on a panel, 42 x 60 cm.
Inv. 3950

17 "Red Point," 1930
Oil on plywood, 50.3 x 66.3 cm
Inv. 3550

Otti Berger

18 Color Ladders, ca. 1927
Colored tissue paper over pencil on gray cardboard, 10 x 29 cm. From the file "Drawings from Klee's Instruction, ca. 1927/28, II," p. 64
Inv. 3848

Werner Drewes

19 Aggression, 1932
Oil on fiberboard, 39 x 86 cm.
Inv. 3693; ill. 17, p. 29

Friedly (Petra) Kessinger-Petitpierre
Folder 1: Color Instruction in Connection with Abstract Elements of Form, 1929/30
Spring binder with eighteen studies, 35.3 x 27 cm.
Inv. 3576/1–18

20 "The Surface"
India ink and tempera over pencil and typewritten text on paper, on gray cardboard, 22.7 x 31.9 cm.
Inv. 3576/1; ill. 147

21 "The Three Basic Planes Combined into a Common Form"
India ink and tempera over pencil on paper, with typewritten captions, 22.9 x 32 cm.
Inv. 3576/2; ill. 148

22 "Variation of the Square Plane"
Pencil on paper, mounted on cardboard, typewritten text, 22.4 x 32.1 cm.
Inv. 3576/3

23 Correspondence Between Colors and Forms
Tempera over pencil, India ink, typewritten explanation, 22.9 x 32 cm.
Inv. 3576/4; ill. 149

148

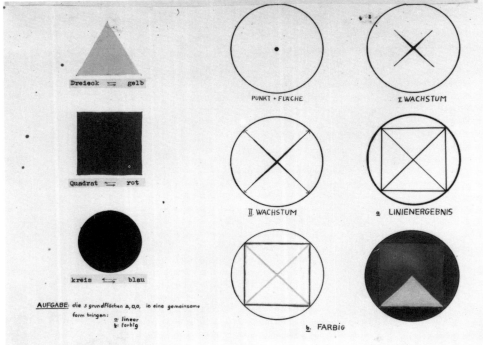

Dreieck ⇌ gelb

Quadrat ⇌ rot

kreis ⇌ blau

AUFGABE: die 3 grundflächen △,□,○, in eine gemeinsame form bringen: a: linear b: farbig

PUNKT + FLÄCHE

I WACHSTUM

II. WACHSTUM

a. LINIENERGEBNIS

b. FARBIG

24 "Colored Angles and Elementary Colored Relationship"
Colored pencil and typewritten text on paper, 30.3 x 22.4 cm.
Inv. 3576/5; ill. 70, p. 79

25 "The Angles in Relation to Color"
India ink, colored pencil, watercolor, typewritten text on paper, 30.2 x 22.6 cm.
Inv. 3576/6; ill. 69, p. 78

26 "Colored Angles and Elementary Color Relationship"
Colored pencil, watercolor on paper, typewritten captions, mounted on gray cardboard, 30.3 x 22.6 cm.
Inv. 3576/7

27 "The Angles in Relationship to Color"
Tempera, ink, and typewritten text on paper, 30.1 x 21.2 cm.
Inv. 3576/8; ill. 150

28 "The Straight Line in Relationship to Color"
Tempera over pencil, typewritten text on gray cardboard, 30.2 x 22.6 cm.
Inv. 3576/9; ill. 67, p. 76

29 "The Basic Tensions of Colors"
Tempera, India ink, and typewritten text on gray cardboard, 32.2 x 24.6 cm.
Inv. 3576/10; ill. 31, p. 51

30 Color Ladders and Color Scales in Concentric Circles
Tempera over pencil on paper, typewritten captions; mounted on gray cardboard, 32.1 x 24.1 cm.
Inv. 3576/11

31 "From Light to Dark"
Tempera over pencil; watercolor on paper, typewritten captions; mounted on gray cardboard, 32 x 24.5 cm.
Inv. 3576/12

32 "The Primary Colors—the Primary Forms"
Collage of strips of paper painted with watercolor and India ink, typewritten captions on gray mottled cardboard, 31.5 x 24.2 cm.
Inv. 3576/13

33 "Variation with Green"
Collage of strips of paper painted with watercolor or tempera, typewritten captions on gray mottled cardboard, 31.4 x 24.2 cm.
Inv. 3576/14

34 Color Studies
Collage of shapes and strips of paper painted with watercolor and India ink, typewritten explanation on gray mottled cardboard, 31.4 x 24.2 cm.
Inv. 3576/15

35 Color Contrasts
Collage of squares of paper painted with watercolor over pencil on gray mottled cardboard, 31.4 x 24.2 cm.
Inv. 3576/16

36 Color Contrasts
Watercolor over pencil on paper, mounted on gray mottled cardboard, 31.3 x 24.1 cm.
Inv. 3576/17

37 Color Contrasts
Watercolor over pencil on paper, mounted on gray mottled cardboard, 31.3 x 24.2 cm.
Inv. 3576/18

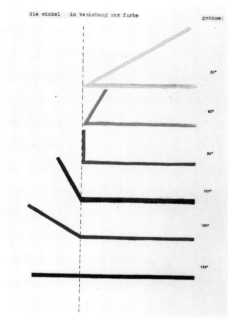

150

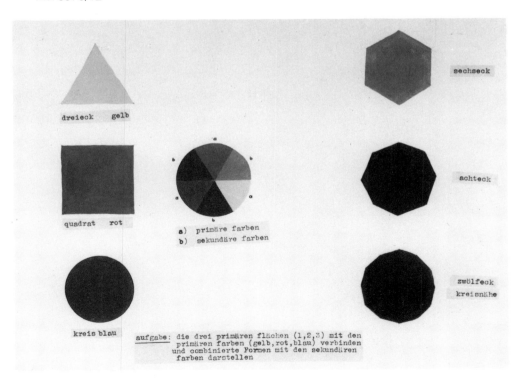

149

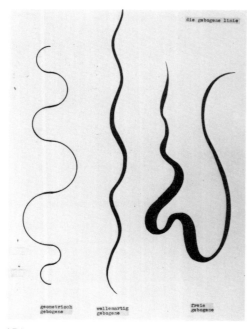

151

Folder 2: "Principals of Abstract Form in Relationship to Color," 1929/30
Spring binder with ten studies, 35.4 x 27.5 cm.
Inv. 3577/1–10

38 "The Curved Line"
India ink, typewritten explanation on paper, 30.3 x 22.2 cm.
Inv. 3577/1; ill. 151

39 Main Tension—Secondary Tension
India ink, typewritten text on paper, 23 x 32.1 cm.
Inv. 3577/2; ill. 10, p. 25

40 "Sharpening of the Drawing through Wire Work"
India ink on paper; India ink on transparent paper, 32.1 x 24 cm.
Inv. 3577/3; ill. 152

41 "Variation"
Collage of ink drawing and a typewritten explanation, mounted on watercolor paper, 32 x 24 cm.
Inv. 3577/5; ill. 153

42 Variation
India ink on paper; India ink on transparent paper, 32.1 x 24.1 cm.
Inv. 3577/6; ill. 154

43 "Penetration"
India ink over pencil, typewritten caption on paper, 32.2 x 24.3 cm.
Inv. 3577/6; ill. 154

44 Geometric Study
Ink on paper, 32.2 x 24.2 cm.
Inv. 3577/7; ill. 155

45 "Penetration"
India ink over pencil, typewritten captions on paper, 32.2 x 24.2 cm.
Inv. 3577/8; ill. 14, p. 26

46 "Lines"
India ink over pencil, typewritten captions on cardboard, 32.2 x 24.2 cm.
Inv. 3577/9; ill. 156

47 Line Study
Pencil on paper, mounted on gray cardboard, 32.1 x 23.9 cm.
Inv. 3577/10

Folder 3: "Analytical Drawing," 1929/30
Folder with twelve studies, 36 x 26.5 cm.
Inv. 3578/1–12

48 "Theme 1; Main Tension and Geometric Network: Triangular Division"
Colored ink and India ink over pencil; India ink on transparent paper, 32.8 x 25.1 cm.
Inv. 3578/1; ill. 116, p. 121

49 "Free Variation on Theme 1"
India ink over pencil, typewritten text on paper, 32.7 x 25.1 cm.
Inv. 3578/2; ill. 117, p. 121

50 "Theme 2: Main Tension—Secondary Tension"
India ink and colored ink over pencil, typewritten captions on paper, 32.9 x 25 cm.
Inv. 3578/3; ill. 118, p. 121

51 "Variation on Theme 2: Inner Tensions"
India ink, pencil, colored pencil, typewritten text on paper, 32.7 x 25.1 cm.
Inv. 3578/4; ill. 119, p. 121

52 "Theme 3: Main Tension—Secondary Tension"
India ink and colored ink, watercolor over pencil, typewritten captions on cardboard; tempera over pencil, typewritten text on transparent paper, 32 x 24.5 cm.
Inv. 3758/5

53 "Theme 4: Tensions"
India ink over pencil on cardboard; India ink and colored ink over pencil, typewritten text, on transparent paper, 32.9 x 25.2 cm.
Inv. 3578/6

54 "Variation on Theme 4"
Watercolor, tempera, colored pencil over pencil on cardboard, 32.9 x 25.2 cm.
Inv. 3578/7; ill. 68, p. 77

152

153

154

55 "Theme 5: Main Tension—Secondary Tension"
India ink and typewritten captions on paper; tempera, India ink, and colored ink, typewritten explanation on transparent paper, 32.9 x 25.2 cm.
Inv. 3758/8

56 "Free Variation on Theme 5"
Watercolor, India ink, and typewritten captions on paper, 32.4 x 25 cm.
Inv. 3578/9

57 "Theme 6: Main Tension—Secondary Tension—Point Distribution"
India ink, tempera over pencil, typewritten explanation on cardboard; first overlay: colored ink and typewritten captions on transparent paper; second overlay: India ink and typewritten captions on transparent paper, 32.9 x 25.2 cm.
Inv. 3578/10; ill. 120, p. 122

58 "Continuation of Theme 6: Point Distribution Copy—Sum of Lines"
India ink over pencil, typewritten captions on blue-gray cardboard; colored ink and typewritten caption on transparent paper, 32.9 x 24.4 cm.
Inv. 3578/11; ill. 121; p. 122

59 "Free Variation on Theme 6: Free Depiction of Planes—Free Curves"
India ink over pencil, pastels, watercolor, and typewritten explanation on watercolor paper; colored ink over pencil, typewritten captions on transparent paper; India ink and typewritten captions on transparent paper, 31.9 x 24.2 cm.
Inv. 3578/12; ill. 122, p. 122
Folder, "The Square," 1930
Black folder with flaps, 27 x 27 cm.
The folder holds twelve works of approximately the same sized square format on watercolor paper, executed in blue ink with brush and quill.
60 Sheet one 26 x 26 cm.; Ill. 6, p. 24
61 Sheet two 26.1 x 25.9 cm.
62 Sheet three 26.2 x 26.1 cm.
63 Sheet four 26 x 25.9 cm.; Ill. 157
64 Sheet five 26 x 26.4 cm.; Ill. 158
65 Sheet six 26.1 x 25.9 cm.
66 Sheet seven 26.1 x 26 cm.
67 Sheet eight 26 x 26.3 cm.
68 Sheet nine 26.2 x 25.9 cm.
69 Sheet ten 26.3 x 26 cm.
70 Sheet eleven 25.7 x 26 cm.; Ill. 7, p. 24
71 Sheet twelve 25.9 x 26.2 cm.
Inv. 3579/1–12

Hans Kessler
Notes and studies from Kandinsky's classes, 1931/32
Notebook with eleven pages of handwritten notes, interspersed with pencil sketches, 29.7 x 21 cm.; as well as ten studies in various techniques and formats, none larger than 29.9 x 21 cm. (see catalogue no. 203)
Inv. 2965/1–24

155

156

72 Tensions and Pulsebeats of the Basic Colors and Forms
Collage of pieces of paper painted with tempera, pasted on typewriter paper and labelled by hand, 29.7 x 21 cm.
Inv. 2965/11; ill. 159

73 "Schema of the Tensions"
Colored pencil on typewriter paper, 21 x 29.7 cm.
Inv. 2965/14

74 "Schema of the Objects"
India ink, colored pencil on drawing paper, 20.8 x 29.7 cm.
Inv. 2965/15

75 "Breakup of the Basic Colors into White and Black"
Tempera, India ink over pencil, colored pencil on drawing paper, 20.3 x 29.5 cm.
Inv. 2965/16

76 "Arrangement of the Primary Colors with Either a Calm or Agitated Effect"
Collage of pieces of paper colored with tempera on gray cardboard, pencil, ink, 29.9 x 20.9 cm.
Inv. 2965/17, ill. 160

77 "Rhythm"
Charcoal on drawing paper, 29.8 x 20.9 cm.
Inv. 2965/18

78 "Weight-Bearing and Resonating"
Charcoal on drawing paper, 29.7 x 20.8 cm.
Inv. 2965/19

79 "Rhythmic Arrangement of Weight"
Collage of pieces of paper painted with tempera, pencil and colored pencil added, 20.9 x 29.7 cm.
Inv. 2965/20

157

158

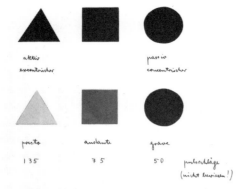

159

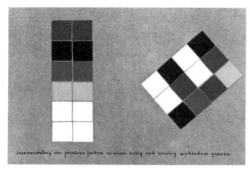

160

161

80 "Union of Two Centers"
 Collage of paper strips, some painted
 with black tempera, some white, mount-
 ed on white paper, 14.9 x 29.7 cm.
 Inv. 2965/21

81 "Union of Two Centers"
 Collage of pieces of paper, some paint-
 ed with red and some with black tem-
 pera, mounted on gray cardboard, 14.9 x
 29.7 cm.
 Inv. 2965/22

82 "Accent"
 Collage of pieces of paper painted with
 tempera, mounted on white paper, pen-
 cil, 20.9 x 29.8 cm.
 Ill. 161

Karl Klode

83 Analytical Drawing, 1930
 India ink over pencil on paper, 28.4 x
 22.4 cm.
 Inv. 3037/1

84 Analytical Drawing with Schemata, 1930
 India ink over pencil on paper, 28.4 x
 20.6 cm.
 Inv. 3037/2

85 Analytical Drawing with Schema, 1930
 India ink over pencil on paper, 28.6 x 21
 cm.
 Inv. 3037/3; ill. 162

86 Analytical Drawing with Schema, 1930
 India ink over pencil on paper, 28.7 x 21
 cm.
 Inv. 3037/4; ill. 16, p. 28

87 "Transparent and Opaque Planes with
 Weight Above," 1932
 Tempera on cardboard, mounted on
 white cardboard support, 30.2 x 37.7 cm.
 Inv. 3035; ill. 78, p. 87

88 Untitled Composition, 1931
 Oil on jute-covered plywood, 62.8 x 59.7
 cm.
 Inv. 3041; ill. 15, p. 28

89 "Circus," 1932
 Pen and black ink on paper, 27 x 21.1
 cm.
 Inv. 2956

Lothar Lang

90 Free Color Study, 8 November 1926
 Tempera and India ink over pencil on
 cardboard, 39.4 x 30.2 cm.
 Inv. 567; ill. 88, p. 100

91 Correspondence between Colors and
 Lines, ca. 1926/27
 Colored ink wash over pencil on card-
 board, 17.4 x 30.6 cm.
 Inv. 568; ill. 163

92 Spatial Effects of Yellow and Blue,
 2 January 1927
 Tempera and India ink over pencil on
 cardboard, 25.4 x 36.1 cm.
 Inv. 569; ill. 30, p. 50

93 Stepped Color Scale, 12 December 1926
 Tempera and India ink over pencil on
 cardboard, 18.2 x 25 cm.
 Inv. 570

162

163

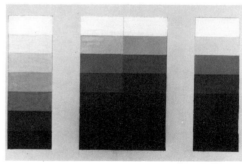

164

165

94 Color Scale in Concentric Circles, 12 December 1926
Tempera and India ink over pencil on cardboard, 18.2 x 24.9 cm.
Inv. 572

95 Color Ladders, 2 January 1927
Tempera and India ink over pencil on cardboard, 25.3 x 35.9 cm.
Inv. 573

96 Color Ladders, ca. 1926/27
India ink and very thin tempera over pencil on cardboard, 24.9 x 35.6 cm.
Inv. 574

97 Color Ladders, ca. 1926/27
India ink and tempera over pencil on cardboard, 25.4 x 36.2 cm.
Inv. 579, ill. 164

98 Color Study, ca. 1926/27
Tempera over pencil on cardboard, 22.7 x 31.1 cm.
Inv. 577

99 Green Free Form and Yellow Triangle, ca. 1926/27
Tempera over pencil on cardboard, 19.8 x 25.8 cm.
Inv. 580; ill. 165

100 "The Center Accented by Blue-Red Opposition," 1929
Tempera over pencil on cardboard, 30.5 x 30 cm.
Inv. 581; ill. 57, p. 70

101 Color Scale, ca. 1926/27
Tempera over pencil on cardboard, cut out and mounted on black photographic cardboard, 29.8 x 44.5 cm.
Ill. 50, p. 65

102 Analytical Drawing, 15 November 1926
India ink over pencil on cardboard, 23.2 x 18.4 cm.
Inv. 571; ill. 103, p. 114

103 Analytical Drawing, 20 November 1926
India ink over pencil on cardboard, 22.5 x 17.8 cm.
Inv. 583

104 Analytical Drawing, ca. 1926/27
India ink over pencil on cardboard, 29.6 x 21.8 cm.
Inv. 584, ill. 104, p. 114

105 Analytical Drawing, 8 November 1926
India ink over pencil on cardboard, 22.5 x 17 cm.
Inv. 585

106 Analytical Drawing with Schema, ca. 1926/27
India ink over pencil on cardboard, 36.5 x 25.8 cm.
Inv. 586; ill. 107, p. 115

107 Analytical Drawing with Schema, ca. 1926/27
India ink over pencil on cardboard, 34.3 x 25 cm.
Inv. 587

108 Analytical Drawing with Schema, ca. 1926/27
India ink over pencil on paper, 36.4 x 25.7 cm.
Inv. 588; ill. 106, p. 115

Heinrich Neuy

109 Stepped Color Scale, 1930
Tempera over pencil on paper, cut out and mounted on gray-green cardboard, 41.9 x 29.5 cm.
Inv. 1255, ill. 29, p. 47

110 Color Scale in Concentric Circles
Tempera and India ink over pencil on paper, cut out and mounted on gray-green cardboard, 42 x 29.6 cm.
Inv. 1256

111 Color Ladder, 1930
Collage of pieces of paper painted with tempera, pasted on gray-green cardboard, 29.7 x 41.7 cm.
Inv. 1257

112 Color Ladder, 1930
Collage of pieces of paper painted with tempera, cut out and mounted on gray-green cardboard, 29.6 x 41.9 cm.
Inv. 1258; ill. 49, p. 64

113 Color Ladder, 1930
Collage of pieces of paper painted with tempera, pasted on gray-green cardboard, 42 x 29.8 cm.
Inv. 1259; ill. 166

114 "Relationship of Similar Objects," 1930
India ink and colored ink mounted on cardboard, 42 x 29.5 cm.
Inv. 1251; ill. 167

115 "Objects Translated into Main Tension," 1930
India ink and colored ink over pencil on cardboard, 41.8 x 29.6 cm.
Inv. 1252

116 "A Second Call of the Singer in the Night," 1930
India ink on watercolor paper, typewritten captions, pasted on white cardboard, 25.7 x 18.1 cm.
Inv. 1253

117 "Main Tensions Translated into Color," 1930
India ink and tempera over pencil on watercolor paper, 41.5 x 30.2 cm.
Inv. 1254; ill. 168

Hermann Röseler

118 Untitled Composition, 1927
Oil paint on pasteboard, covered on both sides with paper, 40.5 x 40 cm.
Inv. 3754

Herbert Schürmann

119 Color Circle Study, 1932
Tempera and India ink over pencil on paper, 44.6 x 61.8 cm.
Inv. 789; ill. 55, p. 68

120 Free Study, 1932
Colored ink and very thin tempera over pencil on transparent paper, 24 x 47.8 cm.
Inv. 806

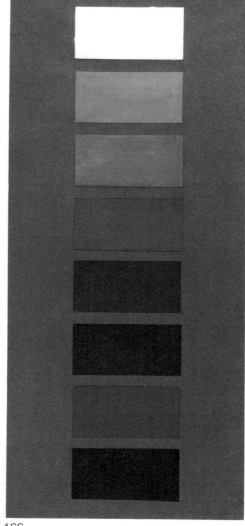

166
167

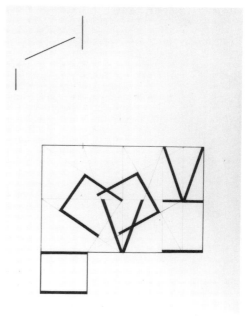

168

169

170

Hans Thiemann

121 "Accenting the Center; Balance Above and Below," ca. 1930
Tempera over pencil; India ink, colored ink, and typewritten explanation on paper, cut out and mounted on black cardboard, 49.1 x 34.8 cm.
Inv. 603; ill. 58, p. 71

122 "Representation of a Curve in Color," ca. 1930
Tempera over pencil on cardboard and paper for the left arrow, typewritten explanation, 49.3 x 34.9 cm.
Inv. 604; ill. 72, p. 80

123 "Construction with Triangles," ca. 1930
Collage of colored paper on beige paper, all much yellowed; tempera over pencil on watercolor paper, typewritten explanation, all mounted on black cardboard, 49.1 x 34.9 cm.
Inv. 605, ill. 4, p. 24

124 Color Scales and Color Circles, ca. 1930
Collage of colored paper, some paper pieces painted with tempera, typewritten text, all mounted on black cardboard, 49.3 x 34.9 cm.
Inv. 607; ill. 43, p. 60

125 "Yellow Forms on a Blue Ground and Blue Forms on a Yellow Ground," ca. 1930
Colored paper, partially over pencil, typewritten captions, all mounted on black cardboard, 49.2 x 34.9 cm.
Inv. 608; ill. 32, p. 51

126 "Horizontal-Vertical Construction," ca. 1930
Tempera over pencil on cardboard, typewritten captions, all mounted on black cardboard, 49.2 x 34.9 cm.
Inv. 609; ill. 5, p. 24

127 "The Tensions Originate Rhythmically from a Single Point"
Colored ink on ochre-toned paper, typewritten captions, mounted on black cardboard, 49.3 x 34.9 cm.
Inv. 601; ill. 169

128 "Dramatic Tension, Obstinately Curved," ca. 1930
India ink and tempera over pencil on gray cardboard; India ink on drawing paper, typewritten captions, mounted on black cardboard, 34.8 x 48.7 cm.
Inv. 602; ill. 12, p. 26

129 "Lyrical-Calm Tension," ca. 1930
Tempera on black paper; India ink on paper, typewritten captions, 49.2 x 34.8 cm.
Inv. 606; ill. 13, p. 26

130 "Both Main Tensions Produce the Schema (Green and Red Traingle)," ca. 1930
India ink over pencil, tempera sprinkled on yellow paper, probably once white, typewritten captions, all mounted on black cardboard, 49.2 x 34.8 cm.
Inv. 610, ill. 170

131 "The Main Tension Produces a Nearly Isosceles Triangle," ca. 1930
India ink and colored ink on gray-green paper, typewritten text, all mounted on black cardboard, 49.3 x 34.9 cm.
Inv. 611

132 Main Tension (the Green Triangle) Overlaid with a Network of Secondary Tensions, ca. 1930
Colored ink on drawing and transparent paper, typewritten captions, all mounted on black cardboard, 49.3 x 34.9 cm.
Inv. 612; ill. 111, p. 117

133 Still-Life Drawing, 1930
India ink, mounted on brown cardboard, 50 x 35 cm.
Inv. 613, ill. 105, p. 114

Frank Trudel

134 "Analysis of a Still Life by Means of 'Lines of Force,'" 1932
Pencil on drawing paper; India ink on transparent paper, 22.1 x 29.7 cm.
Inv. 4337

Fritz Tschaschnig

135 Spatial Effect of Colors and Forms, 1931
Tempera over pencil on black cardboard, 42.4 x 33.2 cm.
Inv. 559

136 Correspondence Between Colors and Lines, 1931
Tempera over pencil on black cardboard, 42.4 x 33 cm.
Inv. 561; ill. 71, p. 80

137 Spatial Effect of Colors and Forms, 1931
Tempera over pencil on black cardboard, 42.4 x 33.1 cm.
Inv. 563; ill. 89, p. 100

138 Free Composition with Analytical Drawing, 1931
Tempera over pencil on black cardboard and transparent paper, 42.5 x 32.9 cm.
Inv. 560

139 Free Composition with Analytical Drawing, 1931
Tempera over pencil on black cardboard and transparent paper, 42.3 x 32.9 cm.
Inv. 562; ill. 125, p. 123

140 Red Door, 1932
Oil on canvas, afterwards fixed to a panel, 45.5 x 63.5 cm.
Inv. 3876

141 Green Districts behind Walls, 1932
Oil on paper and plywood, 48.3 x 46.2 cm.
Inv. 3878

Bella Ullmann-Broner

Folder, "Color Studies at the Bauhaus," 1931
Notebook (new) with nineteen studies in different techniques and sizes, none larger than 30 x 23.2 cm., with an additional sheet with handwritten explanation
Inv. 3243/1–19

"Explanation of the Color Scales, etc." 1931
Pencil on graph paper, 27.1 x 19.9 cm.
Inv. 3243

142 "Sheet 1: Black-White Circular Scales"
Tempera over pencil on graph paper,
handwritten explanation on graph paper,
all sections cut out and mounted on card-
board, 21.1 x 39.9 cm.
Inv. 3243/1; ill. 171

143 "Sheet 2: Color Circle after Ostwald and
Circle Divided Into Twelfths in the Color
Sequence of the Ostwald Circle"
Tempera over pencil on graph paper,
handwritten explanation on graph paper,
all sections cut out and mounted on card-
board, 21.1 x 29.8 cm.
Inv. 3243/2; ill. 56, p. 69

144 "Sheet 3: Color Scales in Eighteen Steps"
Tempera on graph paper, handwritten
explanations, some also on graph paper,
others written directly on the supporting
cardboard on which the cut-out scale
was pasted, 21.1 x 29.8 cm.
Inv. 3243/3

145 "Sheet 4: Color Scales in Eight and Ten
Steps"
Same technique as in sheet three, cat.
144; 29 x 20.8 cm.
Inv. 3243/4; ill. 172

146 Black-White Study
Tempera and India ink on cardboard, cut
out and mounted on gray cardboard,
26.1 x 20.2 cm.
Inv. 3243/5

147 "Demonstration of the Distribution of
Color in the Circle with Complementary
Colors"
Cut-out pieces of paper, painted with
tempera and pasted in a circle on gray
paper, India ink, and a layer of transpa-
rent paper with typewritten captions and
India ink, 29.9 x 23 cm.
Inv. 3243/6; ill. 9, p. 25

148 "Diagram of the Emotional Effects of the
Spectral Colors, Calming—Exciting"
Pieces of paper painted with tempera
and pasted on gray paper, typewritten
captions and India ink, 30.1 x 23.2 cm.
Inv. 3243/7; ill. 173

149 "Distribution of Colors in the Circle"
Tempera over pencil, typewritten cap-
tions on cardboard, 29.8 x 21.2 cm.
Inv. 3243/8

150 "Beginning with White and Progressing
Through the Colors to Black"
Tempera over pencil on cardboard, all
scales cut out and pasted on watercolor
paper, 21.1 x 30 cm.
Inv. 3243/9; ill. 48, p. 63

151 "Gradations of Lightness"
Tempera and India ink over pencil on
paper, typewritten explanation, mounted
on gray paper, 29 x 21.6 cm.
Inv. 3243/10; ill. 8, p. 25

152 Tonal Ladder
Tempera over pencil on cardboard, cut
out and mounted on gray paper, 29 x
20.5 cm.
Inv. 3243/11

153 "White Has the Tension Above, Black Be-
low, the Colors Lie on a Horizontal"
Tempera and India ink over pencil, type-
written explanation, all mounted on gray
paper, 29.2 x 22.5 cm.
Inv. 3243/12

154 "The Primary Colors with Their Basic
Forms; Experiment in Giving Form to the
Secondary Colors"
Pieces of paper painted with tempera,
typewritten explanation, all mounted on
gray paper, 21 x 29.6 cm.
Inv. 3243/13; ill. 74, p. 81

171

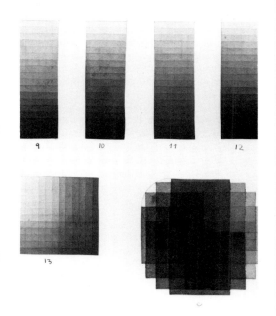

172

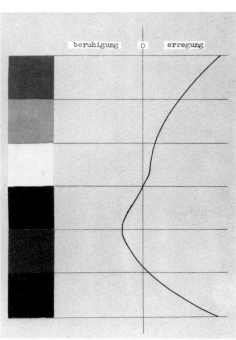

173

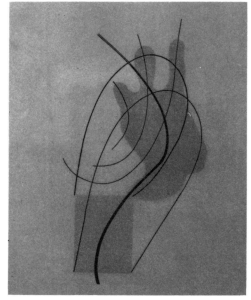

174

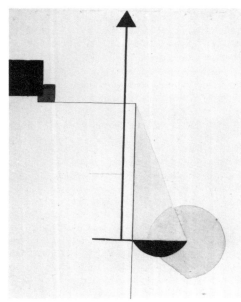

175

155 "Lightness Values"
Tempera and India ink on paper, type-written explanation, all mounted on gray paper, 29 x 20.9 cm
Inv. 3243/14

156 "Composition of the Basic Forms, Treated in Line and Color"
Tempera or India ink on paper, typewritten text, all mounted on gray paper, 29.4 x 19.5 cm.
Inv. 3243/15; ill. 92, p. 101

157 "Color Studies"
Tempera over pencil on paper, typewritten captions, all mounted on gray paper, 21.9 x 29.2 cm.
Inv. 3243/16

158 "Color Studies"
Technique the same as entry 157, 20.9 x 29 cm.
Inv. 3243/17

159 "Color Studies"
Technique the same as entry 157, 20.8 x 29.1 cm.
Inv. 3243/18; ill. 39, p. 56

160 "White Advances—Black Recedes"
Tempera and India ink over pencil on paper, typewritten text, all mounted on gray paper, 21 x 29.3 cm.
Inv. 3243/19; ill. 44, p. 61

Folder, "Kandinsky Course/Preliminary Course," ca. 1929/30
Notebook (new) with fourteen studies of various sizes and techniques, none larger than 30.2 x 32.9 cm.
Inv. 3242/1–14

161 "Image of Tension—Union of a Geometric Form with a Free One"
Pieces of paper painted with tempera and pasted with typewritten captions on gray paper; overlay of transparent paper with India ink drawing and pasted typewritten text, 30 x 23.1 cm.
Inv. 3242/1; ill. 174

162 Analytical Drawing
Tempera over pencil on black cardboard; colored ink on transparent paper, 20.9 x 28.2 cm.
Inv. 3242/2; ill. 99, p. 111

163 "Representation—Geometric Network with Centerpoint, Depiction of Main Tension"
India ink on drawing paper; transparent paper with typewritten explanation, 27.8 x 20.9 cm.
Inv. 3242/3; ill. 98, p. 110

164 Composition
Tempera, India ink and colored ink over pencil on watercolor paper, 24.5 x 21 cm.
Inv. 3242/5; ill. 175

165 Analytical Drawing
India ink over pencil on drawing paper; colored ink on transparent paper, 29.7 x 21.2 cm.
Inv. 3242/5; ill. 115, p. 120

166 "Representation—Geometric Network—Diagram of Tension"
Tempera over pencil, typewritten captions on black cardboard; colored ink on transparent paper, 27.7 x 19 cm.
Inv. 3242/6

167 "Representational Drawing—Geometric Network"
India ink over pencil, typewritten captions on drawing paper and transparent paper, 27.6 x 21.2 cm.
Inv. 3242/7

168 "Representation—Geometric Network—Tension Diagram"
India ink over pencil, typewritten captions on drawing paper; colored ink over pencil on transparent paper, 29.8 x 21.1 cm.
Inv. 3242/8; ill. 112, p. 118

169 Analytical Drawing with Schema
India ink and colored ink over pencil on drawing paper, 29.6 x 21.1 cm.
Inv. 3242/9

170 Analytical Drawing
Colored ink over pencil on drawing paper and on transparent paper, 29.6 x 21 cm.
Inv. 3242/10

171 Analytical Drawing
India ink and colored ink over pencil on drawing paper; colored ink on transparent paper, 29.6 x 21.1 cm.
Inv. 3242/11

172 Analytical Drawing with Schema
India ink and colored ink over pencil on drawing paper, 29.5 x 21.1 cm.
Inv. 3242/12

173 Free Color Combination
Pastel on paper, 21 x 14.7 cm.
Inv. 3242/13

174 "Colored Treatment of a Network"
Tempera, India ink, and colored ink over pencil on paper, typewritten text on transparent paper, 29.5 x 24.2 cm.
Inv. 3242/14; ill. 124, p. 123

Charlotte (Charly) Voepel-Neujahr

175 Correspondence of Colors and Lines, ca. 1927/28
Tempera over pencil on watercolor paper, 18.9 x 16.8 cm.
Inv. 1242

176 Gray Free Form and Yellow Triangle, ca. 1927/28
Tempera over pencil on watercolor paper, 15.1 x 15 cm.
Inv. 3174/1

177 Free Color Combination, ca. 1927/28
Tempera and India ink on watercolor paper, 11.9 x 18.3 cm.
Inv. 3174/11

178 Correspondence between Colors and Lines, ca. 1927/28
Pastel and pencil on transparent paper, on cardboard, 29.7 x 41.9 cm.
Inv. 3174/111

179 Analytical Drawing, ca. 1927/28
India ink and colored ink over pencil on drawing paper, 20.9 x 30 cm.
Inv. 1207

180 Analytical Drawing with Schemata, ca. 1927/28
Pastel and pencil on transparent paper, 19.2 x 27.9 cm.
Inv. 1208

181 Analytical Drawing with Schema, ca. 1927/28
Technique and size the same as entry 180
Inv. 1209

182 Analytical Drawing, ca. 1927/28
India ink and colored ink over pencil on drawing paper, 20.9 x 29.7 cm.
Inv. 1210

183 Analytical Drawing with Schemata, ca. 1927/28
Technique and size the same as entry 180
Inv. 1211

184 Analytical Drawing, ca. 1927/28
India ink, colored ink, and tempera over pencil on watercolor paper, 29.9 x 21.1 cm.
Inv. 1212

185 Analytical Drawing, ca. 1927/28
India ink, tempera over pencil on watercolor paper, 29.9 x 21 cm.
Inv. 1213

186 Analytical Drawing with Schema, ca. 1927/28
Technique and size the same as entry 180
Inv. 1214; ill. 109, p. 116

187 Analytical Drawing, ca. 1927/28
Tempera over pencil on watercolor paper, 29.9 x 24.1 cm.
Inv. 1215, ill. 110, p. 116

188 Color Composition After an Analytical Drawing, ca. 1927/28
India ink and tempera over pencil on watercolor paper, 31.5 x 22.9 cm.
Inv. 3765/1; ill. 96, p. 108

189 Analytical Drawing with Schema, ca 1927/28
Technique and size the same as entry 180
Inv. 3173/1

190 Analytical Drawing, ca. 1927/28
Technique and size the same as entry 180
Inv. 3173/2

191 Analytical Drawing with Schemata, ca. 1927/28
Technique and size the same as entry 180
Inv.3173/3

192 Analytical Drawing with Schema, ca. 1927/28
Technique and size the same as entry 180
Inv. 1373/4

193 Analytical Drawing with Schemata, ca. 1927/28
Technique and size the same as entry 180
Inv. 3173/5; ill. 95, p. 108

194 Analytical Drawing with Schema, ca. 1927/28
Technique and size the same as entry 180
Inv. 3173/6

195 Analytical Drawing with Schema, ca. 1927/28
Technique and size the same as entry 180
Inv. 3173/7

196 Analytical Drawing with Schema, ca. 1927/28
Technique and size the same as entry 180
Inv. 3173/8

197 Analytical Drawing, ca. 1927/28
India ink and colored ink over pencil on drawing paper, 20.9 x 29.9 cm.
Inv. 3173/9

198 Color Composition After an Analytical Drawing, ca. 1927/28
Tempera over pencil on watercolor paper, 34 x 23.5 cm.
Inv. 3174/iv; ill. 97, p. 109

199 Development, 1928
India ink and tempera over pencil on watercolor paper, 21 x 12.4 cm.
Inv. 1217

200 Free Color Combination, ca. 1928
Tempera over pencil on watercolor paper, 13.1 x 10.5 cm.
Inv. 1218

201 "The Blue Sphere"
Tempera and pastel on drawing paper, 21.9 x 30 cm.
Inv. 3765/2

Kandinsky's Students' Class Notes

Hermann Fischer

202 Two pages of notes from Kandinsky's instruction, dated 3,8, and 10 May 1930, found in a thick notebook with notes from various courses
Inv. 3849

Hans Kessler

203 Notebook with eleven pages of handwritten class notes, interspersed with pencil sketches, as well as ten studies in various techniques and formats (see catalogue entries 77–82)
Inv. 2965/1–24

Irmgard Sörensen-Popitz (Söre Popitz)

204 Nine sheets of class notes on color theory, 1924
Inv. 3958/1–9

Hans Thiemann

205 During his period of study with Kandinsky, Thiemann annotated his copy of *From Point and Line to Plane* (1928) with numerous underlinings and comments.
Inv. 4331

Frank Trudel

206 Six sheets with sketches and notes from the theoretical course for the second semester held in Dessau, summer semester, 1932. One sheet is dated 13 April 1932
Inv. 4336/1–6

Unknown author, presumably Vera Meyer-Waldeck

207 Letter of several pages sent to Otti Berger, dated Gargellen, 27 July 1927, in which the author discusses, among other things, details of the course held by Kandinsky. Attached is a manuscript of seven pages, entitled "Creation/Kandinsky," as well as two sheets of drawing paper with notes (partially in another handwriting) and schemata for analytical drawings.

176

177

178

Supplement

During the process of cataloguing, the following works from Kandinsky's instruction became known:

Wilhelm Imkamp
208 Untitled Composition, 6 August 1928
Tempera over pencil drawing on watercolor paper, 12.4 x 10.5 cm.
Inv. 1219

Ida Kerkovius
209 Analytical Drawing, ca. 1922/23
Pencil on drawing paper, 26.4 x 37 cm.
Inv. 1231
210 Analytical Drawing, ca. 1922/23
Ink over pencil on drawing paper, 27.2 x 37.1 cm.
Inv. 1232; ill. 176

Fritz Levedag
211 "Little Watercolor 1929", 1929
Pencil, India ink and watercolor on drawing paper, 19 x 18.9 cm.
Inv. 3552

Katja Rose (Käthe Schmidt)
Folder, "Analytical Drawing/Kandinsky," 1931/32
Envelope with fifteen works and one sheet with a table of contents
212 "Gradation of the Basic Colors to Black and White"
Tempera over pencil, typewritten captions on drawing paper, 20.8 x 29.6 cm.
213 "The Three Basic Colors, Yellow, Red, Blue, with Complementary Colors"
Tempera, India ink, and colored ink over pencil, typewritten explanation on drawing paper, 20.8 x 29.6 cm.
214 "Enlivening of a Ground Plane of Drab Color by Means of a Strong Accent"
Tempera over pencil and typewritten text on drawing paper; pencil and pastel on paper, 20.8 x 29.6 cm.
215 "Transformation of Tension Through Transformation of the Placement of Forms in Relation to Each Other"
Colored ink over pencil on drawing paper, 20.8 x 29.6 cm.
216 "Balancing the Weight of Black and White Basic Plane"
India ink over pencil, 20.8 x 29.6 cm.
217 Rhythm Study with a Complex of Lines
India ink over pencil on paper, 21 x 28.6 cm.
218 Balance Study
Pencil on paper, 21 x 28.9 cm.
219 Analytical Drawing
India ink over pencil preparatory drawing on drawing paper, with an overlay of India ink on transparent paper, 21.5 x 27 cm.; 29.8 x 20.9 cm.
220 Analytical Drawing
Technique and size same as entry 219
Ill. 177

221 Analytical Drawing
Pencil on paper, 21.5 x 27 cm.
222 Analytical Drawing
Technique and size the same as entry 219
223 Analytical Drawing
Pencil on paper, 27 x 21.5 cm.
224 Analytical Drawing
Technique and size the same as entry 219; also, with five overlays of diagrams of tensions: pastel or pastel and India ink on transparent paper, 17.7 x 22.4 cm., 18 x 26.6 cm., 16.3 x 27.4 cm., 15.5 x 26.2 cm., and 16.6 x 25.2 cm.
225 Analytical Drawing
Pencil on paper, 21.5 x 27 cm.
226 Analytical Drawing
India ink over pencil on drawing paper; colored ink on transparent paper, 24.3 x 32.5 cm.
227 Analytical Drawing
Technique and size the same as entry 226
Ill. 178
228 Analytical Drawing
Technique the same as entry 226; 32.5 x 25.2 cm.; in addition, three sheets with tension diagrams; pencil and pastel on paper, 21 x 28.7 cm.
229 Analytical Drawing
Technique the same as entry 226; 32.5 x 25.2 cm.

Gerhard Weber
230 Analytical Drawing, 1931/32
Pencil on drawing paper; colored ink on transparent paper, 34.6 x 45.1 cm.
231 Analytical Drawing, 1931/32
Technique same as entry 230; 45.9 x 28.3 cm.

Vincent Weber
232 Color Study, 1922
Tempera, partially over pencil, on paper, 32.9 x 21 cm.
Inv. 126
233 Color Studies, 1922
Tempera on paper, mounted on paper, 33 x 21 cm.
Inv. 1225

Notes

Kandinsky at the Bauhaus

1 "Program of the Staatliche Bauhaus in Weimar," April 1919; in Hans M. Wingler, ed., *The Bauhaus: Weimar, Dessau, Berlin, Chicago,* Cambridge, Mass., 1969, pp. 31–32. Regarding Gropius's equivocal attitude toward easel painting and the reason for hiring painters, see Marcel Franciscono, *Walter Gropius and the Creation of the Bauhaus in Weimar: The Ideals and Artistic Theories of Its Founding Years,* Urbana, 1971, especially chapter 5.

2 Peg Weiss, *Kandinsky in Munich: The Formative Jugendstil Years,* Princeton, 1979, see chapters III and XI, figures 98–116b. Later, in Russia, Kandinsky made designs for porcelain cups and saucers to be made by the former imperial porcelain factory in Leningrad, as did other artists of the Russian avant-garde; see the example illustrated in Will Grohmann, *Wassily Kandinsky: Life and Work,* New York, 1958, figure 30, dated 1919 (probably c. 1921).

3 "Program for the Institute of Artistic Culture" (1920), in Kenneth C. Lindsay and Peter Vergo, eds., *Kandinsky: Complete Writings on Art,* Boston, 1982 (hereafter referred to as Lindsay/Vergo, I or II), vol. I, pp. 461ff.; Kandinsky wrote concerning a synthesis leading to a "building dedicated to the great utopia" (p. 463). Earlier the same year he had written an article, "The 'Great Utopia',"about the coordination of all the arts and the construction of a universal building of the arts; and in December 1920, as representative of the Institute of Artistic Culture (Inkhuk) to the first Pan-Russian conference on art, he discussed synthetic art in his lecture; see Troels Andersen, "Some Unpublished letters by Kandinsky," *Artes: Periodical of the Fine Arts,* II (October 1966), pp.

101, 106. Earlier, in "On Stage Composition," *Der Blaue Reiter,* Munich, 1921, he had discussed Wagner's creation of monumental art in opera; Lindsay/Vergo, I, pp. 260–262. For Kandinsky's writings from 1919–1921, the time of his involvement in the new artistic organizations during the Russian revolutionary period, see Lindsay/Vergo, I, pp. 421–477. I have treated the Russian phase of his artistic career, during World War I and the Revolution, in *Kandinsky: Russian and Bauhaus Years, 1915–1933,* The Solomon R. Guggenheim Museum, New York, 1983.

4 Lindsay/Vergo, I, pp. 267–283 and 257–264. Kandinsky's theater pieces have been collected, in French translation, in *Wassily Kandinsky: Écrits complets,* volume III, *La Synthèse des Arts,* Philippe Sers, ed., Paris, 1975, pp. 61–119. (Hereafter referred to as: Sers III.) Finally, it should also be mentioned that Kandinsky and Franz Marc, as coeditors, included a number of articles on music in *Der Blaue Reiter,* including essays by the composers Arnold Schönberg and Thomas von Hartmann and an article on Scriabin's *Prometheus,* as well as musical scores by Schönberg, Alban Berg, and Anton von Webern.

5 See Weiss, *op. cit.,* pp. 63–65.

6 Andersen, *op. cit.,* pp. 103–104 and n. 11. Regarding Kandinsky's role in art education programs in Russia, see also: Nina Kandinsky, *Kandinsky und Ich,* Munich, 1976, pp. 86–88; Szymon Bojko, "Vkhutemas," *Art and Artists,* IX (December 1974), p. 11; and John E. Bowlt, "Concepts of Color and the Soviet Avant-Garde," *The Structurist* (Saskatoon, Canada), No. 13/14 (1973/1974), pp. 23–24, and his essay, "Vasilii Kandinsky: The Russian Connection," in the book coedited with Rose-Carol Washton Long, *The Life of Vasilii Kandinsky in Russian Art: A Study of "On the Spiritual in Art,"* Newtonville, Mass., 1980, pp. 29ff.

7 "Program for the Institute . . .," Lindsay/Vergo, I, pp. 457–472; see also Camilla Gray, *The Great Experiment: Russian Art, 1863–1922,* New York, 1962, pp. 222–223.

8 "Das Kunstprogramm des Kommissariats für Volksaufklärung in Russland," *Das Kunstblatt,* III (March, 1919), p. 92.

9 John E. Bowlt, ed., *Russian Art of the Avant-Garde: Theory and Criticism, 1902–1934,* New York, 1976, pp. 196–198.

10 Andersen, *op. cit.,* pp. 100–103.

11 Regarding the invitation to join the Bauhaus, see: Nina Kandinsky, *op. cit.,* p. 89; and Julia and Lyonel Feininger, "Wassily Kandinsky," in Wassily Kandinsky, *Concerning the Spiritual in Art,* New York, 1947, p. 12.

12 The official invitation was delivered to Kandinsky in Berlin by Walter and Alma

Gropius, in March 1922; the Kandinskys arrived in Weimar in early June; Nina Kandinsky, *op. cit.,* pp. 94, 96.

13 Grohmann, *op. cit.,* p. 172. The Jury Free murals have been reconstructed at the Musée national d'art moderne, Centre Georges Pompidou, Paris; see the museum's brochure, *Le Salon de réception conçu en 1922 par Kandinsky,* 1977.

14 Konstantin Umankskij, "Kandinskijs Rolle im russischen Kunstleben," *Der Ararat,* Mai-Juni 1920, Sonderheft II, pp. 28–30; *Neue Kunst in Russland, 1914–1919,* Potsdam-München, 1920, pp. 19–23, 44, 56; and Hugo Zehder, *Wassily Kandinsky; unter autorisierter Benutzung der russischen Selbstbiographie,* Dresden, 1920.

15 *Ibid.,* pp. 4–5.

16 *Op. cit.,* pp. 98–99, 108–9, 117; that Gropius would have been aware of Kandinsky's activities in Russia is indicated by the fact that he had in January 1919 received a copy of the "Aufruf der russischen Künstler" sent to the Arbeitsrat für Kunst by a group of artists, including Kandinsky (Franciscono, *op. cit.,* p. 150 n. 54; see also Andersen, *op. cit.,* p. 102f.).

17 *Erste Allgemeine Deutsche Kunstausstellung,* Moscow, 1924, cited by Krisztina Passuth, "Berline centre de l'art est-européen," in Centre national d'art et de culture Georges Pompidou, *Paris-Berlin: rapports et contrastes franco-allemagne, 1900–1933,* Paris 12 July–6 November, 1978, p. 228.

Ré Soupault-Niemeyer, a student at the Bauhaus from 1921 to 1925, has commented on the fact that at the time when it was announced that Kandinsky would be coming to the Bauhaus, his reputation, his writings, and his conception of the synthesis of the arts were already well known and much discussed at the school; Nina Kandinsky, *op. cit.,* pp. 95–96.

18 Franciscono, *op. cit.,* pp. 162–163, 170–171.

19 *Satzungen Staatliches Bauhaus in Weimar,* Weimar, July 1922, p. 2.

20 In *Staatliches Bauhaus Weimar 1919–1923,* Weimar-München, 1923; Lindsay/Vergo, II, pp. 499–501, 501–504; also in Wingler, *op. cit.,* pp. 74, 75.

21 "Program for the Institute. . . ," Lindsay/Vergo, I, p. 459; *Punkt und Linie zu Fläche: Beitrag zur Analyze der malerischen Elemente* (Bauhaus Book No. 9), Munich, 1926; Lindsay/Vergo, II, pp. 527–699.

22 "The Basic Elements of Form," Lindsay/Vergo, II, p. 500; "Color Course and Seminar," *ibid.,* p. 502. The three levels—elements, construction, composition—are also cited in the third essay by Kandinsky included in *Staatliches Bauhaus Weimar 1919–1923,* "Abstract Synthesis

on the Stage," in Lindsay/Vergo, II, see pp. 506–507; and in other of his writings of the Bauhaus period.

23 In Wingler, *op. cit.,* p. 80; the statement was part of the minutes of the Masters Council, 4 April 1924.

24 Outlines of his courses were published in *VI. Internationaler Kongress für Zeichnen, Kunstunterricht und angewandte Kunst,* Catalog, Prague, 1928, pp. 246–247 (reprinted in Wingler, *op. cit.,* pp. 144, 146; and *Junge Menschen kommt aus Bauhaus,* Bauhaus prospectus, Dessau, 1929, p. 8. His teaching notes have been published in a French translation: "Cours du Bauhaus," in Sers III, pp. 157–391; the first lecture of the summer semester, 1925, was on 17 June, pp. 163ff. The surviving student exercises are virtually all from the Dessau period.

In addition to teaching, Kandinsky may have had some administrative duties at the Dessau Bauhaus, as Vice-Director (more probably acting director); referred to by Nina Kandinsky, *op. cit.,* pp. 127, 139.

25 See: Kandinsky's letters to Grohmann of 16 July 1925 and November 1925, in *"Lieber Freund . . ." Künstler schreiben an Will Grohmann,* edited by Karl Gutbrod, Köln, 1968, pp. 48, 49; the foreword to *Point and Line,* Lindsay/Vergo, II, p. 530; and Grohmann, *op. cit.,* pp. 161, 179.

26 Sers III, p. 162 (27 September 1926) and 271 (1 February 1926). Six analytical drawings from around 1922 are known: four illustrated in *Staatliches Bauhaus Weimar 1919–1923* and two others by Alfred Arndt; see the section on "Analytical Drawing," here, note 46; in addition, Arndt has mentioned studying analytical drawing with Kandinsky in his account of his first years at the Bauhaus, after his arrival in fall of 1921: "How I Got to the Bauhaus in Weimar. . . ," in Eckhard Neumann, ed., *Bauhaus and Bauhaus People,* New York, 1970, p. 58. The earliest analytical drawings in the collection of the Bauhaus-Archiv are those by Lothar Lang from November 1926 (C. 102, 103, 105).

The Semester Plan is dated "about 1928" by Wingler and placed in the section on the Gropius era, which ended when his resignation became effective, 1 April 1928; *op. cit.,* p. 121. The plan lists architecture as its first division and thus reflects Hannes Meyer's presence, beginning 1 April 1927, as head of the newly instituted architecture department. In addition to "analytisches Zeichnen," it lists the "Seminar für freie plastische und malerische Gestaltung," which Kandinsky was teaching from May 1927 on; see Sers III, pp. 370ff., first class: 16 May 1927. On the other hand, it cannot date

from the period of Meyer's directorate, from April 1928 on, because this seminar is listed as being offered for students in their third semester and following semesters, whereas beginning in the early days of the Meyer period, it was offered for those in their fourth semester and later; see the outline in the Catalog of the *Sixth International Congress for Drawing, Art Education, and Applied Art,* in Wingler, *op. cit.,* p. 146; and also *Junge Menschen kommt aus Bauhaus,* p. 8.

27 *"Leiber Freund . . ." Kunstler schreiben an Will Grohmann,* pp. 51–52, 14 September 1926.

28 *i10; International Revue* (Amsterdam), I, No. 1 (1927); in Lindsay/Vergo, II, p. 715; he began his statement by saying that the new plan had been worked out "in the course of last summer"; the second sentence quoted here is omitted in Lindsay/Vergo.

29 Gropius himself later wrote, concerning Meyer, "Wie ist es . . . zu verstehen, dass er 'Malklassen' einführte, die unter mir nie bestanden und deren Einrichtung nicht nur meiner Idee, dass Kunst nicht gelehrnt werden kann, widersprach, sondern, was schwerer wiegt, seine eigenen Ideen kompromittierte"; letter to Tomás Maldonado originally published in the magazine of the Hochschule für Gestaltung, Ulm, reprinted in Claude Schnaidt, *Hannes Meyer: Bauten, Projekte und Schriften,* Teufen, Schweitz, 1965, p. 120. I am grateful to Professor O. K. Werckmeister for referring me to this letter. As already indicated, the evidence contrary to this statement is manifold. Further: Nina Kandinsky has written, "Bereits in Weimar war Kandinsky mit Gropius übereingekommen, in Dessau eine private Malklasse einrichten zu dürfen"; *op. cit.,* p. 127. Kandinsky himself wrote in his essay, "Bare Wall," dated January 1929, that for nearly two years regular instruction in painting had been offered; *Der Kunstnarr* (Dessau), I (April 1929); reprinted in Wingler, *op. cit.,* p. 154; in Lindsay/Vergo, II, p. 732–734.

30 See the course outlines in *Sixth International Congress. . . ,* in Wingler, *op. cit.,* pp. 144–146.

31 *Ibid.,* p. 146; the notes for the painting class are in Sers III, pp. 370–375 (16 May–27 June 1927, 4 November 1927) and 381–383 (6 January 1933). See Wingler, *op. cit.,* pp. 526–527, regarding painting by Bauhaus students.

32 However, as already mentioned (note 26 here), at first the "Independent Painting and Sculpture Seminar" was taught to students from their third semesters on; and in the last year of the school's existence, in Berlin, "fine art" was one of the specialized areas of study taught from the second semester on; "Syllabus and

Curriculum," October 1932, in Wingler, *op. cit.,* p. 191.

33 Sers III, pp. 370–375.

34 "Junge Bauhausmaler," *Bauhaus,* Nos. 2/3 (1928), p. 31.

35 Sers III, pp. 373, 374.

36 Sers III, pp. 274–278, 321–370, 375–376, 389–390 (28 April 1928 through winter semester of 1929/30); the course is listed in *Junge Menschen kommt aus Bauhaus, loc. cit.*

Kandinsky had previously given a series of advanced lectures on form and composition—probably given only once, since there is only one date on each lecture, unlike many of his other lecture notes: 15 lectures, 18 June 1925 to February 1926; Sers III, pp. 236–251. Evidence that these were not truly part of Kandinsky's preliminary course is provided by the fact that they do not correspond to the outline for that course (pp. 184–185), with which the basic group of lectures for the Abstract Form Elements course do generally correlate (pp. 163–236, 251–274; beginning 17 June 1925, to 11 September 1925, then repeated and augmented, to 1 March 1926, with additional lectures from subsequent years inserted into the sequence); also, this advanced series includes the comment "see preliminary course" (p. 245); finally, two student names are cited in the notes, Werner Isaacsohn and Walter Fieck (sic; pp. 248–249), who were among the students who had come from Weimar to Dessau and thus weren't first-semester students; see the "Immatriculation List of Bauhaus Students of the Dessau and Berlin Periods," in Wingler, *op. cit.,* p. 622, Nos. 38 and 62. This series of lectures seems to be the closest of any to *Point and Line to Plane,* which Kandinsky was writing during the first part of the series.

37 Sers III, pp. 278–281, 283–321, 376–381, 383–387, 390–391 (beginning 12 December 1930, winter semester 1930/31; summer semester 1931; winter semester 1931/32).

38 "Color Course and Seminar," Lindsay/Vergo, II, especially p. 503; *VI. Internationaler Kongress fur Zeichnen. . . , loc. cit.,* pp. 144, 146; *Junge Menschen kommt aus Bauhaus, loc. cit.*

39 Julia and Lyonel Feininger, *op. cit.,* p. 13; Ursula Diederich Schuh, "In Kandinsky's Classroom," in Neuman, *op. cit.,* p. 162.

40 Eberhard Roters, *Painters of the Bauhaus,* New York, 1969, pp. 130–131; Jean Leppien, quoted in Nina Kandinsky, *op. cit.,* p. 135; Suzanne Markos-Ney (Leppien), *ibid.,* pp. 131, 133; Gunta Stölzl, *ibid.,* pp. 108–109.

41 Leppien, *loc. cit.,*

42 Markos-Ney, *loc. cit.,* p. 132.

43 Max Bill, "Kandinsky, l'éducateur/Kan-

dinsky als Pädagoge und Erzieher," in Bill, ed., *Wassily Kandinsky,* Paris, 1951, pp. 97–98 (French) and 148 (German); Herbert Bayer, quoted in Nina Kandinsky, *op. cit.,* p. 110; Leppien, *ibid.,* p. 128; Marcos-Ney, *ibid.,* p. 132; Julia and Lyonel Feininger, *loc. cit.* Kandinsky's letters to his former student Hans Thiemann attest to his long-term interest in a former student's work, warm sympathy both personal and artistic, and professional encouragement: "Zwölf Briefe von Wassily Kandinsky an Hans Thiemann, 1933–1939," *Wallraf Richartz Jahrbuch,* XXXVIII, 1976, especially pp. 156 and 159.

44 *Op. cit.,* pp. 64–65; Weiss discusses Kandinsky's pedagogical talent, attracting students and encouraging their individual abilities.

45 Student exercises in the German Democratic Republic have been published in the *Wissenschaftliche Zeitschrift der Hochschule für Architektur und Bauwesen Weimar,* 26 Jahrg., 1979, Heft 4/5, p. 449 (by Konrad Püschel, 1926/27, and Grete Reichardt, c. 1927, see illustration 12, p. 451); and a group of twenty-four studies by Reinhold Rossig, 1929, in Galerie am Sachsenplatz, *Bauhaus 2,* Katalog 6 der Galerie, Leipzig, 29 October–29 November 1977, pp. 46–47 and 50–51. See also: the paintings by Eugen Batz and Fritz Tschaschnig and the analytical drawings of Karl Klode in Wolfgang Wangler, *Bauhaus—2. Generation,* Köln, 1980, pp. 68, 76, 88–93; and Peter Hahn, *Junge Maler am Bauhaus,* Galerie del Levante, München, 1979, including the watercolor by Wilhelm Imkamp, *Mystisches Schweben,* 1928. In addition, there are two studies from Kandinsky's analytical drawing course by Margaret Leischner in the Victoria and Albert Museum, London, Circ. 23–1968.

46 At the Bauhaus Archive there is a group of studies for Klee's Preliminary Course, by Otti Berger, 1927/28, Lisbeth Birmann-Ostreicher, 1926/27, Egon Gürtler, 1927, and Margaret Leischner, 1927/28.

47 Works by students in Moholy-Nagy's and Albers's parts of the Preliminary Course are illustrated in Wingler, *op. cit.,* and in *50 Years Bauhaus,* Württembergischer Kunstverein, Stuttgart, 1968.

48 See the works just cited and Johannes Itten, *Design and Form: the Basic Course at the Bauhaus and Later,* Revised edition, New York, 1975.

49 See Marianne L. Teuber, *"Blue Night* by Paul Klee," in *Vision and Artifact,* edited by Mary Henle, New York, 1976, p. 144 and notes 24 and 26. The notes on Dürkheim's lectures by Howard Dearstyne, at the Busch-Reisinger Museum, Harvard University, contain numerous references to Krueger's journals and other publica-

tions by Gestalt psychologists; I am grateful to Mrs. Teuber for showing me her copy of Dearstyne's notes. Kandinsky referred to volumes of the *Neue Psychologische Studien* in class, Sers III, pp. 180–182.

50 Thorleif Schjelderup-Ebbe, "Der Kontrast auf dem Gebiete des Licht- und Farbensinnes," *Neue Psychologische Studien,* 2. Bd., 1926, p. 108.

51 Friedrich Weissenborn, "Die Lage der Qualitäten im Farbenkreis und ihre Komplementärverhältnisse, nach der Schwellenmethode untersucht," *ibid.,* p. 309ff., see color plate IV and plate III. Ulmann-Broner's study, "Diagram of the Emotional Effects of the Color Spectrum . . . ," (Fig. 173, C. 148) seems also to have been derived from an illustration in a scientific publication, but I have been unable to find the source.

52 I am indebted to Dr. Christian Wolsdorff of the Bauhaus Archive for our conversations concerning the construction and execution of the student exercises.

53 Kessinger-Petitpierre's "Geometrical Study" (Fig. 155, C. 44), which consists of a long curving line of repeated circles, is particularly close to some of the studies for Albers.

54 "Bauhaus Wanderschau 1930; '10 Jahre Bauhaus, 1920 bis 1930,'" *Volksblatt Dessau,* 29 January 1930. A clipping of this review, along with a number of other reviews of the exhibition, is in the Albers Scrapbook at the Busch-Reisinger Museum, P/Al/7.

55 *Point and Line,* Lindsay/Vergo, II, pp. 639ff.

56 The date of the gouache by Klode, 1932, indicates that it probably was done in the painting class, since he entered the Bauhaus in 1930 and took the Preliminary Course at that time, as attested by his analytical drawings. Two interesting collages using formal elements and arrangements derived from Kandinsky, dated 1931, must also be from the painting class: *Rund und Spitz* and *Abstrakte Elemente,* reproduced in Hahn, *op. cit.* (see note 45, above).

57 Another painting by Röseler, *Komposition (Stilleben),* June 1927, is also possibly from Kandinsky's painting class; now at the Bauhaus Archive, see here, C. 118.

58 Two paintings by Tschaschnig at the Bauhaus-Archiv, *Grüne Bezirke hinter Mauer* and *Rote Tür,* both from 1932, are from Kandinsky's class and show the decided influence of Klee evident in other paintings by this student (C. 140, 141). Two paintings by Batz, *Ohne Titel,* 1929–1930, and *Roter Punkt,* 1930, show Kandinsky's stylistic influence (C. 16, 17).

59 Sers III, 163–172 (lectures 1–3, 17 and 19 June and 1 July 1925), 201–203 (lecture 4, probably the next class in July 1925),

plus 174–180, 185–197 (related material at least some of which was added in later years; pp. 187ff are labeled "7. lecture" but deal with the same material); see also the outlines pp. 184–185, corresponding to the 1925 summer lectures, and p. 234, which bears the dates April–May 1927 (October–November 1927).

60 Lindsay/Vergo, II, pp. 506–507; regarding poetry he wrote that is had "not yet discovered its own abstract resources." A very brief excerpt from this essay was reprinted in *Bauhaus,* No. 3, 1927, p. 6.

61 Kandinsky's discussion of Wagner in this connection, in "On Stage Composition" (1912), is cited in note 3, above.

62 "The Basic Elements of Form," and "Color Course and Seminar," Lindsay/Vergo, II, pp. 499–504.

63 In Paul Westheim, *Künstler Bekenntnisse,* Berlin, 1925; Lindsay/Vergo, II, p. 509.

64 Lindsay/Vergo, II, pp. 711–712; Sers III, pp. 164, 166, 167 (June 1925), 184; the essay, "And . . . ," presents a chart showing the divisions among human spiritual, intellectual, and artistic activities, similar to that which Kandinsky used in his teaching (Sers III, p. 165, figures 3 and 4): Lindsay/Vergo, II, p. 709.

65 Sers III, pp. 170–172 and elsewhere, see the Introduction by Sers, pp. 17–19.

66 Sers III, pp. 188–189.

67 Cf. Kandinsky's essay, "Abstrakte Kunst," *Cicerone,* XVII, 1925; "Abstract Art," Lindsay/Vergo, II, pp. 512–513.

68 Lindsay/Vergo, II, pp. 758–759; originally published as "Réflexions sur l'art abstrait," *Cahiers d'art,* VI, No. 7–8 (1931). Regarding the need for intuition as an adjunct to intellectual investigations, cf. Paul Klee, "Exact Experiments in the Realm of Art," *Bauhaus,* No. 2/3, 1928; in Wingler, *op. cit.,* p. 148.

69 Sers III, pp. 189–190, 201.

70 *Point and Line,* Lindsay/Vergo, II, p. 548; cf. "Abstract Art," Lindsay/Vergo, II, pp. 514ff.; Sers III, pp. 310–311.

71 *Point and Line,* Lindsay/Vergo, II, p. 552; cf. Sers III, pp. 191–192; "Color Course and Seminar," Lindsay/Vergo, II, p. 502; "Abstract Art," Lindsay/Vergo, II, p. 516f.

72 The science of art is mentioned in Kandinsky's teaching, Sers III, p. 170 and elsewhere; cf. "Yesterday—Today—Tomorrow," Lindsay/Vergo, II, pp. 508–509.

73 *Wassily Kandinsky,* Dresden, 1920, p. 1.

74 Sers III, pp. 198–199, also p. 216.

75 Sers III, pp. 199–200, cited as "Taten und Leiden des Lichts." Luckiesh, *Licht und Arbeit,* Berlin, 1926, chapter I, table I; Kandinsky also used Frauenhofer and Michelson wave-length tables, Sers III, pp. 221–222, 387.

76 Leipzig, 1906, p. 301; Kandinsky's use of this method is discussed in section two, "Color Theory," here.

77 "Art in 'The Epoch of the Great Spiritual':

Occult Elements in the Early Theory of Abstract Painting," *Journal of the Warburg and Courthauld Institutes*, XXIX, 1966, pp. 389 & 391; J. W. Goethe, *Werke*, 33–36, 1884–1897 (*Deutsche National-Literatur*, 114–17).

78 "Paul Klee in the Bauhaus: The Artist as Lawgiver," *Arts Magazine*, LII, No. 1 (September 1977), p. 125.

79 Kandinsky, "Plan for Physicopsychological Department of the Russian Academy of Artistic Sciences" (RAKhN), presented June 1921, in John E. Bowlt, ed., *Russian Art of the Avant-Garde*, p. 197.

80 "Program for the Institute . . . ," Lindsay/Vergo I, p. 459; "Questionnaire to determine the synaesthetic relations between color and form," 1923, in Wingler, *op. cit.*, p. 74.

81 *Bauhaus*, No. 1, 1926, p. 4; in Wingler, *op. cit.*, pp. 112–113; Lindsay/Vergo, II, pp. 703–704.

82 *Bauhaus*, No. 2/3, 1928, p. 10; in Wingler, *op. cit.*, p. 147; Lindsay/Vergo, II, p. 723. Cf. Franciscono, "Paul Klee in the Bauhaus . . . ," *loc. cit.*, p. 126.

83 In his reply to a questionnaire, in Paul Plaut, *Die Psychologie der produktiven Persönlichkeit*, Stuttgart, 1929; in Lindsay/Vergo, II, p. 740.

84 "Reflections on Abstract Art," Lindsay/Vergo, II, p. 759.

85 "The Value of Theoretical Instruction in Painting," Lindsay/Vergo, II, p. 705.

86 "Art Pedagogy," Lindsay/Vergo, II, pp. 723–724. Kandinsky commented on both the criticism of painting and the practice of painting by many at the Bauhaus in "Bare Wall," in Wingler, *op. cit.*, p. 154–155; Lindsay/Vergo, II, pp. 732–734. Such issues are a primary subject of Friedhelm Kröll, *Bauhaus 1919–1933: Künstler zwischen Isolation und kollektiver Praxis*, Düsseldorf, 1974.

87 In Wingler, *op. cit.*, pp. 172. Kandinsky has been called "der Hauptopponent Meyers" by Friedhelm Kröll (*op. cit.*, p. 96), due to the conflict between the two over the role of art at the Bauhaus as well as the place of politics at the school; Kröll discusses this situation further, pp. 102–103. Evidently Kandinsky was instrumental in alerting the Oberbürgermeister of Dessau, Fritz Hesse, to Meyer's encouragement of left-wing politics at the school, leading Hesse and the City Council to terminate his contract on August 1, 1930. Among the relevant documents are: Meyer's open letter to Hesse, "My Expulsion from the Bauhaus," published in *Das Tagebuch* (Berlin), 16 August 1930, in Wingler, *op. cit.*, pp. 163–165; "Herr Kandinsky, is it true . . . ?" *Bauhaus, Sprachrohr der Studierenden*, Nr. 3, 1930, in Wingler, p. 169; Fritz Hesse, *Von der Residenz zur Bauhausstadt* (Erinnerungen an Dessau, Vol. I), Bad

Pyrmont, 1963, p. 245, on Meyer's dismissal. Nina Kandinsky has reported on Kandinsky's alarm at hearing from a student that Meyer was a communist and was introducing communist propaganda at the school, but has claimed that he was not responsible for Meyer's dismissal; *op. cit.*, pp. 139–140, 142, 145–146.

88 "On the Problem of Art Education at the Bauhaus," in Wingler, *op. cit.*, p. 184; "Syllabus and Curriculum," October 1932, *ibid.*, pp. 182–184.

89 Franciscono, *Walter Gropius and the Creation of the Bauhaus in Weimar*, chapter 5.

90 The phrase is Lothar Lang's: *Das Bauhaus 1919–1933; Idee und Wirklichkeit*, 2. Auflage, Berlin (Ost), 1966, p. 165, n. 139.

91 In Wingler, *op. cit.*, p. 80. See Sers III, p. 275 (Fourth Semester, lecture given 27 April 1928 and 2 November 1928): Kandinsky remarked that there was indecision at the Bauhaus about being a school or a production enterprise.

92 Sers III, pp. 275, 329f. See also Sers's discussion in his introduction, pp. 20–25.

For example, Kandinsky stressed the fact that modern architecture, however functionalist it might purport to be, had some purely aesthetic aspects, most notably the quality of dematerialization achieved through the use of glass and the tendency toward height. In one class he compared the practical construction of a silo, and its verticality, with a skyscraper project by Mies van der Rohe, referring to illustrations in Gropius's *Internationale Architektur* (Bauhaus Book No. 1), Munich, 1925, pp. 45–47; Mies's project, according to Kandinsky, was characterized by a "spiritual" verticality and a dematerialization of the material; Sers III, pp. 368–369 (21 September 1928).

93 *Ibid.*, pp. 343, 355–356.

94 *Ibid.*, p. 332.

95 Nina Kandinsky, p. 119; Breuer designed the bedroom and dining-room furniture for the couple, "nach genauen Angaben Kandinskys."

96 Sers III, p. 342.

97 *Ibid.*, pp. 330, 335.

98 "Bauhaus-Vortrag," *Anhalter Anzeiger Dessau*, 3, II. 30. Cf. Sers III, pp. 278, 383, 390f., for Kandinsky's comments on the animal beginnings of dance, music, and architecture, and his conclusion that the human being has an innate instinct for painting and sculpture, apart from practical needs.

99 See note 46, above. "Violett (Bühnenstück)" was announced as one of the books in preparation, in the prospectus of 1927 for the Bauhaus Books, in Wingler, *op. cit.*, p. 130; a French translation of the Russian version is published in Sers

III, pp. 83–111. For Kandinsky's comments on theater in his teaching, see Sers III, p. 328 and elsewhere.

100 However, Kandinsky did support and defend the work of the Bauhaus theater, in response to the opposition to it by Hannes Meyer and some of the students, as Oskar Schlemmer recorded in his correspondence. Indeed, Schlemmer reported that Kandinsky felt that many of his own ideas were actualized in the work of the Bauhaus stage under Schlemmer's leadership; *The Letters and Diaries of Oskar Schlemmer*, edited by Tut Schlemmer, Middletown, Connecticut, 1977, letter of 8 September 1929 to Otto Meyer, p. 248.

101 Kandinsky, "Bilder einer Ausstellung (Modeste Mussorgsky)," *Das Kunstblatt*, XIV, No. 8 (August 1930); Lindsay/Vergo, II, pp. 750–751; Ludwig Grote, "Bühnenkompositionen von Kandinsky," *i 10; Internationale Revue* (Amsterdam), II, No. 13 (1928), pp. 4–5. See also Nina Kandinsky, *op. cit.*, pp. 152ff., including a reproduction of a page of the musical score with Kandinsky's instructions for the staging.

102 *"Lieber Freund . . ." Künstler schreiben an Will Grohmann*, p. 45.

103 In *Kandinsky, 1901–1913*, Berlin, Der Sturm, 1913; Lindsay/Vergo, I, pp. 368–369. Much later, in his Bauhaus teaching, Kandinsky mentioned the artistic unity achieved in the Russian peasant houses; Sers III, p. 363 (28 September 1928).

104 See Bayer's brief remarks in Nina Kandinsky, *op. cit.*, p. 109.

105 See the museum's brochure, cited in note 13, above; the reconstruction is based on the five original gouache maquettes, now in the collection of the museum. See also Carola Giedion-Welcker, "Kandinsky's Approach to the Monumental," *Homage to Wassily Kandinsky*, New York, 1975, pp. 51–55.

106 The music room has also been reconstructed, at Artcurial, Centre d'art plastique contemporain, in Paris; the large porcelain tiles were made by the firm of Villeroy & Bloch; the room was inaugurated in June 1975.

107 "Wandmalerei (Bauhaus-Ausstellung, 1923)," Bauhaus-Archiv Inv. Nr. 1020; transcribed in Wulf Herzogenrath, *Oskar Schlemmer: Die Wandgestaltung der neuen Architektur*, Munich, 1973, p. 35.

108 See the illustrations in Wingler, *op. cit.*, pp. 451, 535; *50 Years Bauhaus*, pp. 130, 133, Nos. 387, 389–391.

109 "Raumgestaltung einer Durchfahrt," in *Staatliches Bauhaus Weimar 1919–1923*, color plate VI.

110 "Die Arbeit in der Wandmalerei . . . ," *loc. cit.* (see note 23, above).

111 *Bauhaus Dessau: Hochschule für Gestaltung*, Curriculum, April 1931. An earli-

er use of the term is in the title of an essay by a Bauhaus student on the architectural use of color: Walter Fiek, "Von farbiger Raumgestaltung," *Vivos Voco,* V, Nos. 8/9 (1926), p. 271.

112 Gustav Adolf Platz, *Die Baukunst der neuesten Zeit,* Berlin, 1927, Plate XX: "Entwurf des Ateliers Kandinsky in Dessau."

113 Sers III, p. 327 (18 May 1928).

114 See the photograph of the room, illustrated in Grohmann, *op. cit.,* figure 21, and elsewhere.

115 Sers III, p. 378 (second-semester course).

116 Nina Kandinsky, *op. cit.,* pp. 118–119; for other, contemporary accounts of these interiors, see the articles by Max Osborn and Fannina W. Halle, in Wingler, *op. cit.,* pp. 124, 150–151.

117 Sers III, pp. 333 (18 May 1928) and 275 (27 April and 2 November 1928). See note 92, above.

118 *Ibid.,* p. 333; Nina Kandinsky, *op. cit.,* p. 118.

Color Theory

1 "The Basic Elements of Form," "Color Course and Seminar," Lindsay/Vergo, II, pp. 499–501, 501–504. The hierarchical ordering of the elements was also discussed in Kandinsky's Russian proposals; see "Program for the Institute of Artistic Culture," Lindsay/Vergo, I, pp. 457–472.

2 *Ibid.,* p. 460; cf. also Camilla Gray, *The Great Experiment: Russian Art, 1863–1922,* New York, 1962, p. 222.

3 *Sixth International Congress . . . ,* in Wingler, *op. cit.,* p. 144.

4 An outline of the course appears in Kandinsky's "Cours du Bauhaus," in *Wassily Kandinsky: Écrits complets,* volume III, *La Synthèse des arts,* Philippe Sers, ed., Paris, 1975, pp. 184–185. (Hereafter referred to as: Sers III.) The seven lectures listed there as devoted to color, lectures numbers five through eleven, essentially correspond to the following classes for which there are teaching notes: No. 5, Yellow and Blue, pp. 203–207; No. 6, Red, pp. 207–209; No. 7, White and Black, pp. 210ff.; No. 9, Combinations Yellow/Blue/White/Black, pp. 219–222; No. 9, 14 December 1925, Green and Gray, pp. 261–264; No. 10, 25 June 1926 (7 February 1927, 4 July 1927), Orange and Violet, pp. 264–268. The dates are given in the Sers edition only for the last two of these, although it is clear from earlier lectures in the series (No. 2, 19 June 1925, and No. 3, 1 July 1925, pp. 166ff.) that the others are from summer of 1925. The dates from 1927 given in parentheses are for the occasions when the lecture was repeated, presumably an incomplete listing of such reuses.

In addition to the teaching notes (Sers III, pp. 157–391), a number of items that Kandinsky used to demonstrate aspects of his theories to his class have survived and are now in the possession of Professor Sers: a collection of paper geometrical shapes in different colors for studying compositional effects—rectangles, squares, disks, and a triangle; a set of six pieces, each with a yellow, blue, or white circle on a square background of black or white; two studies of white and black squares on medium gray backgrounds; and a "nine-part color triangle" and template, showing the triads of primary, secondary, and tertiary colors. In addition, there are a series of lines, ranging from thin to broad, on white paper and a set of illustrations of paintings and other art used for Kandinsky's analyses of these works in class. References to the color studies in this group are made below, in notes 29, 84, and 135.

5 *On the Spiritual,* Lindsay/Vergo, I, pp. 117ff. *Point and Line,* Lindsay/Vergo, II, pp. 577ff.

6 Paul Klee, *Notebooks, Volume I: The Thinking Eye,* edited by Jürg Spiller, London, 1973, pp. 467ff. Johannes Itten, *Tagebuch: Beiträge zu einem Kontrapunkt der bildenden Kunst,* Berlin, 1930, pp. 77ff.; *The Art of Color,* New York, 1961. I have compared the color theories of Kandinsky, Klee, Itten, and other Bauhaus masters in *Bauhaus Color,* The High Museum of Art, Atlanta, Georgia, 1976.

7 J. W. Goethe, *Zur Farbenlehre,* "Didaktischer Teil" (originally published 1810), in *Naturwissenschaftliche Schriften,* 1. Teil, Artemis-Verlag Zürich, 1949, paragraph 696. For Kandinsky's use of the terms *plus-minus,* see Sers III, p. 214. Re: *active* and *passive,* see Goethe paragraph 831 and also paragraphs 503, 504, and elsewhere.

8 For example, the list of qualities in lecture Nr. 5, Sers III, p. 206.

9 Sers III, p. 198; the deletions are Kandinsky's. Cf. Goethe paragraphs 765, 766; 778, 781, 782.

10 Sers III, 204–205; cf. *On the Spiritual,* Lindsay/Vergo, I, pp. 179ff.

11 See the diagrams in Sers III, p. 205.

12 Sers III, pp. 207 and 208, exercise numbers 2 and 3; see also p. 173, exercise numbers 1 and 2. Cf. *On the Spiritual,* Lindsay/Vergo, I, p. 179: ". . . yellow tends toward light (i.e., white) to such an extent that no very dark yellow can exist."

13 *Ibid.,* p. 178. He also cited the four cases in his teaching, Sers III, p. 204. See also the notes by Irmgard Sörensen-Popitz (Söre Popitz), "Vorkurs Bauhaus—Farbenlehre mit Übungen—Kandinsky," 1924, at the Bauhaus-Archiv: the "4 Hauptklänge," cited on p. 1 (C. 204).

14 "Rückblicke" appeared in *Kandinsky, 1901–1913,* Der Sturm, Berlin, 1913; Lindsay/Vergo, I, see p. 364.

15 *On the Spiritual,* Lindsay/Vergo, I, pp. 157–158. L. D. Ettlinger, *Kandinsky's "At Rest",* London, 1961, pp. 11–12.

16 *On the Spiritual,* Lindsay/Vergo, I, p. 159. Ettlinger cites F. Galton, *Inquiries into Human Faculty* (1883). Sixten Ringbom links Kandinsky's interest in synaesthesia to spiritualist writings, particularly those of the Theosophists, who considered the phenomena as part of the refined sensitivity of those who were highly developed spiritually, and thus Ringbom believes that Kandinsky wouldn't have accepted a physiological explanation, as deriving from positivistic science: "Art in 'The Epoch of the Great Spiritual': Occult Elements in the Early Theory of Abstract Painting," *Journal of the Warburg and Courtauld Institutes,* XXIX, 1966, pp. 398–399; and *The Sounding Cosmos: a Study in the Spiritualism of Kandinsky and the Genesis of Abstract Painting,* Abo, Finland, 1970, pp. 88–93.

See Jonathan Fineberg, *Kandinsky in Paris, 1906–1907,* Ann Arbor, 1984, regarding other sources for Kandinsky's knowledge of synaesthesia, *audition coloree,* and further concepts that were of concern to the symbolists associated with the journal *Les Tendances Nouvelles,* as well as theories of the Neo-Impressionists.

17 *On the Spiritual,* Lindsay/Vergo, I, p. 158.

18 Sers III, p. 182, cf. also p. 217. See *On the Spiritual,* Lindsay/Vergo, I, p. 160: "The soul is the piano, with its many strings." The comment about yellow (Sers III, *ibid.*) is a paraphrase of a statement in *On the Spiritual,* Lindsay/Vergo, I, pp. 157–158. Re: Kandinsky's experiments at the Institute of Artistic Culture, Moscow, with synaesthetic relationships between music, drawing, and color, see Troels Andersen, "Some Unpublished Letters by Kandinsky," *Artes: Periodical of the Fine Arts,* II (Oct. 1966), p. 107.

19 Sers III, 206; cf. *On the Spiritual,* Lindsay/Vergo, I, pp. 158–159. Kandinsky's continued interest in synaesthesia is further indicated by his summary of the theory in his essay, "L'Art concret," *XXe Siècle,* I, No. 1 (1938); "Concrete Art," Lindsay/Vergo, II, pp. 815–816, where he explicitly refers to his discussion on this subject in *On the Spiritual.*

20 The connections between colors and the sounds of musical instruments were mentioned in *On the Spiritual,* Lindsay/Vergo, I, pp. 159, 162, and elsewhere. Kandinsky probably derived his idea of correspondences between vowels and colors from an article by Karl Scheffler that he cited, *ibid.,* p. 161: "Notizen über die Farbe," *Dekorative Kunst,* VII (February, 1901), pp. 183–196, see p. 187; referred to in Peg Weiss, *Kandinsky in Munich: The Formative Jugendstil Years,*

Princeton, 1979, p. 110. Scheffler associated *u* with *dunkelblau,* but *i* with *brennend rot.*

21 *On the Spiritual,* Lindsay/Vergo, I, p. 163. Another characteristic of colors that can be related to synaesthesia is the feeling of lightness or heaviness they may convey, involving a sixth sense, kinesthesia, the internal sense of bodily movements and tensions. Kandinsky's conception of colors as having various "weights" is discussed here in the section on "The Role of Color in Pictorial Composition"; see *Point and Line,* Lindsay/Vergo, II, p. 593.

22 *On the Spiritual,* Lindsay/Vergo, I, p. 159. Kandinsky referred to this evidence from chromotherapy in his 1920 proposal for the Institute of Artistic Culture, Moscow. Scheffler, *loc. cit.,* mentioned chromotherapy. Ringbom has shown that Kandinsky had learned about this occult science from A. Osborn Eaves' booklet *Die Kräfte der Farben,* Berlin, 1906; *The Sounding Cosmos,* pp. 86–87.

23 Sers III, p. 222. Kandinsky's knowledge of the use of color in German medical facilities may have come from his Bauhaus colleague Hinnerk Scheper, who in 1924 prepared color designs for the University Clinics in Münster; see Lou Scheper, "Retrospective," in Eckhard Neumann, *Bauhaus and Bauhaus People,* New York, 1970, p. 116.

24 Goethe, paragraphs 764 and 777.

25 Sers III, p. 221, where there is also a list further identifying the physical and emotional effects of the individual colors.

26 Sers III, pp. 180–181, cf. also p. 216; *Neue Psychologische Studien,* VI (1932), pp. 505–506; Krueger's references to Van Emmichoven are to his dissertation, *De werking der kleuren op het gevöel,* Utrecht, 1923. Re: evidence from physics, Kandinsky listed the wavelengths of the spectral colors, according to Frauenhof, and related them to the exciting (warm) and calming (cool) colors; Sers III, p. 221–222. Elsewhere he listed wavelength tables from Michelson (Sers III, p. 387) and from Matthew Luckiesh, *Licht und Arbeit* Berlin, 1926 (Sers III, pp. 199–200).

27 *On the Spiritual,* Lindsay/Vergo, I, p. 158, and elsewhere. Cf. the use of the term *Pulsschläge* in the notebook of the student Hans Kessler (C. 203, p. 9, 1931/32). The combinations of the basic colors and shapes are assigned tempi and beats: the yellow triangle—presto, 135; the red square—andante, 75; the blue circle—grave, 50. In parentheses under the word *Pulsschläge,* the student has irreverently written "nicht bewiesen!" Kandinsky's own more elaborate diagram (with 130 beats for the yellow triangle) appears in the teaching notes; Sers III, p. 260.

28 *On the Spiritual,* Lindsay/Vergo, I, p. 179 and Table I; Kandinsky also mentioned a third kind of movement of yellow and blue, ascending and descending, that plays a role in pictorial composition.

29 *Ibid.;* circles of this sort are represented diagramatically in his teaching notes, Sers III, p. 205. Goethe described essentially the same effects, paragraph 16. Kandinsky showed spatial effects as well as the simultaneous effects caused by different backgrounds by using some of the demonstration pieces now in the possession of Philippe Sers (see note 4, above), i.e., the set of six paper pieces each with a disk of blue, yellow, or white on a black or white square background.

30 Assignment, exercise No. 3, Sers III, p. 173.

31 Sers III, p. 214, Sörensen-Popitz (cf. note 13 here), p. 3. Exercises using the other color combinations are cited in Sers III, pp. 216, 264, 266.

32 O. N. Rood, *Die moderne Farbenlehre, mit Hinweisung auf ihre Benutzungen in Malerei und Kunstgewerke,* Leipzig, 1880, chapter VX; original American edition: *Modern Chromatics, with Applications to Art and Industry,* New York, 1879. Rood's book was an important influence on the French Neo-Impressionists, and he was included among the "Témoignages," in Paul Signac's *D'Eugène Delacroix au néo-impressionisme* (1899), chapter VII, section 4, of which Kandinsky knew the German edition (see below, note 44).

33 Bauhaus Archive, Inv. Nos. 1133, 1134, 1135; *50 Years Bauhaus,* p. 40, Nos. 45–47.

34 Numbers 1, 3, 4, and 5 of this series are at the Busch-Reisinger Museum, Harvard University, acquisition numbers 1949.725, 724, 726, 727; *Concepts of the Bauhaus: The Busch-Reisinger Museum Collection,* edited by John David Farmer and Geraldine Weiss, Cambridge, Mass., 1971, p. 36. Numbers 2 and 6 are at the Bauhaus Archive. Re: Hirschfeld-Mack's workshop and his color studies, see: Herbert Bayer, Walter and Ise Gropius, *Bauhaus 1919–1928,* The Museum of Modern Art (New York, 1938), third printing, Boston, 1959, p. 39; *50 Years Bauhaus,* pp. 60–61, Nos. 218–221; L. Hirschfeld-Mack, *The Bauhaus: An Introductory Survey,* Victoria, Australia, 1963, pp. 5–6, 20–22; "Letter from Ludwig Hirschfeld-Mack to Standish Lawder," *Form* (Cambridge, Eng.), No. 2 (Sept. 1966), p. 13. In a letter of 15 November 1937 to Herbert Bayer, he explained that the theoretical charts "Filled a room in the 1923 exhibition in Weimar" (in the files of The Museum of Modern Art, New York).

35 Bauhaus Archive, numbered 8 and 9 by Hirschfeld-Mack.

36 Plate IV, p. 67. This study is listed at the end of Kandinsky's article, "Color Course and Seminar" as one of the "Examples of the experimental and constructive exercises of the color seminar," along with Kandinsky's plate, "The three primary colors distributed among the three primary forms"; Lindsay/Vergo, II, pp. 503–504. Also included, confusingly, are three plates by Hirschfeld-Mack, which probably came out of his own workshop.

37 In Sörensen-Popitz's notes (C. 204), which date from 1924, see pp. 2–3, including the square-in-square diagram; Sers III, pp. 173, 208, 214.

38 Braunschweig, 1874, pp. 233–235. Von Bezold referred to red and blue as the warm and cold colors, and Kandinsky assigned the characteristics of red to yellow. The physiological phenomenon, termed "chromatic aberration," has been known since the late nineteenth century; cf. David Katz, *The World of Color,* London, 1935, p. 69, citing: Helmholtz, *Handbuch der physiologischen Optik,* second edition, Hamburg and Leipzig, 1896, pp. 156ff.; and E. Brücke, *Die Physiologie der Farben für die Zwecke des Kunstgewerbes,* Leipzig, 1887, p. 173f.

39 Goethe paragraphs 16 and 90, and plate IIa; in the Artemis edition, this plate precedes p. 945. Kandinsky himself illustrated such diagrams in *Point and Line,* Lindsay/Vergo, II, p. 678, plate 5, "Black point and white point as elementary color values."

40 *On the Spiritual,* Lindsay/Vergo, I, pp. 179, 180. Cf. Sörensen-Popitz, p. 2: "Weiss fliesst über die Grenze; . . . Weiss auf Schwarz grösser; Schwarz auf Weiss kleiner." Kandinsky cited the French edition of Helmholtz, *Optique et la peinture,* Paris, 1902 (Sers III, p. 175); published at the end of E. Brücke, *Principes scientifiques des Beaux-Arts,* of which the first edition appeared in 1878. In the German edition the discussion of irradiation appears on pp. 85–87: in *Populäre wissenschaftliche Vorträge,* Vol. III, Braunschweig, 1876. Kandinsky's reference to Helmholtz's lectures appears under the heading "From the subjective to the objective," and Helmholtz began his discussion with the statement that the phenomena of irradiation belong "an die Reihe dieser subjectiven Erscheinungen, welche die Künstler auf ihren Gemälden objectiv darzustellen genöthigt sind" (p. 85).

41 See Marianne L. Teuber, "*Blue Night* by Paul Klee," in *Vision and Artifact,* edited by Mary Henle, New York, 1976, p. 143, re: Kandinsky's and Klee's probable interest in Lipps's theory, citing his *Raumästhetik und geometrisch-optische Täuschungen,* Leipzig, 1897, and *Aesthetik,* I and II, Hamburg and Leipzig, 1903 and 1906. P. Weiss discusses Lipps

and his influence, pp. 24, 26, 113 (cf. note 20 here).

42 *The Sounding Cosmos,* pp. 86–87, and figure 23, with the quote from Eaves's book (p. 7); cf. *On the Spiritual,* Lindsay/Vergo, I, Table I, p. 178.

43 Berlin, 1920, Plate II and p. 115. Cf. Goethe paragraph 38 and plate IIa (note 39 here); re: simultaneous contrast, see also paragraph 56. M. L. Teuber discussed the influence of Hering's book on Hirschfeld-Mack's early studies as well as on Klee in her paper, "Paul Klee: Abstract Art and Visual Perception," 61st Annual Meeting of the College Art Association of America, New York City, January 1973. Presumably, Paris's studies in the *Staatliches Bauhaus Weimar . . .* book were executed in Kandinsky's color seminar (see note 36 here), but he was probably also influenced by Hirschfeld-Mack. This relationship to the two influences, teacher and fellow student, is seen in another of Paris's studies on the plate: "Example of the different effects produced on white and on black by the same linear and two-dimensional elements" (Plate IV), Lindsay/Vergo, II, p. 509. As in a double lithograph by Hirschfeld-Mack from around 1922, now at the Bauhaus Archive, identical complex designs are repeated in reverse on black and white, recalling Kandinsky's discussion of the difference between black and white as backgrounds for colors (*50 Years Bauhaus,* p. 60, No. 220; *On the Spiritual,* Lindsay/Vergo, I, p. 186). Kandinsky used simpler designs for the same purpose in *Point and Line,* Lindsay/Vergo, II, p. 679, Plate 6.

44 Kandinsky cited the edition published in Berlin (Charlottenburg), 1910, *On the Spiritual,* Lindsay/Vergo, I, pp. 149, 161, 186.

45 Von Bezold, chapter 4, pp. 168ff.

46 Kandinsky referred to Hölzel in his teaching; Sers III, p. 293. P. Weiss has discussed Hölzel's influence on him, p. 161, note 158. Former students of Hölzel at the Bauhaus included Ida Kerkovius, Oskar Schlemmer, and Vincent Weber, in addition to Itten and Hirschfeld-Mack.

47 See Walter Hess, *Das Problem der Farbe in den Selbstzeugnissen moderner Maler,* Munich, 1953, p. 97 (in chapter 11, on Hölzel); and Hölzel, "Über die kunstlerischen Ausdrucksmittel und deren Verhältnis zu Natur und Bild," in *Die Kunst für Alle,* 1904, especially 15 December, p. 140.

48 Kandinsky treated these effects in his teaching notes; Sers III, 214, 217–219.

49 *On the Spiritual,* Lindsay/Vergo, I, p. 186.

50 *Ibid.,* p. 194.

51 Sers III, pp. 208, 215, 216, 264, 266.

52 Sers III, p. 207; Goethe, paragraph 539. Kandinsky's lecture on red: Sers III, pp.

207–209; cf. pp. 212–213.

53 Goethe, paragraphs 174–175, 150–151.

54 Goethe, paragraph 794; quoted by Kandinsky, Sers III, p. 199, and partially, p. 216. Re: "increase," Goethe, paragraphs 517ff.

55 Sers III, p. 215: Kandinsky quoted the information from an article by Siegfried Berndt, "Die Entwicklung des farbigen Gefühls und seines Ausdrucks," *Der Pelikan,* Nr. 26, 1927, pp. 5–13; and he explicitly cited this source.

56 Sers III, pp. 209, 212–213, 262–264; the simple horizontal scale was assigned as exercise No. 4, p. 173.

57 *Point and Line,* Lindsay/Vergo, II, pp. 579–580, figures 21 and 22; the caption to the stepped scale in Thiemann's exercise (Fig. 43, C. 124) is *Representation of the Descent.*

58 Goethe, paragraph 573. Before Goethe, the painter Anton Raphael Mengs had arranged the five basic colors in the order of their inherent lightness values. His writings were well known to Goethe. Concerning the influence of Mengs on Goethe, cf., John Gage, *Color in Turner,* New York, 1969, p. 181.

59 Philipp Otto Runge, *Hinterlassene Schriften,* Vol. I, Hamburg, 1840 (facsimile, Göttingen, 1965), pp. 143–144; see Jörg Traeger, *Philipp Otto Runge und sein Werk,* Munich, 1975, p. 197, re: the relationship between Kandinsky's color scale and Runge's.

60 Wilhelm Ostwald, *Die Farbenfibel,* third edition, Leipzig, 1977, pp. 14–15, see also p. 22.

61 Sers III, 203 and 210; *Point and Line,* Lindsay/Vergo, II, p. 578; *On the Spiritual,* Lindsay/Vergo, I, p. 185.

62 Hering, *op. cit.,* p. 4.

63 *Die Farbenfibel,* p. 1. Ostwald explained the nature of the achromatic colors further in his more substantial book, *Farbkunde,* Leipzig, 1923, pp. 56ff.; re: Hering see especially p. 28.

64 Sers III, pp. 204 and 210; *Farbkunde,* pp. 22, 24.

65 *Point and Line,* Lindsay/Vergo, II, p. 574; *On the Spiritual,* Lindsay/Vergo, I, p. 190, Table III.

66 Sers III, p. 218.

67 Sers III, p. 208; *Point and Line,* Lindsay/Vergo, II, pp. 580–581; cf. *On the Spiritual,* Lindsay/Vergo, I, p. 184, Table II, characterizing red as possessing a "movement within itself."

68 Busch-Reisinger Museum, acquisition numbers 1949.720 and 723; the pair is illustrated in H. Bayer, et al., *Bauhaus 1919–1928,* p. 39. Cf. Hering, *op. cit.,* p. 146 and Plate III, figure 1 (see note 43 here). Another important use of the concentric format by Hirschfeld-Mack is seen in one of the rings for his color top of 1922 (Ring VII; Bauhaus Archive): the bands

are arranged according to the color-value scale, from black on the periphery through blue, red, and yellow to white in the center.

69 *On the Spiritual,* Lindsay/Vergo, I, pp. 163, 187ff.; Sers III, p. 207, and also p. 242 re: the different characteristics of warm, vermilion red (resistance) and cool, carmine red (relaxation).

70 Goethe, paragraphs 538–539. The importance of the concept of "increase" for Goethe, along with that of "polarity," was discussed in Rudolf Magnus's book, which Kandinsky may have known: *Goethe als Naturforscher,* Leipzig, 1906, pp. 300–302.

71 *On the Spiritual,* Lindsay/Vergo, I, pp. 188, 189; re: the range of orange, see Sers III, p. 264; the color scale including orange and violet, in Sers III, p. 266; cf. Goethe, 573. An early appearance of this color-value scale at the Bauhaus is Hirschfeld-Mack's disk with horizontal divisions following the sequence: Busch-Reisinger Museum, acquisition number 1949.731. The mount for the disk (from which it has become detached) bears the caption: "Position of red between the brightness of day and darkness" (1949.732).

72 Runge, p. 116; Traeger, p. 195, compares Kandinsky and Runge in this regard.

73 Lecture No. 9, Sers III, pp. 261–264, and No. 10, pp. 264–268 (see note 4 here).

74 *Point and Line,* Lindsay/Vergo, II, p. 580.

75 *On the Spiritual,* Lindsay/Vergo, I, p. 186.

76 *Ibid.;* see Signac, *op. cit.,* chapters I and II.

77 Exercise No. 6, Sers III, pp. 174 and 388.

78 Re: the complementary relationship of red and green, characterized as "particularly 'beautiful'" in its effect, see *On the Spiritual,* Lindsay/Vergo, I, p. 187.

79 Sers III, pp. 239–240, cf. p. 248. Re: the simultaneous contrast effects, see, for example, O.N. Rood, *op. cit.,* chapter XV (see note 32 here).

80 Sers III, pp. 227 and 235; Ostwald, *Die Farbenfibel,* pp. 9–10. Cf. Ostwald, *Die Harmonie der Farben,* Leipzig, 1921, pp. 7–8: "die praktische Grauleiter"; this book was cited by Kandinsky, Sers III, p. 175. Cf. also, *Farbkunde,* chapter on "Die unbunten Farben," pp. 56ff.: "Die Grauleiter als Messwerkzeug."

81 Sers III, pp. 264ff; cf. p. 216 for exercise with orange on violet; *On the Spiritual,* Lindsay/Vergo, I, pp. 188–189.

82 Re: the tertiaries and their part in relationships of contrast, see Sers III, p. 267f., cf. p. 247.

83 Sers III, pp. 247–251.

84 Sers III, p. 304, from the second-semester course, probably summer of 1931. A device for demonstrating these chromatic sequences is provided by the "nine-part color triangle" developed by Hölzel, an example of which was used by Kandin-

sky in his teaching (in the possession of Philippe Sers, see note 4, above); he referred to it in the same lecture; Sers III, pp. 303, 304. In this scheme, the primary hues are positioned at the corners, the secondaries on the sides, and the tertiaries in the interior of the triangle. The different sequences through the triangle produce different harmonies or rhythms, Kandinsky said. He used a template that could be superimposed on the color chart, showing only one group consisting of a primary and the secondary color, with the tertiary in between. These relationships were demonstrated in the book by Hölzel's student Carry von Biema, *Farben und Formen als lebendige Kräfte,* Jena, 1930, pp. 107ff.; she captioned her diagram: "drei schöne komplementäre Akkorde, bei denen die tertiären Farben die Übergänge bilden." Kandinsky owned a copy of this book; see Kenneth C. E. Lindsay, *An Examination of the Fundamental Theories of Wassily Kandinsky,* Ph.D. dissertation, University of Wisconsin, Madison, 1951, p. 214. An earlier example of the color triangle at the Bauhaus is the study by Hirschfeld-Mack at the Bauhaus Archive ("Zusammenstellung der primären, sekundären und tertiären Farben in einem gleichseitigen Dreieck," c. 1922–1923). For Hölzel's diagram, see Hess, *op. cit.,* p. 94 and figure 5. Josef Albers later used the design, which he called the "Goethe Triangle," and in his book he illustrated von Biema's diagrams, including those that Kandinsky adapted in his use of the template; see Albers, *Interaction of Color,* New Haven, 1971, pp. 66–67.

85 Sers III, pp. 266–268.

86 *On the Spiritual,* Lindsay/Vergo, I, p. 190, Table III; orange and violet are cited as "complementary colors," p. 189. This unorthodox color circle appears in Sörensen-Popitz's notes, p. 1 (C. 204); it is open to question, however, whether this part of her notes was from Kandinsky's lectures or came directly from *On the Spiritual,* since it is so close to the book.

87 See Hering, section 12, "Die Reihe der Farbentöne"; Ostwald, *Farbkunde,* p. 27f., re: the four fundamental colors, plus black and white, and their complementary pairing.

88 See, for example, *Farbkunde,* p. 7. Re: Ostwald's eight-part circle and its colors, see *Die Farbenfibel,* pp. 14–15 and 17. Cf. *Farbkunde,* chapter on "Der Farbtonkreis," pp. 74ff., re: "Normung des Farbtonkreis."

89 Goethe, paragraphs 60; 61; re: the resulting harmony.

90 Sers III, pp. 183, 271, 282.

91 Sers III, p. 203; cf. *On the Spiritual,* Lindsay/Vergo, I, pp. 162–163. L. D. Ettlinger (see note 15 here), pp. 13–14, has sug-

gested that Kandinsky was influenced by Ernst Mach in this notion of the impossibility of separating color and form in actual experience, citing Mach's essay, "Die Raumempfindungen des Auges," reprinted in *Die Analyse der Sinnesempfindungen,* fifth edition, 1906, pp. 84ff. M. L. Teuber has discussed the influence of Mach's book on Klee, e.g. in *"Blue Night by Paul Klee"* p. 142f, cf. note 17.

92 *Point and Line,* Lindsay/Vergo, II, p. 578. Re: the studies of form-color correspondences as leading to a synthesis, see Sers III, p. 174 and 223.

93 *On the Spiritual,* Lindsay/Vergo, I, p. 163.

94 "Program for the Institute," Lindsay/Vergo, I, pp. 461–462; and plate V, *Staatliches Bauhaus Weimar* (Fig. 59, here); see also *Point and Line,* Lindsay/Vergo, II, pp. 591–592. Earlier, the three primary color-shape combinations, placed against both black and white, were illustrated in the Russian edition of *On the Spiritual* ("O dukhovnom v iskusstve"—*Trudy Vserossiiskogo sezda russkikh khudozhnikov v Petrograde,* Petrograd, 1914, vol 1); see color illustration, John Bowlt, "Concepts of Color and the Soviet Avant-Garde," *The Structurist,* No. 13/14 (1973/1974), Saskatoon, Canada, p. 20.

95 *Point and Line,* Lindsay/Vergo, II, pp. 588–592.

96 Re: the questionnaire, see Wingler, *op. cit.,* p. 74. According to the student Gyula Pap, Klee took exception to the contention that yellow corresponded to the triangle, remarking that the yolk of an egg was both yellow and circular; "Liberal Weimar," in Eckhard Neumann, *op. cit.,* p. 79. Schlemmer accepted the affinity of yellow and the triangle, but felt that red corresponded with the circle, and blue with the square; see his letter to Otto Meyer of 3 January 1926, in *Letters and Diaries. . . ,* p. 188.

97 *On the Spiritual,* Lindsay/Vergo, I, p. 163; re: color plate, see note 94, here. The Hirschfeld-Mack studies, with their appropriate as well as deviant combinations, are at the Busch-Reisinger Museum, acquisition numbers 1949.712–719; in a letter of 29 December 1937 to Herbert Bayer, in the files of the Museum of Modern Art, Hirschfeld-Mack referred to these studies as part of Kandinsky's (Color) Seminar. In his book *The Bauhaus,* he mentioned the study of the form-color correspondences in the seminar; p. 6.

98 See Bayer et al., *Bauhaus 1919–1928,* p. 69. Recently, the stairwell murals in the building in Weimar have been reconstructed.

99 Plate 37, p. 79.

100 Letter to Otto Meyer, 17 July 1929, in Schlemmer, p. 246.

101 *Point and Line,* chapter on "Line," Lindsay/Vergo, II, pp. 572ff., see especially

pp. 577ff. In his teaching notes, the outline of his Preliminary Course includes the correspondences between lines and colors in lecture No. 12, and those between shapes and colors in lecture No. 13 (Sers III, p. 185). These lectures immediately follow the series of classes on color, at the end of the course.

102 An exercise by Hans Thiemann relates the chromatic and achromatic colors with the vertical and horizontal (Fig. 13, C. 126): both black and blue are assigned to the horizontal bars, while white and gray, yellow and orange are given to the verticals.

103 *Point and Line,* Lindsay/Vergo, II, pp. 589ff.

104 *Ibid.,* pp. 595ff; Sers III, exercise assignment, p. 279.

105 Sers III, optional exercise for the class No. 12, p. 389.

106 *D'Eugene Delacroix au néo-impressionisme,* recent edition in the series *Miroirs de l'art,* Paris, 1964, p. 49; for other references to the Neo-Impressionists' use of these analogies, and to Superville and Blanc, see pp. 94, 97.

107 In his *Grammaire. . . ,* Paris, 1867, p. 33, Blanc recounted these ideas of Superville. Cf. Ettlinger, pp. 19–20.

108 Cf. Signac, *op. cit.,* p. 94.

109 "Analyse des éléments premiers de la peinture," *Cahiers de Belgique,* 4 (1928); "Analysis of the Primary Elements in Painting," Lindsay/Vergo, II, see p. 854. *Point and Line,* Lindsay/Vergo, II, pp. 651–653.

110 Lindsay/Vergo, II, p. 854; and Sers III, p. 272. Re: exercises using color-shape relationships for lyric or dramatic expression, see Sers III, p. 251; re: the tensions of the appropriate combinations, see pp. 252–255.

111 *On the Spiritual,* Lindsay/Vergo, I, pp. 171, 193–195.

112 In Johannes Eichner, *Kandinsky und Garbriele Münter,* Munich, 1957. Lindsay/Vergo, I, p. 397.

113 Private Collection; color illustration in Paul Overy, *Kandinsky: The Language of the Eye,* New York, 1969, Plate 50.

114 Kandinsky discussed the compositional procedure of balancing the inherent "weights" of colors and forms in his analysis of his own paintings: *Composition 2* (1910), in the Cologne lecture (see Lindsay/Vergo, I, p. 397); and *Composition 6* (1913), in the album *Kandinsky 1901–1913;* Lindsay/Vergo, I, pp. 385ff.

115 *On the Spiritual,* Lindsay/Vergo, I, pp. 193, 194, 197.

116 See Kandinsky's answer to the "Enquête," "L'Art d'aujourd'hui est plus vivant que jamais," *Cahiers d'art,* X, Nos. 1–4 (1935); "Art Today," Lindsay/Vergo, II, p. 767.

117 *On the Spiritual,* Lindsay/Vergo, I, p. 176 and note; Leonardo's little spoons are later referred to in Kandinsky's essay,

"La Valeur d'une oeuvre concrète," *XXe Siècle*, Nos. 5–6 (1939); "The Value of a Concrete Work," Lindsay/Vergo, II, pp. 822–823.

118 *On the Spiritual*, Lindsay/Vergo, I, p. 193.

119 "The Value of a Concrete Work," Lindsay/Vergo, II, p. 823.

120 Sers III, pp. 262–263, 371; cf. p. 250.

121 Sers III, p. 304; Goethe, paragraphs 891–895.

122 *On the Spiritual*, Lindsay/Vergo, I, p. 193f. Cf. Kandinsky's remark in "The Value of a Concrete Work," Lindsay/ Vergo, II, p. 823: ". . . throughout the history of painting the disharmony of yesterday has always become the harmony of today."

123 Goethe, paragraphs 816ff.

124 *On the Spiritual*, Lindsay/Vergo, I, p. 194.

125 Erika Hanfstaengl, *Wassily Kandinsky: Zeichnungen und Aquarelle*, Munich, 1974, No. 262, p. 107.

126 *Ibid.*, No. 265, pp. 107, 174. Another one of the diagrams, No. 266, seems to refer to the watercolor *Farbstudie: Quadrate mit konzentrischen Ringen*, No. 261.

127 Itten, *Tagebuch*, p. 78.

128 "The Value of a Concrete Work," Lindsay/Vergo, II, p. 823.

129 "My courses at the Hochschule für Gestaltung at Ulm" (dated 20 January 1954), in *Form* (Cambridge, Eng.), No. 4, 1967, p. 9. See also Albers, *Interaction of Color.*

130 "Réflexions sur l'art abstrait," *Cahiers d'art*, VI, Nos. 7–8 (1931); Lindsay/Vergo, II, p. 758. Kandinsky's first reference to this phenomenon was in his essay "Über die Formfrage," *Der Blaue Reiter*, Munich, 1912; "On the Question of Form," Lindsay/Vergo, I, p. 244, note.

131 "The Value of a Concrete Work," Lindsay/Vergo, II, p. 820.

132 Helmholtz, *Populäre wissenschaftliche Vorträge*, III, p. 91, cf. p. 82. Kandinsky's quotes from Krueger's article on Kirschmann, in *Neue Psychologische Studien* (VI, 1932, p. 506), include one in which the author referred to findings that pertain to retinal fatigue: ". . . dass eine das ganze Gesichtsfeld beherrschende Farbe . . . 'sehr bald ihren Qualitätscharakter ganz oder zum grössten Teile einbüsst'"; Sers III, p. 182, cf. p. 216.

133 "The Value of a Concrete Work," Lindsay/Vergo, II. p. 824.

134 "Optisches über Malerei," p. 81, 84–85. This principle was followed by the Neo-Impressionists.

135 "In Kandinsky's Classroom," in Neumann, *op. cit.*, pp. 161–162.

A group of the variously colored basic shapes that Schuh described have in fact survived (in the possession of Philippe Sers, see note 4, above). In addition, as part of the same group of pedagogical materials, there are two paper demonstration pieces on each of which are placed a small white square and a small black square, against a medium gray background. In one the black square overlaps the white; in the other the white overlaps the black—demonstrating some of the spatial effects and contradictions that Kandinsky taught were among the interactions of colors and forms.

136 Sers III, p. 232.

137 Re: these spatial characteristics, see Sers III, pp. 252–255.

138 *On the Spiritual*, Lindsay/Vergo, I, pp. 171–173; re: spatial effects, cf. p. 195, and the Cologne lecture, Eichner, *loc. cit.*

139 *Point and Line*, Lindsay/Vergo, II, p. 648.

140 "Toile vide, etc.," *Cahiers d'art*, X, Nrs. 5–6 (1935); "Empty Canvas, etc.," Lindsay/Vergo, II, p. 783.

141 *On the Spiritual*, Lindsay/Vergo, I, p. 170.

142 In *Kandinsky 1901–1913*, especially "Composition 6" (see note 114 here); *Point and Line*, Lindsay/Vergo, II, p. 593.

143 In Eichner, *op. cit.;* Lindsay/Vergo, I, p. 397.

144 *On the Spiritual*, Lindsay/Vergo, I, p. 151f, and note. "Notes d'un peintre," *La Grande Revue*, 25 December 1908; German translation in *Kunst und Künstler*, VII, 1909, pp. 335–47; the latter was cited by Kandinsky.

For a recent discussion of the influence of Matisse on German artists, see Günter Metken, "Regards sur la France et l'Allemagne: le climat des rapports artistique: contacts personnels, voyages, publications," in Centre national d'art et de culture Georges Pompidou, *Paris-Berlin: rapports et contrastes france-allemagne, 1900–1933*, Paris, 12 July–6 November 1978, p. 24.

145 In *Henri Matisse: Ecrits et propos sur l'art*, edited by Dominique Fourcade, Paris, 1972, p. 46.

146 "Empty Canvas, etc.," Lindsay/Vergo, II, p. 782.

147 *Loc. cit.*

Analytical Drawing

1 Kandinsky's primary account of the course is the brief article, essentially an outline: "Unterricht Kandinsky: analytisches Zeichnen (I. Semester)," *Bauhaus*, Nos. 2/3, 1928; "Art Pedagogy/ Analytical Drawing," Lindsay/Vergo, II, pp. 726–729. A shorter outline appeared in *Sixth International Congress. . .* , in Wingler, *op. cit.*, p. 144. The brief descriptions and references in the teaching notes appear in Kandinsky's "Cours du Bauhaus," in *Wassily Kandinsky: Ecrits complets*, volume III, *La Synthèse des arts*, Philippe Sers, ed., Paris, 1975, pp. 162 (27 September 1926), 271 (1 February 1926), and passim., including references in his free painting class and his fourth- and second-semester courses, to be cited below (hereafter citations to the volume edited by Professor Sers will be given as Sers III). Fourteen of the analytical drawings are included in *50 Years Bauhaus*, Württembergischer Kunstverein, Stuttgart, 1968, Nos. 134–147.

2 Projektionslehre and Werkzeichnen are listed in *Satzungen Staatliches Bauhaus in Weimar*, Weimar, July 1922, p. 2; draughtsmanship and projection drawing in the "Work Plan for the Preliminary Course" (c. 1925–1926) in Wingler, *op. cit.*, p. 109; and in the "Curriculum" of 1925, as part of the practical and theoretical instruction in form, Wingler, *op. cit.*, p. 107.

3 Lindsay/Vergo, II, p. 729.

4 Sers III, pp. 162, 271. Cf. *Point and Line*, Lindsay/Vergo, II, p. 625: ". . . the law of opposition and of juxtaposition. This law gives rise to two principles—the principle of parallelism and the principle of contrast—in the same way as has been shown in the case of combinations of lines" (the reference is to the earlier discussion of "Linear complexes," pp. 612ff.).

5 "Kandinsky, l'éducateur/Kandinsky als Pädagoge und Erzieher," in Max Bill, editor, *Wassily Kandinsky*, Paris, 1951, pp. 96–97 (French), 148 (German). Bill arrived at the Bauhaus in 1927.

6 Cf. Jean Leppien's list of objects, quoted in Nina Kandinsky, *Kandinsky und Ich*, 2. Auflage, Munich, 1976, p. 134: "Brettern, Leisten, Latten, Linealen, usw." Leppien was at the Bauhaus from 1929 to 1930.

7 Lindsay/Vergo, II, drawing 4, p. 729; the objects are listed as "saw, grindstone, bucket," p. 728. The same setup seems to be rendered in Voepel-Neujahr (Fig. 109, C. 186), and since both she and Fritzsche matriculated in winter of 1927/ 28, they undoubtedly were in the same class. The grinding wheel in its stand also appears in Klode (Fig. 162, 16, C. 85, 86) and Thiemann (Fig. 170, C. 130) (these three are of the same setup) and also in Ullmann-Broner (Fig. 175, C. 164).

8 Wingler, *op. cit.*, pp. 436–437. Beckmann's studies are unique among the surviving analytical drawings in being based on a photograph of a still life.

9 Peg Weiss, *Kandinsky in Munich: the Formative Jugendstil Years*, Princeton, 1979, p. 64.

10 Sers III, pp. 372 (13 June 1927) and 374 (start of the 1927/28 winter semester).

11 Originally published as "Réflexions sur l'art abstrait," *Cahiers d'art*, VI, Nos. 7–8 (1913); Lindsay/Vergo, II, p. 759.

12 *On the Spiritual*, Lindsay/Vergo, I, p. 208. His remarks on Cubism include, elsewhere in *On the Spiritual*, the statement: "Picasso seeks to achieve the constructive . . . through numerical relations"; p. 152.

13 Sers III, p. 289 (second semester, summer of 1931). Supporting and accenting lines are equivalent to the principal tensions and secondary tensions demonstrated in the analytical drawings.

14 Lindsay/Vergo, II, pp. 625–626, 630.

15 *Ibid.,* pp. 626ff.

16 *Ibid.,* p. 625.

17 "Reflections on Abstract Art," Lindsay/Vergo, II, p. 760. In conjunction with this point of view and with that expressed in his teaching of summer 1931 (v. note 13 here), cf. Hans Kessler's course notes in the Bauhaus Archive, "Kandinsky: abstrakte *Formenlehre; analytisches Zeichnen*" (probably winter semester of 1931/32), p. 4: "Es gibt zwei Arten von Naturalismus: 1. Naturalismus als Nachahmung der äusseren Erscheinungen; 2. Naturalismus als ein Aufbauen auf ein Prinzip, das in der Natur vollkommen das Gleiche ist."
Regarding Kandinsky's changing attitude to "the inner analogy of art and nature" and relationship of his thinking to that of Klee, see Sixten Ringbom, "Paul Klee and the Inner Truth to Nature," *Arts Magazine,* 52, No. 1 (Sept. 1977), p. 115.

18 Lindsay/Vergo, II, p. 728 and drawing 2, p. 727; the student's name is given in the caption as R. L. Kukowka, the middle initial evidently in error; see the list of student names in Wingler, *op. cit.,* p. 622, No. 74.

19 Sers III, p. 271 (1 February 1926).

20 *Loc. cit.* (see note 1 here).

21 *Loc. cit.*

22 Lindsay/Vergo, II, p. 729, drawing 4.

23 *Ibid.,* p. 728.

24 *Ibid.,* p. 727, drawing 3; the last name is given as Fiszmer, evidently misspelled; see Wingler, *ibid.,* No. 76.

25 Lindsay/Vergo, II, p. 726, drawing 1 (unattributed); the idea is discussed following the description of stage three, pp. 728–729.

26 *Point and Line,* Lindsay/Vergo, II, pp. 604–606. Kessinger-Petitpierre reflected this part of Kandinsky's theories more explicitly in the first sheet of her portfolio "Principles of abstract form in relation to color," entitled "The Curved Line" (Fig. 151, C. 38); the freely curved example on this sheet is comparable to the lines in the variation under discussion.

27 Lindsay/Vergo, I, p. 209.

28 Lindsay/Vergo, II, p. 677, Plate 4. Sixten Ringbom pointed out the connections between this diagram, the passage in *On the Spiritual,* and a sketch for the painting *Black Spot I* (1912): *The Sounding Cosmos: a Study in the Spiritualism of Kandinsky and the Genesis of Abstract Painting,* Abo, Finland, 1970, pp. 100–101. The drawing is the *Kompositionschema zu 'Schwarzer Fleck I,'* 1911/12, in the Städtisches Galerie im Lenbachhaus,

Munich; see Erika Hanfstaengl, *Wassily Kandinsky: Zeichnungen und Aquarelle,* Munich, 1974, No. 202.

29 Neuy (Fig. 168, C. 117) looks like a free color composition, but its title designates it as an analytical drawing: *Principal Tensions Translated into Color.* Ullmann-Broner (Fig. 175, C. 164) is a free study, probably done in the context of the analytical drawings; while Fig. 174, C. 161, *Tension Diagram, Combination of a Geometric and a Free Form,* is an analysis of a kind of exercise assigned in the Abstract Form Elements course—cf. Lang (Fig. 165, C. 99) and Voepel-Neujahr (C. 176); Sers III, p. 257 (11 September 1925?); Kessinger-Petitpierre (C. 39) is a similar exercise to Ullmann-Broner's, as its caption explains: "Aufgabe: eine geometrische und eine freie Form so zu einanderstellen, dass sie eine Hauptspannung und eine Nebenspannung ergeben."
There are a number of pertinent studies of a purely graphic nature: Kessinger-Petitpierre (Figs. 152, 153, C. 40–42) are a series of abstract elaborations probably based on an analytical drawing, as the titles of the first two indicate: "Sharpening of the Drawing through Wire Work" and "Variation"; the three are consecutively numbered, 1, 1a, 1b. Free studies that are purely graphic are: Kessinger-Petitpierre (Figs. 14, 154–156, C. 43–47) and her portfolio of twelve abstract drawings, *The Square;* Neuy (C. 116); and Schürmann (C. 120).

30 Klode (Fig. 15, C. 88); and the *Still Life* by Hermann Röseler, illustrated in *Bauhaus,* Nos. 2/3, 1928, p. 31, accompanying Ludwig Grote's article, "Junge Bauhausmaler"; the illustration is captioned, "Malklasse W. Kandinsky." In his free painting class Kandinsky recommended the analytical drawing approach as a starting point; Sers III, p. 374 (start of the winter semester of 1927/28).

31 Will Grohmann, *op. cit.,* p. 107: drawing for *Composition 2,* 1910, No. 1; Hanfstaengl, *op. cit.,* Nos. 212–216, 233.

32 Hanfstaengl, Nos. 249 and 250; the inscriptions are in Russian; see also Nos. 202, 232, 251–252.

33 Grohmann, *op. cit.,* p. 96, fig. 24 (1913, No. 4).

34 *Kandinsky 1901–1913,* Berlin, 1913; his commentaries on paintings appear in Lindsay/Vergo, I, pp. 383–391; see especially pp. 383–384; he uses the word *Linienknoten.*

35 Lindsay/Vergo, II, pp. 696–698: Plate 23, "Inner relationship between complex of straight lines and curve (left-right), for the picture *Black Triangle* (1925)"; Plate 24, "Horizontal-vertical structure with contrasting diagonal and tensions created by points—schema of the picture

Intimate Message (1925)"; and Plate 25, "Linear structure of the picture *Little Dream in Red* (1925)."

36 Lindsay/Vergo, II, p. 559, Fig. 10; "Tanzkurven: zu den Tänzen der Palucca," *Das Kunstblatt,* 10 March 1926; Lindsay/Vergo, II, pp. 520–523. Kandinsky had already suggested reproducing body movements photographically and graphically in his "Program for the Institute of Artistic Culture," Lindsay/Vergo, I, p. 467.

37 Bill, *op. cit.* (note 5, here), both painting and drawing are illustrated on p. 98; Grohmann, *op. cit.,* p. 217 (1930, No. 21).

38 The schematic drawing is reproduced in Lindsay/Vergo, II, p. 835, along with Kandinsky's text of 1938, *Stabilité animée,* pp. 834–835, which was written for the Zürich journal *Werk* but not published; the painting is reproduced along with the drawing in Hans K. Roethel in collaboration with Jean K. Benjamin, *Kandinsky,* New York, 1979, pp. 150–151.

39 Theodore Reff, "Painting and Theory in the Final Decade," in *Cézanne, The Late Work,* ed. William Rubin, The Museum of Modern Art, New York, 1977, p. 47, referring to writings by Jean-Pierre Thénot, *Morphographie; ou l'art de representer . . . des corps solides* (Paris, 1838), pp. 50–56, and Charles Blanc, *Grammaire des arts du dessin* (2nd ed., Paris, 1870), pp. 572–576. Reff's comments are discussed by Peter Morrin in relation to Ažbè: "Some Remarks on Recent Ažbè Scholarship," *Slovene Studies: Journal of the Society for Slovene Studies* (New York), Vol. 1, No. 1, (1976), p. 31.

40 Sixten Ringbom, "Paul Klee and the Inner Truth to Nature," *Arts Magazine,* Vol. 52, No. 1 (September 1977), p. 114 and elsewhere.

41 "Academic *Dessin* Theory in France after the Reorganizaton of 1863," *Journal of the Society of Architectural Historians,* XXXVI, No. 3 (October 1977), pp. 145ff.

42 Werner Hofmann, "Kandinsky und Mondrian, 'Gekritzel' und 'Schema' als graphische Sprachmittel," in Darmstadt, Mathildenhöhe, *1. Internationale der Zeichnung,* 1964, pp. 23–24; citing Crane's *Line and Form* (London, 1900; German edition, 1901). Peg Weiss has discussed the fact that Crane's work and writings were known in Germany in the 1890s, *op. cit.,* p. 23, see also p. 8; and Marcel Franciscono has mentioned Crane as background to Hölzel's and Itten's analyses of compositions, citing Crane's *Bases of Design* (London, 1898; German edition, *Grundlagen der Zeichnung,* 1901), p. 8, "Ornamental Lines in the Frieze of the Parthenon"—*Walter Gropius and the Creation of the Bauhaus in Weimar: the Ideals and Artistic Theories of its Founding Years,* Urbana, 1971, p. 213, n. 72.

43 Weiss, *op. cit.*, p. 16f.; and Morrin, *op. cit.*, p. 30.

44 Weiss stresses the importance of Hölzel for the development of Kandinsky's thinking, *op. cit.*, pp. 40ff. Diagrams analyzing pictorial compositions appear in Hölzel's "Über bildliche Kunstwerke in architektonischen Raum," *Der Architekt,* XV (1909), pp. 73–80, and Neue Folge, XVI (1910), pp. 9–11, 17–20, 41–44, 49–50. Kandinsky referred to Hölzel in his Bauhaus teaching, regarding the use of lines and rhythm in composition; Sers III, p. 293 (second-semester course).

 Weiss has also suggested that student examples from the Obrist-Debschitz School in Munich, from around 1904, reveal similarities with Kandinsky's much later analytical drawings (*op. cit.*, p. 122 and note 36); however, the visual evidence is unconvincing (Figs. 94 and 95).

45 "Adolf Hölzel und sein Kreis," *Der Pelikan,* No. 65 (April 1963), pp. 34ff.; see also in the same special number of *Der Pelikan* devoted to Hölzel, Wolfgang Venzmer, "Adolf Hölzel—Leben und Werk," pp. 4–14.

46 "Analysen alter Meister," *Utopia: Dokumente der Wirklichkeit,* Weimar, 1921, pp. 17, 19 (reproduced in *50 Years Bauhaus,* p. 39, No. 32); schematic diagrams of other works are included in Itten's article, pp. 11, 13.

47 *Staatliches Bauhaus Weimar 1919–1923,* Weimar, Munich, 1923, pp. 56–59, figs. 27–30; fig. 27 is by G. Schunke, figs. 28 and 29 by M. Rasch. Figs. 29 and 30 are reproduced under the heading "Kandinsky's Course" and dated 1922 in Herbert Bayer, Walter and Ise Gropius, *Bauhaus 1919–1928,* The Museum of Modern Art (New York, 1938), third printing, Boston, 1959, p. 38. Two analytical drawings, done for Kandinsky's course in 1922, are listed in Bauhaus Archive, *Alfred Arndt: Maler und Architekt,* Darmstadt, 1968, Nos. 7 and 8.

48 Lindsay/Vergo, I, p. 167, note; pp. 139ff. including notes; see *ibid.*, p. 151, concerning Cézanne's "often mathematical formulas."

49 Sers III, pp. 306f., 310ff., 313ff. (all part of his second-semester course), 357f. (fourth-semester course, 19 October 1928); see also pp. 292f. (second-semester course) and 323 (fourth-semester course, 23 November 1929).

50 Sers III, pp. 308, 320 (both from his second-semester course).

51 Weiss, *op. cit.*, pp. 34ff., especially pp. 36–37.

52 Cited by Carola Giedion-Welcker, "Kandinsky als Theoretiker," in Bill, ed., *Wassily Kandinsky* (1951), p. 101 (French), 150 (German); from Van de Velde's *Kunstgewerbliche Laienpredigten* (1902).

53 Teuber, "*Blue Night* by Paul Klee," in *Vision and Artifact,* edited by Mary Henle, New York, 1976, p. 143 (see note 41 of section two here). *Point and Line,* Lindsay/Vergo, II, pp. 597ff., 602ff.

54 Weiss, *op. cit.*, pp. 36–37 and p. 120, n. 73. *Point and Line, loc. cit.* and pp. 612ff.

Bibliography

Albers, Josef. "My courses at the Hochschule für Gestaltung at Ulm." *Form,* Cambridge, Eng., No. 4 (1967), pp. 8–10.

———. *Interaction of Color.* New Haven, 1971.

Andersen, Troels. "Some Unpublished Letters by Kandinsky." *Artes: Periodical of the Fine Arts,* II (October 1966), pp. 90–110.

Barnett, Vivian Endicott. *Kandinsky at the Guggenheim.* New York, 1983.

Bauhaus Dessau; Hochschule für Gestaltung. Curriculum, April 1931.

Bauhaus Archive. *Alfred Arndt: Maler und Architekt.* Darmstadt, 1968.

———. *Kunstschulreform 1900–1933.* Edited by Hans M. Wingler. Berlin, 1977.

Bauhaus Archive Museum. *Sammlings-Katalog.* Berlin, 1981.

"Bauhaus-Vortrag" (signed "W.") *Anhalter Anzeiger Dessau.* 3 February, 1930.

Bayer, Herbert; Gropius, Walter, and Ise. *Bauhaus 1919–1928.* The Museum of Modern Art, New York, 1938: 3rd printing, Boston, 1959.

Berndt, Siegfried. "Die Entwicklung des farbigen Gefühls und seines Ausdrucks." *Der Pelikan,* Nr. 26 (1927), pp. 5–13.

Bezold, Wilhelm von. *Die Farbenlehre in Hinblick auf Kunst und Kunstgewerbe.* Braunschweig, 1874.

Biema, Carry von. *Farben und Formen als lebenige Kräfte.* Jena, 1930.

Bill, Max, ed. *Wassily Kandinsky.* Paris, 1951.

Blanc, Charles. *Grammaire des arts.* Paris, 1867.

Bojko, Szymon. "Vkhutemas." *Art and Artists,* IX (December 1974), pp. 8–13.

Bowlt, John E. "Concepts of Color and the Soviet Avant-Garde." *The Structurist,* Saskatoon, Canada, No. 13/14 (1973/1974), pp. 20–29.

———, editor, and trans. *Russian Art of the Avant-Garde: Theory and Criticism, 1902–1934.* New York, 1976.

———, and Long, Rose-Carol Washton, editors. *The Life of Vasilii Kandinsky in Russian Art; A Study of "On the Spiritual in Art."* Translated by John Bowlt. Newtonville, Mass., 1980.

Busch-Reisinger Museum, Harvard University. *Concepts of the Bauhaus: The Busch-Reisinger Collection.* Edited by John David Farmer and Geraldine Weiss. Cambridge, Mass., 1971.

Douglas, Charlotte. "Colors without Objects: Russian Color Theories (1908–1932)." *The Structurist,* Saskatoon, Canada, No. 13/14 (1973/1974), pp. 30–41.

Ettlinger, L. D. *Kandinsky's "At Rest."* London, 1961.

Feininger, Julia and Lyonel. "Wassily Kandinsky." In Wassily Kandinsky. *Concerning the Spiritual in Art.* New York, 1947, pp. 12–14.

Fiek, Walter. "Von farbiger Raumgestaltung." *Vivos Voco,* V, No. 8/9 (1926), p. 271.

Fineberg, Jonathan. *Kandinsky in Paris, 1906–1907.* Ann Arbor, 1984.

Fourcade, Dominique, ed. *Henri Matisse: Écrits et propos sur l'art.* Paris, 1972.

Franciscono, Marcel. "Paul Klee in the Bauhaus: The Artist as Lawgiver." *Arts Magazine,* LII, No. 1 (September 1977), pp. 122–127.

———. *Walter Gropius and the Creation of the Bauhaus in Weimar: The Ideals and Artistic Theories of its Founding Years.* Urbana, Ill., 1971.

Gage, John. *Color in Turner.* New York, 1969.

Goethe, J. W. *Zur Farbenlehre.* 1810; reprinted in *Naturwissenschaftliche Schriften.* 1. Tiel, Artemis-Verlag Zürich, 1949.

Gray, Camilla. *The Great Experiment: Russian Art, 1863–1922.* New York, 1962.

Grohmann, Will. *Wassily Kandinsky: Life and Work.* New York, 1958.

Gropius, Walter. *Idee und Aufbau des Staatlichen Bauhauses Weimar.* Weimar, 1923. Also in *Staatliche Bauhaus Weimar 1919–1923.* Weimar-Munich, 1923, pp. 7–18.

Grote, Ludwig. "Bühnenkompositionen von Kandinsky." *i 10; Internationale Revue,* Amsterdam, II, No. 13 (1928), pp. 4–5.

———. "Junge Bauhausmaler." *Bauhaus,* No. 2/3 (1928), p. 31.

Haftmann, Werner. "Kandinsky (1927–1933)." *Derrière le miroir,* No. 154 (November 1965), pp. 1–[18].

Hahl-Koch, Jelena, ed. *Arnold Schoenberg–Wassily Kandinsky: Letters, Pictures & Documents.* Trans. by John Crawford. Salem, New Hampshire, 1984.

Hahn, Peter. *Junge Mahler am Bauhaus.* Galleria del Levante, Munich, 1979.

Hanfstaengl, Erika. *Wassily Kandinsky: Zeichnungen und Aquarelle; Katalog der Sammlung in der Städtischen Galerie im Lenbachhaus München.* Munich, 1974.

Helmholtz, Hermann von. "Optisches über Malerei." In Hermann von Helmholtz, *Populäre wissenschaftliche Vorträge,* Vol III. Braunschweig, 1876, pp. 55–97. French edition, "Optique et la peinture." In *Principes scientifiques des beaux-arts.* E.

Brücke. 5th edition, Paris, 1902.

Hering, Ewald. *Grundzüge der Lehre vom Lichtsinne.* Berlin, 1920.

Herzogenrath, Wulf. *Oskar Schlemmer: Die Wandgestaltung der neuen Architektur.* Munich, 1973.

Hess, Walter. *Das Problem der Farbe in den Selbstzeugnissen moderner Maler.* Munich, 1953.

———. "Zu Hölzels Lehre." *Der Pelikan,* No. 65 (April 1963), pp. 18–34.

Hirschfeld-Mack, Ludwig. *The Bauhaus: An Introductory Survey.* Victoria, Australia, 1963.

———. "Letter from Ludwig Hirschfeld-Mack to Standish Lawder." *Form,* Cambridge, Eng., No. 2 (September 1966), p. 13.

Hofmann, Werner. "Kandinsky und Mondrian, 'Gekritzel' und 'Schema' als graphische Sprachmittel." In *1. Internationale der Zeichnung.* Darmstadt, Mathildenhöhe, 1964, pp. 13–27.

Hölzel, Adolf. "Über bildliche Kunstwerke in architektonischen Raum." *Der Architekt,* XV (1909), pp. 73–80, and *Neue Folge,* XVI (1910), pp. 9–11, 17–20, 41–44, 49–50.

———. "Über die künstlerischen Ausdrucksmittel und deren Verhältnis zu Natur und Bild." *Die Kunst für Alle,* XX (1904), pp. 81–88, 106–113, 121–142.

Homage to Wassily Kandinsky. New York, 1975. English edition of "Centenaire de Kandinsky," *XXᵉ Siècle,* no. XXVII, December 1966.

Hüter, Karl Heinz. *Das Bauhaus in Weimar: Studie zur gesellschaftspolitischen Geschichte einer deutschen Kunstschule.* Berlin (East), 1976.

Itten, Johannes. "Adolf Hölzel und sein Kreis." *Der Pelikan,* No. 65 (April 1963), pp. 34–40.

———. "Analysen alter Meister." In *Utopia: Dokumente der Wirklichkeit.* Weimar, 1921, pp. 28–78.

———. *The Art of Color.* New York.

———. *Design and Form: the Basic Course at the Bauhaus and Later.* Revised edition. New York, 1975.

———. *Tagebuch: Beiträge zu einem Kontrapunkt der bildenden Kunst.* Berlin, 1930.

Junge Menschen kommt aus Bauhaus. Bauhaus prospectus. Dessau, 1929.

Kandinsky, Nina. *Kandinsky und ich.* Munich, 1976.

Kandinsky, Wassily. "Abstrakte Kunst." *Der Cicerone,* XVII, 1925, pp. 638–647.

———. "Analyse des éléments premiers de la peinture." *Cahiers de Belgique,* No. 4 (May 1928), pp. 126–132.

———. "Die Arbeit in der Wandmalerei des Staatliches Bauhauses" (1924). In *Das Bauhaus, 1919–1933, Weimar, Dessau, Berlin.* Edited by Hans M. Wingler. Bramsche, 1962, pp. 93–94.

———. "L'Art concret. *XXᵉ Siècle,* I, No. 1 (1938), pp. 9–16.

———. "Aus 'Violett,' romantisches Bühnenstück." (Excerpt: Picture VI, beginning.)

Bauhaus, No. 3, 1927, p. 6.

———. "Bilder einer Ausstellung (Modeste Mussorgsky)." *Das Kunstblatt*, XIV, No. 8 (August 1930), p. 246.

———. Briefe an Will Grohmann. *"Lieber Freund . . ." Künstler schreiben an Will Grohmann*. Edited by Karl Gutbrod. Cologne, 1968, pp. 45–71.

———. [Enquête] "L'Art d'aujoud'hui est plus vivant que jamais." *Cahiers d'art*, X, Nos. 1–4 (1935), pp. 53–56.

———. "Farbkurs und Seminar." In *Staatliches Bauhaus Weimar 1919–1923*. Weimar-Munich, 1923, pp. 27–28.

———. "Der gelbe Klang." In *Der Blaue Reiter*. Munich, 1912, pp. 115–131.

———. "Gestern, Heute, Morgen." In Paul Westheim. *Künstler Bekenntnisse*. Berlin, 1925, pp. 164–165.

———. "Die Grundelemente der Form." In *Staatliches Bauhaus Weimar 1919–1923*. Weimar-Munich, 1923, p. 26.

———. "Die Kahle Wand." *Der Kunstnarr*, Dessau, I (April 19, 1929), pp. 20–22.

———. *Kandinsky: Complete Writings on Art*. Edited by Kenneth C. Lindsay and Peter Vergo. 2 vols. Boston, 1982.

———. *Kandinsky. Essays über Kunst und Künstler*. Edited, with commentaries, by Max Bill. Third edition, Bern, 1973.

———. *Kandinsky 1901–1913*. Der Sturm, Berlin, 1913. (Contains: "Rückblicke," pp. III–XXIX; "Komposition IV," pp. XXXIII–XXXIV; "Komposition VI," pp. XXXV–XXXVIII.) Reprint: *Rückblick*. Introduction by Ludwig Grote. Baden-Baden, 1955.

———. "Kunstpädagogik." *Bauhaus*, No. 2/3, 1928, pp. 8–10.

———. Lecture for the Kreis der Kunst, Cologne, (1913/1914). In Johannes Eichner. *Wassily Kandinsky und Gabriele Münter*. Munich, 1957, pp. 109–116.

———. "Musikraum." In *Deutsche Bauaustellung Berlin 1931. Amtliche Katalog und Führer*. Berlin, 1931, pp. 170–171.

———. "Ein neuer Naturalismus?" *Das Kunstblatt*, VI, No. 9 (September 1922), pp. 384–387.

———. *Punkt und Linie zu Fläche: Beitrag zur Analyse der malerischen Elemente*. (Book No. 9.) Munich, 1926; reprint edition with introduction by Max Bill. Seventh edition, Bern, 1973.

———. "Reflexions sur l'art abstrait." *Cahiers d'art*, VI, Nos. 7–8 (1931), pp. 351–353.

———. ["Selbstdarstellung."] In *Die Psychologie der produktiven Persönlichkeit*. Paul Plaut. Enke in Stuttgart, 1929, pp. 306–308.

———. "Stabilité animé" (1938). In *Kandinsky. Essays über Kunst und Künstler*, pp. 229–231.

———. "Tanzkurven: zu den Tänzen der Palucca." *Das Kunstblatt*, X (March 1926), pp. 117–120.

———. "Toile vide, etc." *Cahiers d'art*, X, Nos. 5–6 (1935), p. 117.

———. "Über die abstrakte Bühnensynthe-se." In *Staatliches Bauhaus Weimar 1919–1923*. Weimar-Munich, 1923. Brief excerpt reprinted in *Bauhaus*, No. 3 (1927), p. 6.

———. "Über Bühnenkomposition." In *Der Blaue Reiter*. Munich, 1912, pp. 103–113.

———. "Über die Formfrage." In *Der Blaue Reiter*. Munich, 1912, pp. 74–100.

———. *Über das Geistige in der Kunst*. Munich, 1912; reprint edition with introduction by Max Bill. Tenth edition, Bern, 1973.

———. "Und. Einiges über synthetische Kunst." *i 10; Internationale Revue*, Amsterdam, I, No. 1 (1927), pp. 4–10.

———. "Unterricht Kandinsky: Analytisches Zeichnen." *Bauhaus*, No. 2/3, 1928, pp. 9–11.

———. "La Valeur d'une oeuvre concrète." *XXe Siècle*, Nos. 5–6 (1939), pp. 48–50.

———. *Wassily Kandinsky: Écrits complets*. Edited by Philippe Sers. Vol. III: *La Synthèse des arts*. Paris, 1975. (Contains "Cours du Bauhaus," pp. 157–391.)

———. *Wassily Kandinsky. Regards sur le passé et autres textes, 1912–1922*. Edited by Jean-Paul Bouillon. Paris, 1974.

———. "Der Wert des theoretischen Unterrichts in der Malerei." *Bauhaus*, No. 1 (December 1926), p. 4.

———. "Zwölf Briefe von Wassily Kandinsky an Hans Thiemann, 1933–1939." *Wallraf-Richartz Jahrbuch; Westdeutsches Jahrbuch für Kunstgeschichte*, XXXVIII, 1976, pp. 155–166.

———, and Marc, Franz, eds. *Der Blaue Reiter*. Munich, 1912. Documentary edition by Klaus Lankheit. Munich, 1965.

Katz, David. *The World of Color*. London, 1935.

Klee, Paul. *Notebooks, Volume 1: The Thinking Eye*. Edited by Jürg Spiller. London, 1973.

———. "Exacte Versuche im Bereich der Kunst." *Bauhaus*, No. 2/3, 1928, p. 17.

Kröll, Friedhelm. *Bauhaus 1919–1933: Künstler zwischen Isolation und Kollektiver Praxis*. Düsseldorf, 1974.

Krueger, Felix. "August Kirschmann." *Neue Psychologische Studien*, VI (1932), pp. 483–513.

"Das Kunstprogramm des Kommissariats für Volksaufklärung in Russland." *Das Kunstblatt*, III (March 1919), pp. 91–93.

Lacoste, Michel. *Kandinsky*. New York, 1979.

Lang, Lothar. *Das Bauhaus 1919–1933; Idee und Wirklichkeit*. Second edition, Berlin (East), 1966.

Lindsay, Kenneth C. *An Examination of the Fundamental Theories of Wassily Kandinsky*. Ph.D. dissertation, University of Wisconsin, Madison, 1951.

———, and Vergo, Peter, editors. See *Kandinsky: Complete Writings on Art*.

Luckiesh, Matthew. *Licht und Arbeit*. Berlin, 1926.

Magnus, Rudolf. *Goethe als Naturforscher*. Leipzig, 1906.

Matile, Heinz. *Die Farbenlehre Philipp Otto Runges*. Bern, 1973.

Matisse, Henri. "Notes d'un peintre." *La Grande Revue*, 25 December, 1908; German translation in *Kunst und Künstler*, VII (1909), pp. 335–347.

Metken, Günter. "Regards sur la France et l'Allemagne: le climat des rapports artistiques: contacts personnels, voyages, publications." In Centre national d'art et de culture Georges Pompidou, *Paris-Berlin: rapports et contrastes franco-allemagne, 1900–1933*. Paris, 12 July–6 November, 1978, pp. 20–29.

Meyer, Hannes. *Bauen und Gesellschaft: Schriften, Briefe, Projekte*. Dresden, 1980.

Moore, Richard A. "Academic *Dessin* Theory in France after the Reorganization of 1863." *Journal of the Society of Architectural Historians*, XXXVI, No. 3 (October 1977), pp. 145–174.

Morrin, Peter. "Some Remarks on Recent Ažbè Scholarship." *Slovene Studies*, I, No. 1 (1979), pp. 25–37.

Munich, Haus der Kunst. *Die Maler am Bauhaus*, 1950.

Musée national d'art moderne, Centre Georges Pompidou. Kandinsky: *Oeuvres de Vasily Kandinsky, 1866–1944*. Catalogue by Christian Derouet and Jessica Boissel. Paris, 1984.

———. *Le Salon de réception conçu en 1922 par Kandinsky*. Paris, 1977.

Naylor, Gillian. *The Bauhaus Reassessed: Sources and Design Theory*. New York, 1985.

Neumann, Eckhard, ed. *Bauhaus and Bauhaus People*. New York, 1970.

Orlandini, Marisa Volpi. *Kandinsky: Dall'art nouveau alla psicologia della forma*. Rome, 1968.

Ostwald, Wilhelm. *Die Farbenfibel*. Third edition, Leipzig, 1917.

———. *Farbkunde*. Leipzig, 1923.

———. *Die Harmonie der Farben*. Leipzig, 1921.

Overy, Paul. *Kandinsky; The Language of the Eye*. New York, 1969.

Passuth, Krisztina. "Berlin centre de l'art est-européen." In Centre national d'art et de culture Georges Pompidou, *Paris-Berlin: rapports et contrastes franco-allemagne, 1900–1933*. Paris, 12 July–November, 1978, pp. 222–231.

Platz, Gustav Adolf. *Die Baukunst der neuesten Zeit*. Berlin, 1927.

Pleynet, Marcelin. *L'Enseignement de la peinture*. Paris, 1971.

Poling, Clark. *Bauhaus Color*. The High Museum of Art, Atlanta, 1976.

———. *Color Theories of the Bauhaus Artists*. Ph.D. dissertation, Columbia University, New York, 1973.

———. "Kandinsky au Bauhaus: Théorie de la couleur et grammaire picturale." *Change*, Paris, special issue, "La Peinture," Nos. 26/27 (February 1976), pp. 194–208.

———. *Kandinsky: Russian & Bauhaus Years*,

1915–1933. The Solomon R. Guggenheim Museum, New York, 1983.

Reff, Theodore. "Painting and Theory in the Final Decade." In *Cézanne, The Late Work.* Edited by William Rubin. The Museum of Modern Art, New York, 1977.

Reidl, Peter Anselm. *Wassily Kandinsky in Selbstzeugnissen und Bilddokumenten.* Reinbeck bei Hamburg, 1983.

Ringbom, Sixten. "Art in 'The Epoch of the Great Spiritual': Occult Elements in the Early Theory of Abstract Painting." *Journal of the Warburg and Courtauld Institutes,* XXIX (1966), pp. 386–418.

———. "Paul Klee and the Inner Truth to Nature." *Arts Magazine,* LII, No. 1 (September 1977), pp. 112–117.

———. *The Sounding Cosmos: a Study in the Spiritualism of Kandinsky and the Genesis of Abstract Painting.* Abo, Finland, 1970.

Rischbieter, Henning, ed. *Art and the Stage in the 20th Century.* Greenwich, Conn., 1968.

Roethel, Hans K. *Kandinsky.* In collaboration with Jean K. Benjamin. New York, 1979.

———, and Jean K. Benjamin. *Catalogue Raisonné of the Oil Paintings.* Two volumes. Ithaca, New York, 1982–1983.

Rood, O. N. *Die moderne Farbenlehre, mit Hinweisen auf ihre Benutzungen in Malerei und Kunstgewerbe.* Leipzig, 1880; original American edition, *Modern Chromatics, with Applications to Art and Industry.* New York, 1879.

Roters, Eberhard. *Painters of the Bauhaus.* New York, 1969.

Runge, Philipp Otto. *Hinterlassene Schriften.* 2 Vols. Hamburg, 1840–1841 (facsimile, Göttingen, 1965).

Satzungen Staatliches Bauhaus in Weimar. Weimar, July 1922.

Scheffler, Karl. "Notizen über die Farbe." *Dekorative Kunst,* VII (February 1901), pp. 183–196.

Schlemmer, Oskar. *The Letters and Diaries of Oskar Schlemmer.* Edited by Tut Schlemmer. Middletown, Conn., 1972.

Schmidt, Paul Ferdinand. *Philipp Otto Runge, Sein Leben und sein Werk.* Leipzig, 1923.

Schnaidt, Claude. *Hannes Meyer: Bauten, Projekte und Schriften.* Teufen, Switzerland, 1965.

Sers, Philippe, editor. See *Wassily Kandinsky: Écrits complets.*

VI. Internationaler Kongress für Zeichnen, Kunstunterricht und angewandte Künste. Catalog, Prague, 1928.

Signac, Paul. *D'Eugène Delacroix au néo-impressionisme.* Paris, 1899; reprint, Paris, 1964. German edition, *Von E. Delacroix zum Neo-Impressionismus.* Berlin (Charlottenburg), 1910.

The Solomon R. Guggenheim Foundation, New York. *In Memory of Wassily Kandinsky.* Edited by Hilla Rebay. New York, 1945.

Staatliches Bauhaus Weimar 1919–1923. Weimar-Munich, 1923.

Teuber, Marianne L. "*Blue Night* by Paul Klee." In *Vision and Artifact.* Edited by Mary Henle. New York, 1976, pp. 131–151.

———. "Paul Klee: Abstract Art and Visual Perception." 61st Annual Meeting of the College Art Association of America, New York City, January 1973.

Tower, Beeke. *Klee and Kandinsky in Munich and at the Bauhaus.* Ann Arbor, 1981.

Traeger, Jörg. *Philipp Otto Runge und sein Werk.* Munich, 1975.

Tritschler, Thomas C. "The Art and Theories of Adolf Hölzel and Their Place in the History of Late Nineteenth and Early Twentieth Century Painting." M. A. thesis, University of Illinois, Urbana, 1969.

Umanskij, Konstantin. "Kandinskijs Rolle im russischen Kunstleben." *Der Ararat,* Sonderheft II (May-June 1920), pp. 28–30.

———. *Neue Kunst in Russland, 1914–1919.* Vorwort von Leopold Zahn, Potsdam-Munich, 1920.

Venzmer, Wolfgang. "Adolf Hölzel—Leben und Werk." *Der Pelikan,* No. 65 (April 1963), pp. 4–14.

Volboudt, Pierre. *Kandinsky.* Trans. by Jane Brenton. New York, 1986.

Wangler, Wolfgang. *Bauhaus—2. Generation.* Cologne, 1980.

Washton-Long, Rose-Carol. *Kandinsky: The Development of an Abstract Style.* New York, 1981.

Weiss, Peg. *Kandinsky in Munich: The Formative Jugendstil Years.* Princeton, 1979.

Welsh, Robert. "Abstraction at the Bauhaus." *Artforum,* VIII, No. 7 (March 1970), pp. 46–51.

Whitford, Frank. *Bauhaus.* New York, 1984.

Wick, Rainer. *Bauhaus-Pädagogik.* Cologne, 1982.

Wingler, Hans M., ed. *Das Bauhaus, 1919–1933, Weimar, Dessau, Berlin.* Bramsche, 1962. Expanded English edition: *The Bauhaus: Weimar, Dessau, Berlin, Chicago.* Cambridge, Mass., 1969.

———. "La Conception pedagogique du Bauhaus." In Centre national d'art et de culture Georges Pompidou, *Paris-Berlin: rapports et contrastes franco-allemagne, 1900–1933.* Paris, 12 July–6 November, 1978, pp. 328–341.

Wissenschaftliche Zeitschrift der Hochschule fur Architektur und Bauwesen Weimar. XXVI, Nos. 4/5. Special issue on the Bauhaus.

Württembergischer Kunstverein and Bauhaus Archive. *50 Years Bauhaus.* Stuttgart, 1968.

Zehder, Hugo. *Wassily Kandinsky.* Foreword by Paul Ferdinand Schmidt. Dresden, 1920.

Biographical Data on Kandinsky's Students

Arndt, Alfred. 1898–1976. Student of mural painting at the Bauhaus 1921–25; journeyman, 1925–27; master, 1929–32; participant in Kandinsky's analytical drawing, 1922–23; later, architect and painter in Probstzella, Jena, and after 1945, in Darmstadt.

Batz, Eugen. 1905– . At the Bauhaus, 1929–31; studied graphics with Joos Schmidt and Peterhans. Attended free painting classes of Klee and Kandinsky; participant in Kandinsky's course on the theory of abstract form and analytical drawing, 1929–30. With Klee in Düsseldorf, 1931; lives as a painter in Wuppertal.

Baschant, Rudolf. 1897–1955. At the Bauhaus, especially the print workshop, from 1921–24. 1923, qualifying exam; 1930–33, teacher at Burg Giebichenstein; 1933, left the teaching profession and worked thereafter in scientific drawing and applied graphics. Active in Linz after the war.

Bayer, Herbert. 1907–1985. 1921–23, studied at the Bauhaus in Kandinsky's workshop for mural painting. 1925–28, master, head of the workshop for typography and commercial art. After 1928, painter and commercial artist in Berlin. 1938, emigrated to the United States. Graphic artist, painter, architect, and curator. Lived in Montecito, California.

Berger, Otti. 1898–1945. Student at the Bauhaus, 1927–30; collaborated as head of the textile section, 1931–32; studied with Kandinsky, 1927; textile designer in Berlin after 1933. Died in a concentration camp.

Beckmann, Hannes. 1909–1977. At the Bauhaus, 1928–32; attended classes held by Kandinsky and Klee. Studied photography in Vienna, 1932–34. Afterwards, active as a photographer in Prague. Emigrated to the United States in 1948. Head of the photographic department of the Guggenheim Museum until 1952, then instructor of art at various schools,

Cooper Union, New York, and Dartmouth College.

Drewes, Werner. 1899–1985. At the Bauhaus 1921–22 and 1927–28. During his second period of studies, attended classes given by Klee, and Kandinsky's free painting course. Afterwards active as a painter, designer, and teacher in the United States. Lived in Reston, Virginia.

Fischer, Hermann. 1898–1974. 1928–32 at the Bauhaus. Attended Kandinsky's classes, 1930. Fabric and tapestry designer in the Netherlands.

Fiszmer (Fissmer), Fritz. Dates unknown. Supposedly at the Bauhaus 1925–26.

Fritzsche, Erich. Dates unknown. Supposedly identical with Fritzsche, Enh. registered as No. 218 in Dessau, 1927–28.

Hirschfeld-Mack, Ludwig. 1893–1965. At the Bauhaus, 1920–25; member of the print workshop after 1922. Organized an independent group for color studies; head of the preliminary course at the State Engineering School, Weimar, 1927. Afterwards, teacher at the experimental school, Wichersdorf. Later an art teacher in Australia.

Imkamp, Wilhelm. 1906– At the Bauhaus, 1926–29. Attended Kandinsky's and Klee's painting classes. Thereafter, independent painter. Lives in Stuttgart.

Keler, Peter. 1898–1982. At the Bauhaus, 1921–25. Studied mural painting with Kandinsky; 1924–25, member; after 1925, interior designer and graphic artist. 1947, appointed to the Academy in Weimar.

Kerkovius, Ida. 1879–1970. At the Bauhaus, 1920–23; participant in Kandinsky's first courses, 1922–23. Later a painter, weaver, and designer.

Kessinger-Petitpierre, Friedly. 1905–1959. At the Bauhaus, 1929–31. Attended Kandinsky's courses on the elements of abstract form and analytical drawing, 1929–30. Followed Klee to Düsseldorf, then active as a painter.

Kessler, Hans. 1906– . At the Bauhaus, 1931–33. 1931–32 attended Kandinsky's courses on the elements of abstract form and analytical drawing. Building technician and manufacturing engineer. Lives in Krefeld.

Klode, Karl. 1904– . At the Bauhaus, 1930–32 in the printmaking section. Attended Kandinsky's courses. Active as a graphic artist. After 1945, a painter and art teacher in Velbert.

Kukowa, Robert Eduard. 1906–1966. At the

Bauhaus, 1925–27. Attended Kandinsky's courses and the workshop in typography taught by Bayer. Did public relations work for publishing houses; later, a journalist and author.

Lang, Lothar. 1907–1974. At the Bauhaus, 1926–31; wall-painting workshop and later section for engineering. Attended Kandinsky's classes in the Preliminary Course, 1926–27. Later active in above- and underground construction.

Levedag, Fritz. 1899–1951. At the Bauhaus, 1926–28. Attended Klee and Kandinsky's courses. 1929, in Walter Gropius's architectural office. 1930–31, moved to Berlin and active as an independent painter. In Wesel after 1945.

Molnar, Farkas. 1897–1945. 1921–25, at the Bauhaus and in Gropius's office. After 1925, architect in Budapest. 1928, Hungarian delegate to the CIAM.

Neuy, Heinrich. 1911– . At the Bauhaus, 1920–32, engineering section; attended Kandinsky's courses on the elements of abstract form and analytical drawing, 1930. Interior designer. Lives in Borghorst.

Paris, Rudolph. 1896–1973. At the Bauhaus, 1922–25, wall-painting workshop. Attended Kandinsky's color seminar. 1925, qualifying exam. Afterwards, instructor at the Art Academy, Dorpat.

Rasch, Maria. 1897–1959. At the Bauhaus, 1919–23, wall-painting workshop. Qualifying exam; later, an independent artist.

Röseler, Hermann. 1906–?. At the Bauhaus, 1924–32, apparently with interruptions. Participated in stage workshop.

Rose, Katja (Schmidt, Käthe). 1905– Participant in weaving courses before entering the Bauhaus in 1931. In addition to training as a weaver, attended Kandinsky's courses 1931–32. Completed weaving studies in 1933. After qualifying exam, she taught weaving and ran a hand weaving mill. Lives in Munich.

Shürmann, Herbert. 1908–1982. At the Bauhaus, 1931–32, section for advertising. Attended Kandinsky's courses, 1931–32. Graphic artist and photographer; also a painter after the war.

Schunke, Gerhard. 1899–1963. At the Bauhaus, 1919–24. Training in carpentry; apprentice in the print workshop. Close contact with Gertrud Grunow, whose theories about the influence of color and light on human beings he expanded and put into practice in a sanatorium.

Sörensen-Popitz, Irmgard (Söre Popitz). 1898– . At the Bauhaus 1924–25. Attended Kandinsky's Preliminary Course. Painter and graphic artist. Lives in Kronberg (Taunus).

Thiemann, Hans. 1910–1977. At the Bauhaus, 1929–33. After Preliminary Course with Albers, attended only courses given by Klee and Kandinsky. Lived as an independent painter and draftsman until he became a member of the Academy of Fine Arts in Hamburg, 1960.

Trudel, Frank. 1911– . At the Bauhaus, 1932–33; then master apprenticeship with Mies van der Rohe until 1935. 1932–33, attended Kandinsky's courses on the elements of abstract form, analytical drawing, and free painting. Architect after the war. Lives in Geneva.

Tschaschnig, Fritz. 1904– . At the Bauhaus, 1929–32. Trained as a painter in the classes of Klee and Kandinsky. Active as painter and craftsman. Occasionally, a teacher at the Craft School in Cologne. Lives in Cologne.

Ullmann-Broner, Bella. 1911– . At the Bauhaus, 1929–30. Attended Kandinsky's courses, 1929. Emigrated to Palestine and the United States. Lives in Stuttgart.

Voepel-Neujahr, Charlotte (Charly Voepel). 1909–1982. At the Bauhaus, 1927–29. Trained in mural-painting workshop. 1927–28, attended Kandinsky's courses on the elements of abstract form, and analytical drawing. Painter and fashion artist. Lived in Berlin.

Weber, Gerhard. 1909–1986. At the Bauhaus, 1931–33. Attended Kandinsky's courses on the elements of abstract form, analytical drawing, and free painting. Architect. Professor at the TU, Munich, since 1955. Lives in Allmannshausen.

Weber, Vincent. 1902– . At the Bauhaus, 1920–24. In summer of 1923 and 1925, attended the Spanish Academy in Rome. 1929–30, Adolf Hözel's master student, then his assistant. Painter and teacher at arts and crafts schools in Stetten, Rome, and in Wiesbaden, where he now lives.

Weininger, Andrew. 1899–1986. At the Bauhaus, 1921–28. Trained in mural painting, collaborated as actor, dancer, and musician in the theater workshop. Interior architect in Berlin after 1928. 1939, independent painter in the Netherlands; 1951, emigration to Canada; has lived in the United States since 1958.

Acknowledgements

Photo Credits

I would like to express my deep gratitude to Hans M. Wingler, who initially suggested this project to me and who was continually helpful and supportive of my work on the materials at the Bauhaus Archive and in the preparation of this book. The staff members of the Archive were also most helpful and cooperative, and I wish particularly to thank Dr. Peter Hahn, now Director, and Dr. Christian Wolsdorff for their assistance in making the materials of the Archive available to me and in otherwise providing me with information and documentation.

My research was generously supported by grants for which I am extremely grateful: from the Deutscher Akademischer Austauschdienst, from the National Endowment for the Humanities, and from Emory University.

Two former students of Kandinsky at the Bauhaus—Eugen Batz, in Wupperthal, and Fritz Tschaschnig, in Cologne—were most generous in offering both information and hospitality on the occasion of my visits with them. Professor Philippe Sers, in Paris, kindly showed me the original manuscript of Kandinsky's teaching notes and the supplementary pedagogical materials. Charles W. Haxthausen, formerly curator of the Busch-Reisinger Museum, Harvard University, was very helpful to me in my research among the extensive Bauhaus materials at the Museum. I am very grateful to Martha Bridges and Laurel Wemett in Atlanta for their assistance in preparing the manuscript, and to Chris Brannock, a graduate student in art history at Emory, for her work on the catalogue and bibliography.

Finally, I dedicate this book to Eve Corey Poling, my wife, whose moral support, insight, and love have aided me immeasurably.

Unless otherwise noted, illustrations have been supplied by their owners. All student works are from the Bauhaus Archive in Berlin unless specified otherwise in the picture caption or below.

© 1982, copyright by A.D.A.G.P., Paris and by COSMOPRESS, Genf for Kandinsky's works: figs. 20, 21, 22–24, 38, 59, 75, 76, 77, 79, 80, 81, 82, 83, 84, 85, 87, 93, 94, 123, 126, 127, 128, 129, 130, 132, 133, 134, 135, 136, 144, 145, 146
Adler, Bruno, Ed., *Utopia, Dokumente der Wirklichkeit*, 1921, (62, 65): fig. 138
Der Architekt, XVI, 1910, 49–50, examples 8, 9, and 10: fig. 137 bauhaus II, Vol. 2/3, 1928, 9–11 and 31: figs. 3, 102, 108, 113, 114
Bauhaus Archive, Berlin: pp. 2, 10; figs. 1, 2, 13, 17, 25, 26, 33, 34, 35, 37, 39, 46, 47, 60, 62, 63, 96, 109, 123, 130, 143, 157, 159, 160, 161, 176, 177, 178
Grohmann, Will, *Wassily Kandinsky*, 1958, 96: figs. 24, 129
Hugh Museum of Art, Atlanta, Georgia: fig. 66
Kandinsky, Wassily, *Essays über Kunst und Künstler*, 1955, 112, 220
cover illustration: figs. 134, 135, 136
Kandinsky, Wassily, *Punkt und Linie zu Fläche*, 1926, figs. 9, 10, 35, 39, 40, diagrams 4, 23: figs. 123, 130, 131, 132, 144, 145, 146
Kandinsky, Wassily, *Über das Geistige in der Kunst*, 1912, diagram 1, p.72: fig. 38
Das Kunstblatt, X, 1926, 117, 119: fig. 133
Musée des Arts Décoratifs, Paris: fig. 18
Platz, Gustav Adolf, *Die Baukunst der neuesten Zeit*, 1927, plate XX: fig. 28

Roters, Eberhard, *Maler am Bauhaus*, 1965, 154: fig. 85
Staatliches Bauhaus Weimar 1919– 1923, 1923, 56–59, 79, plates IV, V, VI: figs. 27, 37, 59, 139, 140, 141, 142
Wingler, Hans M., *Das Bauhaus*, 1962, 394–395: figs. 100, 101

Photographs:
Herman E. Kiessling, Berlin: figs. 4, 5, 6, 7, 8, 9, 10, 11, 12, 14, 15, 16, 27, 28, 29, 30, 31, 32, 40, 41, 42, 43, 44, 45, 48, 49, 50, 51, 52, 53, 54, 55, 56, 57, 59, 67, 68, 69, 70, 71, 72, 73, 74, 86, 88, 89, 90, 91, 92, 95, 97, 98, 99, 103, 104, 105, 106, 107, 110, 111, 112, 115, 116, 117, 118, 119, 120, 121, 122, 124, 125, 147, 148, 149, 150, 151, 152, 153, 154, 155, 156, 158, 162, 163, 164, 165, 166, 167, 168, 169, 170, 171, 172, 173, 174, 175
Other photographs have been provided by museums and galleries. Figs. 58 and 78 have been reproduced from the originals by production-team gmbH, Weingarten